From Fra Angelico to Bonnard

Masterpieces from the Rau Collection

Art Director
Marcello Francone

Editing
Doriana Comerlati

Layout
Cinzia De Zani

First published in Italy in 2000 by
Skira Editore S.p.A.
Palazzo Casati Stampa
via Torino 61
20123 Milano
Italy

Printed and bound in Italy. First edition

ISBN 88-8118-802-3 hardcover edition
ISBN 88-8118-801-5 paperback edition

Distributed in North America and Latin
America by Abbeville Publishing Group, 22
Cortlandt Street, New York, NY 10007, USA.
Distributed elsewhere in the world by Thames
and Hudson Ltd., 181a High Holborn, London
WC1V 7QX. United Kingdom.

SÉNAT

MUSÉE DU LUXEMBOURG

19 rue de Vaugirard, 75006 Paris
tel : 01 42 34 28 64 - fax : 01 46 34 61 62

The exhibition is presented
by the Senate of the French Republic
within the Musée du Luxembourg

Under the Presidency of
Mister Christian Poncelet,
President of the Senate

Representative Artistic Direction:
Patrizia Nitti Marc Restellini

**From Fra Angelico
to Bonnard**
*Masterpieces from the
Rau Collection*
12 July 2000
4 January 2001
Paris, Musée
du Luxembourg

Exhibition:

General Commissioner:
Marc Restellini

The works of this exhibition have been
selected by Doctor Rau with assistance
of Marc Restellini

Collaborated by
Robert Clémentz
*Administrator of the collection and private secretary
of Doctor Rau*

General organization of the exhibition:
Sylvestre Verger

Catalogue of the exhibition:

Supervised by Marc Restellini

Entries on artists and works:
Grahal under the supervision of Michel Laclotte

List of the authors:
Françoise Kunzi (F. K.)
Véronique Damian (V. D.)
François de Vergnettes (F. de V.)
Jean-Christophe Baudequin (J.-Ch. B.)
Isabelle Mayer (I. M.)
Frédéric Elsig (F. E.)
Olivier Zeder (O. Z.)
Philippe Laux (Ph. L.)
Cécile Bouleau (C. B.)
Odile Delenda (O. D.)
Hélène Toussaint (H. T.)
Christophe Dejaune (Ch. D.)

Entries on periods:
Charlotte Martin

Press:
Observatoire, Véronique Jeanneau

Scenography:
Direction: Patrick Marant
Conception: Laurent Guinamard
Description and design: Gilles Guinamard

Model maker:
Jean-Claude Barotto

The exhibition organizers particularly wish to thank
the following personalities for their intervention
and support:

For the Senate:
Alain Méar,
Directeur du cabinet du Président du Sénat
Yves Marek,
Conseiller au cabinet du Président chargé de la Culture
Hélène Ponceau,
Secrétaire Général de la Questure
Le Général Paul Moulian,
Commandant militaire du Palais du Luxembourg
Alain Di Stefano,
Directeur de l'Architecture, des Bâtiments et des Jardins
Claude Dufour, *Service de l'Architecture*

And also:
François Debouté,
Directeur de la communication de Paris Match
Jean-François Chaigneau, *Journaliste*, Paris Match
Lorraine Willems,
Directeur du marketing et de la communication, LCI
Laeticia De Luca,
*Chargé des relations presse et des relations publiques,
LCI*
Françoise Rey, *Société Decaux*
David Caméo,
Cabinet du Ministre de la Culture
Christian Mantéi,
Directeur Général de l'office du Tourisme de Paris
Didier Hamon,
*Directeur de la stratégie et de la politique commerciale,
ADP*
Jean-Paul Bailly, *Président de la RATP*
Gérard Gros, *Métrobus*
Jérôme Bellay,
Directeur Général de l'antenne, Europe 1
Jean-Paul Giraud,
Président Directeur Général de la Fnac

We particularly wish to thank all people from
Art Life, and especially:
Yoshito Nichida, *Chairman*
Teiichiro Yoshida, *Vice-Président*
Yoïchi Nakao, *Managing Director*

The Musée du Luxembourg, housed in the Palais du Luxembourg and placed under the Senate's responsibility, has a prestigious history.

As early as 1615, Marie de Médicis had wanted the Palais du Luxembourg to contain two galleries designed to exhibit paintings. It was for these galleries that Rubens painted L'Histoire de la Reine, currently in the Musée du Louvre. From 1750 onwards, the Musée du Luxembourg was the first painting museum open to the public, who could thus admire works by Leonardo da Vinci, Titian, Veronese, Rembrandt, van Dick, Poussin or Caravaggio.

In 1818, the Musée du Luxembourg became the living artists' museum and, in a way, the very first "Modern Art Museum". It showed David, Gros, Girodet, Vernet, Ingres, Delacroix.

Between 1884 and 1886, the Senate put up the building which now contains the museum. It was left the important Caillebotte legacy. Works by Pissarro, Bonnard, Renoir, Degas and Gauguin were on display there until 1937, when the collections were moved to the new Musée d'Art Moderne. Devoted to modern art, the museum did not avoid controversy. Picasso announced that it was "the most beautiful space in the world", whereas Gauguin, unhappy with the choice of artists, wrote that the the Luxembourg was "a brothel"!

Since then the Musée du Luxembourg, managed by the ministry of Culture, had become an exhibition space, chiefly devoted to the heritage of the French provinces, which provided the general public with a nostalgic taste for a more glorious era.

This year 2000 is now marked by the renewal of the Musée du Luxembourg, which returns to its original function on the Parisian and international art scene, thanks to the convention I signed with the ministry of Culture and the exhibition of masterpieces from Doctor Rau's collection.

I wish to thank Doctor Rau, who managed to assemble an impressive collection, as well as conduct admirable humanitarian actions, for honouring the Senate by his choice of the Musée du Luxembourg to share some of the exceptional masterpieces from his collection, chosen in conjunction with Marc Restellini.

I also want to thank Ms. Patrizia Nitti and the exhibition's general commissioner, Marc Restellini, for bringing to fruition this ambitious project, and, as delegate artistic directors of the museum, for putting their proficiency and knowledge of the art world in the service of the policies the Senate intends to implement for the renewal of the Musée du Luxembourg.

The choice of the prestigious Skira editions to inaugurate, with this exhibition and this very handsome catalogue, a "Musée du Luxembourg" collection, must also be mentioned, for it shows that, straightaway, with the "Masterpieces from the Rau Collection", the Senate has achieved its objective: to place the Musée du Luxembourg at the forefront of cultural life.

Christian Poncelet
President of the French Senate

It is for me a great pleasure to see realized today a long-cherished wish: to show the general public the collection I have put together over more than thirty years. France is now playing host to this exhibition which is travelling all over the world, and which affords a look at the most representative pieces in the collection.

I am very happy that France is doing me the honour of receiving me, France which has been at the heart of Western art for many centuries and has always played a dominant role in my choices for the collection. This collection that I put together patiently and passionately will, I hope, provide a brief look at five centuries of Western art. It is for me highly symbolical that France welcomes me today in one of its most prestigious public spaces, at a time when the whole world is celebrating the millennium. Perhaps this exhibition can also contribute, in its way, to pay homage to the millennium just past.

First of all I want to thank Mr. Christian Poncelet, President of the French Senate, for his warm welcome, and I wish to express my gratitude to him for having chosen my collection to inaugurate the Senate's new cultural policy as regards the Musée du Luxembourg. This honour bestowed on me by the French state is naturally a consecration not only of my artistic choices through the collection, but also for the humanitarian actions I have carried out over the past thirty years.

I also want to extend thanks to the organizers of the exhibition who have worked unstintingly for several months to put on this show. I want to thank Mr. Méar, chief of staff of the President of the

Senate, as well as Mr. Marek, technical counsellor to the President of the Senate. I congratulate Mr. Marc Restellini, as well as Ms. Nitti on their new positions on the board of the Musée du Luxembourg, and address my warmest thanks to Mr. Sylvestre Verger for the organization of the exhibition.

Finally, I particularly wish to thank Mr. Marc Restellini, general commissioner of the exhibition, whom I asked several years ago to undertake the setting up of this project, and to set up a travelling show of my collection throughout the world, and without whom none of this would have happened. May he here receive the friendliest and warmest of thanks.

I now wish the exhibition good luck on its new stage and a great deal of pleasure to all the visitors.

Doctor Gustav Rau

Contents

tion, the *Sea at L'Estaque* (cat. no. 55) by Paul Cézanne, which marks the start of modernity and prefigures the art of the twentieth century.

By Edgar Degas, we will chiefly point out the last *Self-portrait* (cat. no. 58) painted by the artist (1900), where traces of his tragic infirmity can be seen and which stresses the solitude of the nearly blind painter in the greyness of his studio.

By Camille Pissarro a magnificent series traces some of the most beautiful stages in the oeuvre of one of Doctor Rau's favourite artists. The splendid *View of L'Hermitage, Jallais Hill in Pontoise, 1867* (cat. no. 67), is yet again one of the masterpieces of the collection, but we can also admire the very fine *Road from Saint-Germain to Louveciennes* (cat. no. 68), or else a view of the *Courthouse at Pontoise* (cat. no. 69). By Alfred Sisley, the collection has one of his admirable snowscapes – *Effect of Snow at Marly* (cat. no. 71) – which the artist painted during the winter 1875-1876. Gustave Caillebotte is also well represented in the collection with an important view of *Snow-covered Rooftops* (cat. no. 74), a rare subject for this artist, unlike Sisley.

Among the major masterpieces of Impressionism, the Rau collection owns one of Mary Cassatt's finest pastels: a maternity showing *Louise Feeding Her Child* (cat. no. 75). The painting reminds us that the American artist had a great fondness for this subject with its biblical overtones which she reinvented in the Impressionist period at a moment when feminist thinking and movements were getting under way.

Along with the artists as part of the continuing tradition of Impressionism, the collection owns a major work by Paul Signac, a jewel of Pointillism: this profound and sober work represents the *Sea. Saint-Briac* (cat. no. 77) and shows how at that particular time Signac worked completely according to Seurat's ideas and his series of the Grande Jatte island. By Gino Severini, the large *Landscape at Civray* (cat. no. 81) also attests the implication of the Impressionist movement on the international level and on other artistic movements in the twentieth century. In particular, this work from Sev-

erini's first period shows up the influence of Impressionistic landscape in such a specific movement as Futurism in Italy.

Doctor Rau pays homage to Symbolism first of all with Odilon Redon, represented by two major works. One of them is the very impressive *Apollo's Chariot* (cat. no. 83) from the Milton de Groot collection, which was for a long while shown in the Metropolitan Museum of Art in New York. There are also Ferdinand Hodler (cat. no. 84) and Gustav Klimt (cat. no. 85) with two very interesting works.

The Rau collection has large holdings of the Nabi group. Gauguin's presence is very strongly perceived in Sérusier's *Spring at Pouldu* (cat. no. 86); but it is thanks to two essential works – *July* (cat. no. 94) and *Mother and Child on a Yellow Bed* (cat. no. 95) – by the group's theoretician, Maurice Denis, that the Nabis are probably best represented. Then there is a fine work by Félix Vallotton (cat. no. 87), two very representative paintings by Pierre Bonnard, including an important *Saint-Tropez Bay* (cat. no. 88), and a fine series of Edoaurd Vuillard, including two *Self-portraits* (cat. nos. 90, 92), a view of *Chestnut Trees, Rue Truffaut* (cat. no. 91), which is very Nabi, and finally an exceptional large-scale work, painted in tempera, showing a *Portrait of Monsieur André Benac* (cat. no. 93).

Doctor Rau also wants to signify his special fondness for Fauvism and Espressionism. For the first of these two movements, which have many affinities, the main painters in the movement are shown: Maurice de Vlaminck with a rather Fauvist view of the Parisian outskirts – *Fauve Landscape near Chatou* (cat. no. 97); André Derain with some magnificent *Cypresses* (cat. no. 100) from 1907; Albert Marquet (cat. no. 96); Kees van Dongen with a splendid *Little Girl with Sailor Collar* (cat. no. 99), in a square format, showing Dolly van Dongen, his daughter; and above all the *Beach at Sainte-Adresse* (cat. no. 98) by Raoul Dufy, of an exceptional quality, undoubtedly one of the most important by the master from Le Havre. Among the Expressionists are to be found, of course, Edvard Munch (cat. no. 101), but, particularly, a major work by Alexei

Jawlensky (cat. no. 102) and an extraordinary *Clown in a Green Costume* (cat. no. 103) by August Macke. Let us note, finally, an important *Still Life with Bottle and Glasses* (cat. no. 106) by Giorgio Morandi. This exhibition provides a very complete look at the Rau collection and shows up the magnitude of the task undertaken by Doctor Rau over nearly thirty years. An exceptional collection which shows one man's enlightened choices, a man who is a great art lover, rarely seeking advice, and who has managed to endow this collection with a unique specificity and originality. A man of incredible human resources, his collection is like him: powerful, deeply humanistic, solid and independent, never superficial, always profound.

This exhibition is due simply to Doctor Rau's own wishes. All of the organizers join me in espressing here all our gratitude and our friendship. We wish to thank all the members of the Rau Foundation, and particularly Ms. Thost. We also want to express our gratitude to Mr. Clémentz, who looks after the Rau collection and who played a leading role in the setting up and success of this exhibition. We would finally like to thank the team of the Grahal for its active participation in the making of the catalogue, by writing the technical and scientific notes of the works. We wish to extend our warmest thanks to Messrs Borjon and Simonetti, as well as Ms. Gautier.

We wish this exhibition all the success and enthusiastic response it deserves.

Paintings

Remarks

The plates have been grouped into twelve
categories by periods and styles.
For each plate the following data are given:
catalogue number, artist, title, year of
production, material, size, inscriptions.

All of the commentaries have been
originally written in French by the following
authors who are identified by the uppercase
initials at the end:

F. K.	Françoise Kunzi
V. D.	Véronique Damian
F. de V.	François de Vergnettes
J. Ch. B.	Jean-Christophe Baudequin
I. M.	Isabelle Mayer
F. E.	Frédéric Elsig
O. Z.	Olivier Zeder
Ph. L.	Philippe Laux
C. B.	Cécile Bouleau
O. D.	Odile Delenda
H. T.	Hélène Toussaint
Ch. D.	Christophe Dejaune

The entries regarding the works were
carried out under the editorship of the
Grahal (Groupe de Recherche Art Histoire
Architecture et Littérature), who since 1991
has been engaged in carrying out for Doctor
Rau the catalogue of the works comprising
his collection of paintings (two volumes
under the editorship of Michel Laclotte) and
of sculptures (one volume under the
scientific direction of Bertrand Jestaz). The
texts appearing here will be updated on the
occasion of the publication of the general
catalogue of works scheduled for 2001,
in particular the references regarding the
"bibliography" and "exhibitions" headings.

Many thanks to all the team at Grahal:
Michel Borjon, Pascal Simonetti,
Claire Gautier, Pierre Legros.

The works marked with an asterisk (*) were
a donation and form the patrimony of
Doctor Rau's Art Foundation, at Embrach.

The Italian School

Unlike Flemish and French painters, the Italians soon left behind the Gothic style which, in any case, they had adopted with some misgivings. It should also be noted that Italian art is not absolutely homogenous and that the cities – often rivals – in the peninsula witnessed many different schools and styles.

The birth – or Renaissance – of Italian painting as such was mainly developed in Siena and Florence. Although during the fifteenth century there were still to be found traces of a late Gothic (Gentile da Fabriano, Pisanello), most artists, from the fourteenth century on, attempted to create a new style, less rigid and more expressive. Giotto was undoubtedly the forerunner of this new style. The expression of his figures, the movement of forms, the rendering of forms and space mark a break with the Middle Ages, and in this instance, the first approach to modernity.

In the fifteenth century, with the flowering of humanist philosophy and the spread of patronage, Florence definitely enjoyed the status of a cultural capital. Donatello, Brunelleschi and Masaccio are the incarnation of Florentine spirit and style. At that time, Venice remained aloof and marked by the imprint of northern countries.

During the second half of the fifteenth century, provincial workshops sprang up around Florence. The most noteworthy are those of Orvieto, Perugia and Ferrara, in which one finds, respectively, Luca Signorelli, Perugino and Mantegna.

At the end of the fifteenth century a turnabout took place: Rome, under the impulse of the pontifical power, became the main pole of attraction for artists, especially for two geniuses: Raphael and Michelangelo. The *venustà* of the former and the *terribilità* of the second led to a taste for the bizarre, the fantastic in their successors, contorsions or exaggerated stretching of forms. Thus was born the "Mannerist" style, which could be defined as a form of art which, instead of creating forms, is inspired by existing models and frequently arrives at artificial representations; Vasari, Salviati, Parmigianino, Il Rosso, Romano, Beccafumi and Pontormo are among the main exponents of this movement. With the Counter-Reformation inaugurated by the Council of Trent, the Italian painters at the end of the sixteen century evolved differently. We have to await the arrival of the Carracci brothers to see a return of a kind of "Classicism". As for Caravaggio he provided a realistic style, considered outrageous by the critics, but followed by a great many of his contemporaries (Reni, Caracciolo); Italy and soon all of Europe in the seventeenth century saw the emergence of a new style which blossomed mainly through architecture and monumental designs. The chief characteristics of Baroque appear in works by Bernini, Pietro da Cortona, Domenichino, Guercino and Guido Reni. The change from Baroque to the Rococo style took place during the eighteenth century in the cities of Genoa and above all in Venice, in which the painters of *vedute* and of great sceneries, such as Tiepolo, Canaletto and Bellotto, all worked.

Fra Angelico
(Guido di Pietro, known as Fra Angelico, before 1396 ? – 1455)
Saint Nicholas of Bari, 1424–1425
Saint Michael, 1424–1425

Panel, gold background.
H: 35.5 cm; W: 14 cm (each).
On the back of *Saint Nicholas of Bari*, an old ink writing: *Questa figura che rappresenta S. Agostino Vescovo e Dottore, di mano di Giov. Beato Angelico era una delle dieci che adornavano l'Altare del convento di S. Domenico di Fiesole.*
On the back of *Saint Michael*, an old ink writing: *Questa [?] figura che rappresenta [?] S. Michele Arcangelo, di mano di Giov. [?] Beato Angelico: era una delle dieci che adornavano un Altare del convento a [?] S. Domenico di Fiesole.*
GR 1.696 and GR 1.697

The first mention of Fra Angelico (Vicchio di Mugello, Florence, before 1396 ? – Rome, 1455) in a document notes his registration as a painter in the company of San Niccolò at the Carmine church in Florence in 1417; he then entered, around 1418, the San Domenico monastery at Fiesole. His early works, contemporary with those of Masaccio and of Masolino, fall within the sphere of the late Gothic represented in Florence by Starnina, Lorenzo Monaco and Gentile da Fabriano. For San Domenico at Fiesole, he carried out the triptych for the high altar – to which belong the two saints in the Rau collection – the Annunciation *(Madrid, Museo del Prado) and later the* Coronation of the Virgin *(Paris, Musée du Louvre). In 1438, Fra Angelico joined the monastery of San Marco whose decoration he started, with the aid of colleagues, the following year.*
In 1446, Eugene IV summoned the artist to the Vatican to decorate a chapel which is now destroyed. His successor, Nicholas V, commissioned the painter to decorate a neighbouring chapel with the Scenes from the Lives of Saint Lawrence and Saint Stephen. *After a stay in Florence (1450–1453) he went back to Rome where he died February 18, 1455.*

J. Pope-Hennessy's proposal in 1952 to associate the two altarpiece sections in the Rau collection – *Saint Nicholas of Bari* and *Saint Michael* – with that executed by Fra Angelico for the high altar at San Domenico at Fiesole has been critically accepted. The vicissitudes which the triptych showing the *Virgin and Child between the Angels, Saint Thomas Aquinas and Saint Barnabas,* and *Saint Dominic and Saint Peter Martyr* has undergone prove that even masterpieces are not immune from the ravages of time and from the hard law of taste.
Vasari corroborated that in 1501 the Florentine painter Lorenzi di Credi assembled the three main panels to form a unified *pala*. He also enlarged it and added painted architecture and a landscape to the gilt background. The small figures of the saints in the frame's pilasters did not escape this updating: a niche of the *pietra serena*, still visible on photographs taken prior to

restoration, covered up the gold background. But it was probably at the end of the eighteenth or beginning of the nineteenth century that the altarpiece was dismembered. In fact between 1792 – the year Moreni (*Notizie istoriche dei contorni di Firenze parte terza: della porta a San Gallo alla città di Fiesole*) saw the altarpiece still intact – and 1827 – the date of the sale of the five elements of the predella by a Florentine merchant (now London, National Gallery), other elements coming from a fourteenth century polyptych were substituted for the pilasters; the pieces of the base suffered the same fate. Moreover, the dismantling of the altarpiece corresponds to the period of discovery of, and new interest in, the Primitives, the taste for those artists who preceded Raphael having established itself in the second half of the eighteenth century. The inscription on the back of the Rau panels suggests that "ten figures" – meaning ten elements – made up the triptych with pilasters, predella and gables. The attempt at reconstitution put forward by U. Baldini (1977) proposes the following identities, besides two saints in the Rau collection and the three elements which remain in the San Domenico at Fiesole: *Saint Mark* and *Saint Matthew* (Chantilly, Musée Condé), two tondi, the *Angel* and the *Virgin Annunciate* (previously Vienna, Tucker collection), the reliquary-tabernacle in the Hermitage Museum in Saint Petersburg, the two *Angels* in the Galleria Sabauda in Turin, and *God the Father in Benediction* in the British Royal Collection as well as the two bishop saints, one in the National Gallery in London, and the other formerly in the Moses collection in New York.
Although it can still be argued that some of these elements never belonged to the San Domenico polyptych, there is no doubt that the two saints in the Rau collection did. It is however necessary to review the iconography of one of them and to recognise – at the side of *Saint Michael Slaying the Dragon* – not, as the inscription says, Saint Augustine, but *Saint Nicholas of Bari* who is indicated by the presence of three golden balls, his traditional attribute. The

History:
Fiesole, high altar in the church of the San Domenico convent; Sheffield, Rev. Hawkins-Jones collection; London, Sotheby's, June 26, 1957, no. 151; Bel Air (California), Mr. and Mrs. Deane Johnson's collection; London, Sotheby's, December 6, 1972, no. 6.

Exhibition:
Florence, *Mostra delle opere del Beato Angelico*, 1955, nos. 7–8, pl. VIII (presented as from Fra Angelico's studio).

Bibliography:
G. Vasari, *Le Vite de più eccellenti pittori, scultori ed architetti* [1st ed. Florence, 1568], ed. Milanesi, 1878–1885, vol. II, p. 510; J. Pope-Hennessy, *Fra Angelico*, London, 1952, pp. 166–167; B. Berenson, *Italian Pictures of the Renaissance: Florentine School*, London, 1963, p. 15, pls. 592, 593; J. Pope-Hennessy, *Fra Angelico*, London, new ed. completed 1974, pp. 189–190, figs. 7a, 7b; U. Baldini, "Contributi all'Angelico: il trittico di San Domenico di Fiesole e qualche altra aggiunta", in *Scritti di storia dell'arte in onore di Ugo Procacci*, Milan, 1977, pp. 236–246; U. Baldini, *Beato Angelico*, Florence, 1986, pp. 19–20, 228.

high quality of the panels, brought out by their excellent state of preservation and underlined by some stylistic characteristics such as the luxury of the garments and the impact of the colours, as well as the chiaroscuro modelling of the complexions in the manner of Gentile da Fabriano, prove that they are part of Fra Angelico's altarpiece.

In the second edition of his monograph on the artist, J. Pope-Hennessy (1974) goes back on his previous dating of 1428–1430 and dates the altarpiece – and hence the *Saint Nicholas of Bari* and the *Saint Michael* – to the years 1424–1425. The altarpiece of San Domenico in Fiesole thus becomes the first known work by the artist, completed even before the *Saint Peter Martyr* altarpiece (Florence, Museo di San Marco) dated 1429. Consequently, Masaccio's influence on it can be more directly grasped, while the sculptural aspect of the Rau collection saints is still very similar to Donatello's statues.

V. D.

right in Christ's arm. Christ's body spreads out in this confined space. His hand stretches beyond these limits, as do the rich draperies which help give the scene its visionary character. The expressions are measured, yet the panel emanates feeling. All the gestures are delicate, especially that of the Virgin clasping Christ's head against her own. The setting and colours are rich without being excessive. Golds, oranges and browns dominate, with the blues and greens of the sky and vestments of the Virgin and Saint John slightly disrupting this harmony.

Crivelli has painted a devotional image in keeping with traditional iconography. His sound technique is devoid of all the excesses his brother was never able to resist. This work radiates a silence which compelled the believers for whom it was painted to meditate.

F. de V.

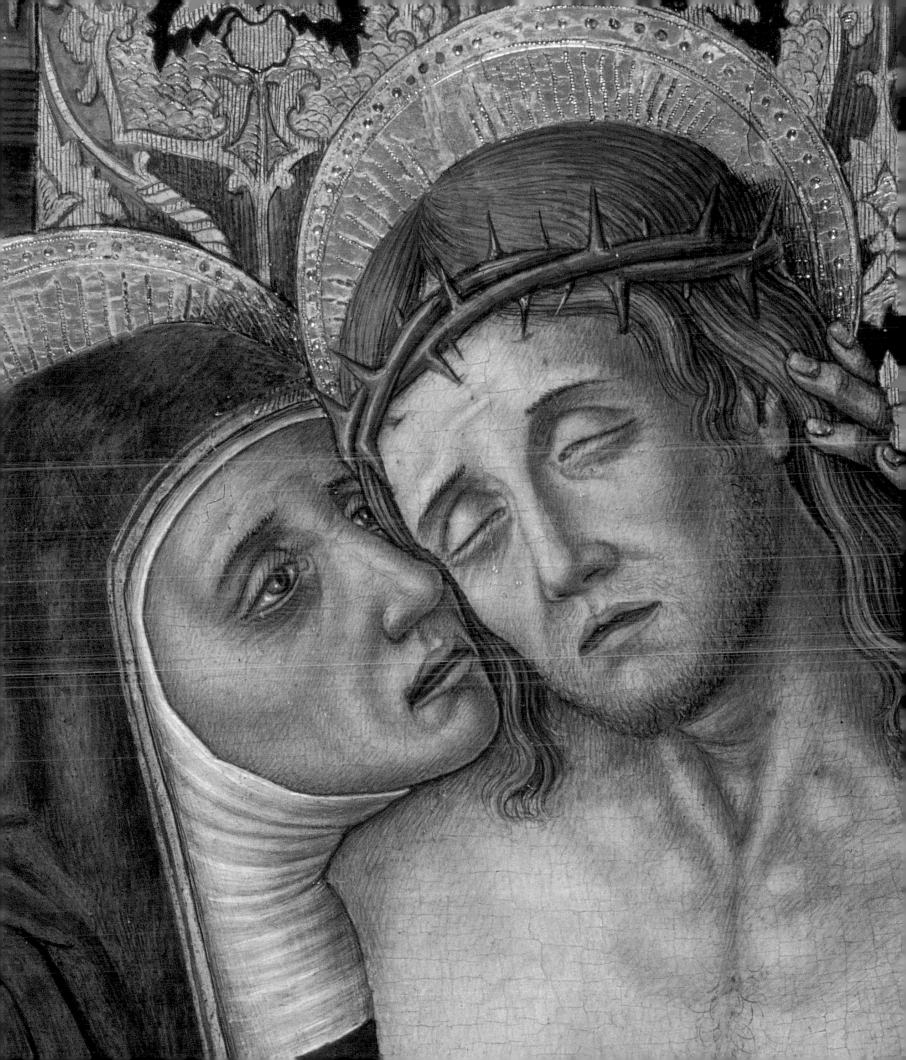

5

Antonio Solario
(Antonio Solario, known as Lo Zingaro, active in the Marches
and Naples during the first quarter of the sixteenth century)
Virgin and Child

Oil on wood.
H: 59.5 cm; W: 50 cm.
Inscription on back: *IEAN
BELLINO N° 174*.
GR 1.82

History:
Venice, collection of Count
Johann-Matthias Schulenburg
(1661–1747); Munich, Galerie
Böhler, 1972.

Exhibitions:
Ancona, *Lorenzo Lotto nelle
Marche. Il suo tempo, il suo
influsso*, 1981, nos. 8, 9;
Geneva, Palexpo, *La
Fondation pour l'écrit. Salon
international du livre et de la
presse. Le livre et la presse
dans la peinture*, 1996.

Bibliography:
*Inventaire de la galerie de
Feu S. E. Mgr le Feldmarechal,
comte de Schulenburg*,
undated [printed before
1774], no. 174, published by
Alice Binion; *La galleria
scomparsa del maresciallo
von der Schulenburg, un
mecenate nella Venezia del
Settecento*, Milan, 1990,
p. 279, no. 174 ("from Jean
Bellino, a painting
representing Our Lady with a
child and beautiful
landscape").

*Little is known about Antonio Solario's ca-
reer. The sources, mainly de Dominici
(1742), are unreliable except for accounts
of his training in Venice. The artist's name
appears for the first time in a document in
the archives of Fermo (the Marches) dated
April 2, 1502 as a Venice-born painter liv-
ing in Fermo. Two large retables, one for
Santa Maria del Carmine church in Fermo,
the other for San Francesco (today San
Giuseppe da Copertino) church in Osimo,
were the subject of a study during the ex-
hibition* Lorenzo Lotto nelle Marche. Il suo
tempo, il suo influsso *(1981, pp. 94–99). De
Dominici indicated that Solario probably
painted frescoes in Naples, but nothing is
known about the rest of his career or the
date of his death.*

In 1987, in an oral statement, E. Fahy re-
jected R. Pallucchini's assertion that Bar-
tolommeo Veneto painted this *Virgin and
Child*. Three years later, A. Tempestini
made the more convincing argument that
the work was due to Antonio Solario. His
comparison with other paintings on the
same theme – *Virgin and Child with the*
Young Saint John the Baptist (signed; Lon-
don, National Gallery), *Virgin Adoring the
Child* (Copenhagen, Statens Museum for
Kunst), *Virgin and Child with a Donor*
(Naples, Museo di Capodimonte), and *Vir-
gin and Child with an Angel, Saint Joseph
and a Donor* (Bristol, City Art Museum) –
is thoroughly persuasive.

The artist adopts the same construction on
two planes. The background always features
a landscape whose precision and delicate ex-
ecution recall the northern European art So-
lario may have seen in Venice. The land-
scape's painstakingly rendered details and
elegance, and the gold highlights on the tree
trunks and foliage, are two of the artist's
trademarks. So are the thin eyebrows, the
eyelids curving over almond-shaped eyes,
the chubby faces of the Virgin and Child and
the thin gold halos. The presentation of the
group, wrapped in the Virgin's heavy man-
tle, recalls the compositions of Giovanni
Bellini and Cima da Conegliano, whose in-
fluence is evident here. This observation
makes it possible to date the painting to ear-
ly in the artist's career.
V. D.

Guido Reni (1575–1642)
David Decapitating Goliath, 1606–1607

Oil on canvas.
H: 174.5 cm; W: 133 cm.
GR 1.261

History:
Lodi collection.

Exhibition:
Bologna, Pinacoteca
Nazionale, *Guido
Reni*, September 5 –
November 10, 1988,
pp. 48–49, no. 16.

Bibliography:
S. Pepper, *Guido Reni. A
Complete Catalogue of His
Works with an Introductory
Text*, Oxford, 1984,
pp. 221–222, no. 25A,
fig. 25, pl. 1; E. Schleier,
"Una proposta per Guido
Reni giovane", in *Arte
Cristiana*, no. 713, 1986,
p. 109.

Guido Reni (Bologna, 1575 – Bologna, 1642) started his training in the academy founded by the Dutch painter Denys Calvaert (1540–1614) around 1575 before frequenting the Carracci Academy. However, the artist departed from the teachings of Annibale and Ludovico Carracci, who advocated a return to the "natural", to rediscover the beauty and grace of Raphael that fascinated him so much. He was able to admire Raphael's Saint Cecilia *in the San Giovanni in Monte church at Bologna (now in the Pinacoteca Nazionale).*
Invited to Rome in 1601 by the Cardinal Paolo Emilio Sfondrato, he stayed in the Eternal City until 1614 – with frequent breaks – and went back there from 1621 to 1627. During his first stay, Reni was struck by the art of Caravaggio: Reni's Crucifixion of Saint Peter *(Vatican Museum) and the first version of* David *(Musée du Louvre) show that he adopted certain characteristics from him. Several masterpieces date from the end of the first period in Rome: the* Samson Victorious *and the* Massacre of the Innocents *(Bologna, Pinacoteca Nazionale) as well as the fresco of* Dawn *for the ceiling of the Casino Rospigliosi in Rome (1614). An independent artist, Reni came back, at the peak of his fame, to Bologna where he died several years later, carried off by a malign fever. There, his pictorial language evolved towards a greater balance and a poetry marked by a more intense spirituality and sentimentalism and an increasingly bright, refined palette.*

The book of Samuel relates the extraordinary combat between David and Goliath the Philistine (1 S 17, 49–54). David comes to the aid of the Israelite army, already ranged in a line against the Philistines led by the giant Goliath. The picture follows the unfurling narrative of the text very closely. The young David advances towards Goliath with a sling as his only weapon. A stone strikes Goliath's forehead and "he fell on his face to the ground [...]. David ran and stood over the Philistine, and took his sword and drew it out of his sheath, and killed him, and cut off his head with it. When the Philistines saw that their champion was dead, they fled away". A deeply devout painter, Guido Reni faithfully transposes this moment in religious history with clarity and a certainty which had been slightly lost since the Renaissance.

This picture has come to be recently added to the *corpus* of Reni: Mina Gregori was the first to suggest the right attribution. With our current knowledge it is impossible to establish the provenance of this painting. S. Pepper (1984) cites the mention by Oretti of a *David Decapitating Goliath* in the collection of Count Giusti del Giardino in Verona.

For stylistic reasons S. Pepper is inclined to date this painting, which is close to the *Martyrdom of Saint Catherine* (Albenga, Museo Diocesano), to Reni's Caravaggist period of 1606–1607. David has the same physical type as in Caravaggio's composition which today is in the Museo del Prado, and there is the same usage of light, in clear-cut chiaroscuro. Here the uneven light, filtering through the clouds in the tormented sky to be reflected from the armour, accentuates the composition's dramatic effect. The painting is structured along horizontal lines and a central vertical axis. It depicts the two main figures in the foreground. Later, the *Samson Victorious* (Bologna, Pinacoteca Nazionale) would be organized the same way.

Reni's Caravaggist period lasted from the spring of 1605, when Pope Clement VII's death led to an interruption of commissions from Rome, to 1608, when he began working alongside Cavaliere d'Arpino for the Cardinal Borghese.
V. D.

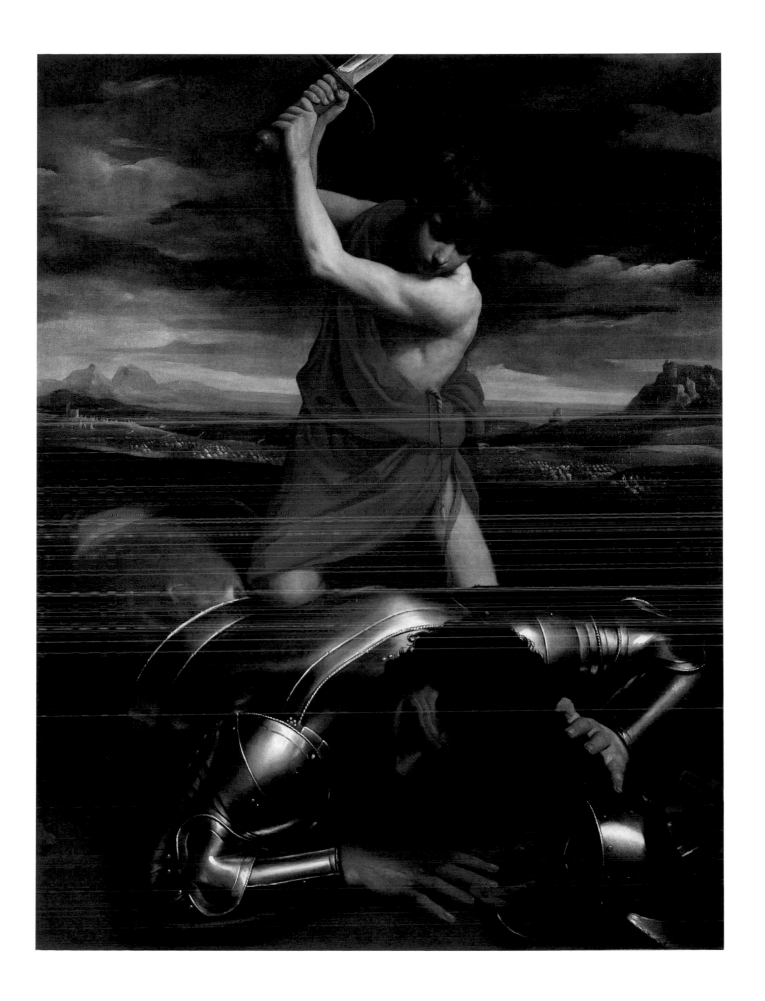

A preparatory drawing for Saint John's hands is in the British Museum. He holds the book he is writing, the Gospel or the Apocalypse, on his lap with his left hand and a quill in his right hand. His attribute, the eagle, looks at him from behind in the shadow. Saint John is looking up towards heaven, his mouth half-open in an expression of divine inspiration, perhaps even ecstasy, which can often be found in works by Dolci, such as the *Mary Magdalen* in the Galleria degli Uffizi in Florence and the *Allegory of Charity* in the Cassa di Risparmi e Depositi in Prato (*Il Seicento fiorentino. Arte a Firenze da Ferdinando I a Cosimo III*, Florence, Palazzo Strozzi, December 21, 1986 – May 4, 1987, pp. 444, 448, nos. 1.250, 1.252, repr.). Space is tight around the figure, whose presence is strengthened by a scarlet drapery. This red mantle, which Christ's favorite disciple is always seen wearing, is evenly distributed in the composition and is a burst of bright colour amid the brown tones. The light that sets off the drapery's folds vividly brightens up the hands and face crowned by a halo.

Saint John the Evangelist is characteristic of Dolci's because of the interiorized but intense religious feeling and the pictorial technique: dense, precise strokes with the look of china even for the complexions, which contributed to the painter's reputation.

I. M.

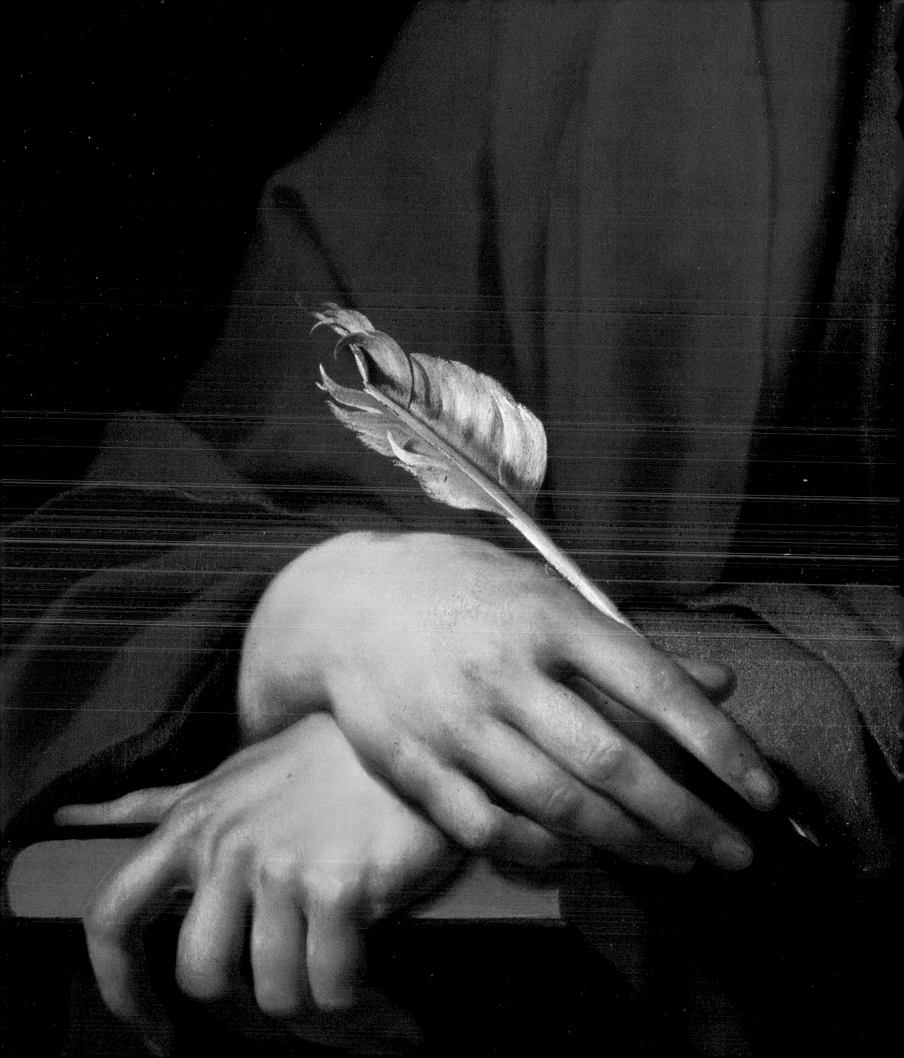

Elisabetta Sirani (1638–1665)
Allegory of Music, 1659

Oil on canvas.
H: 99 cm; W: 73 cm.
On the back of the canvas:
BH and the stencilled letter
and numbers *L.1950*.
GR 1.657

History:
Lowther Castle, Earl of
Lonsdale's collection;
London, sale Appleby Brothers
Ltd, June 11 – July 6, 1963,
no. 14; London, Sotheby's,
July 6, 1972, no. 56.

Elisabetta Sirani (Bologna, 1638 – Bologna, 1665) was the daughter and student of the painter Giovanni Andrea Sirani (1610–1670), who himself studied under and worked with the great Bolognese master Guido Reni (1575–1642). She died at the age of twenty-seven, apparently the victim of a poisoning. The Nota *she kept year after year between 1655 and 1665 and retranscribed in 1678 by Malvasia in his* Felsina pittrice *demonstrates that her brief career was intense (1841 ed., vol. II, pp. 393–400). The* tavoline *and* mezzo figure *prove that her work was highly appreciated by private collectors and important visitors passing through Bologna. They were attracted to this great artist, who had begun her career at the age of seventeen by painting a picture for the Trasasso parish in Bologna.*

Her career included two great periods. The first, somewhat academic one, followed her father's precepts and resembled Reni's "bright" period. The second, mature one, was influenced by Pasinelli and Cignani, and characterized by greater interest in light and a desire to paint more ambitious works. It began in 1663, when the Child Jesus Visiting Saint Anthony *(Bologna, Pinacoteca Nazionale) and* Mary Magdalen *(Besançon, Musée des Beaux-Arts) were painted.*

In 1659, "una mezza figura fatta per la Musica da regalare al mio maestro da suonare" appeared in the *Nota* that Elisabetta wrote on all her paintings and which was carefully retranscribed by Malvasia (1841 ed., vol. II, p. 394). This allegorical half-length figure given to her music teacher may be the one in the Rau collection, where a young, graceful and charming woman personifies Music. She is holding a score and seems to be singing while leaning her left arm on a lyre, the symbol of poetry, at the base of which lie a pair of cymbals and a hammer.

It seems that Elisabetta took music lessons for at least three years. The preceding year she had already given her teacher "una mezza figura d'un salvatore" and the following one, 1660, she offered him a half-figure representing Poetry. Music training seems to have been part of every young painter's instruction during the seventeenth century, especially in Bologna where the *Accademia degli Incamminati* offered artists the broadest possible cultural and scientific education. Guido Reni went to this academy, and he transmitted its precepts to his students, including Elisabetta's father.

The *Allegory of Music*, an outdoor scene, is extremely refined both in its study of *affetti* and carefully rendered colours. The superimposition of white, blue and violet heightened by gold attests to the artist's adoption of Reni's "bright method". A subtle play of shadow and light brushes against the two fine, delicate hands as well as the rest of the figure. They herald Sirani's growing interest in light, which at the time was influenced by Annibale Carracci, Lanfranco, Domenichino and Guido Reni's late period. Aside from the fact that this work may correspond to the 1659 note, it belongs to Elisabetta's "classic" period, when she also painted the *Sibyl* (Bologna, Pinacoteca Nazionale). After 1663, she moved more clearly away from Reni's influence, adopting rich colours and a more marked chiaroscuro.

V. D.

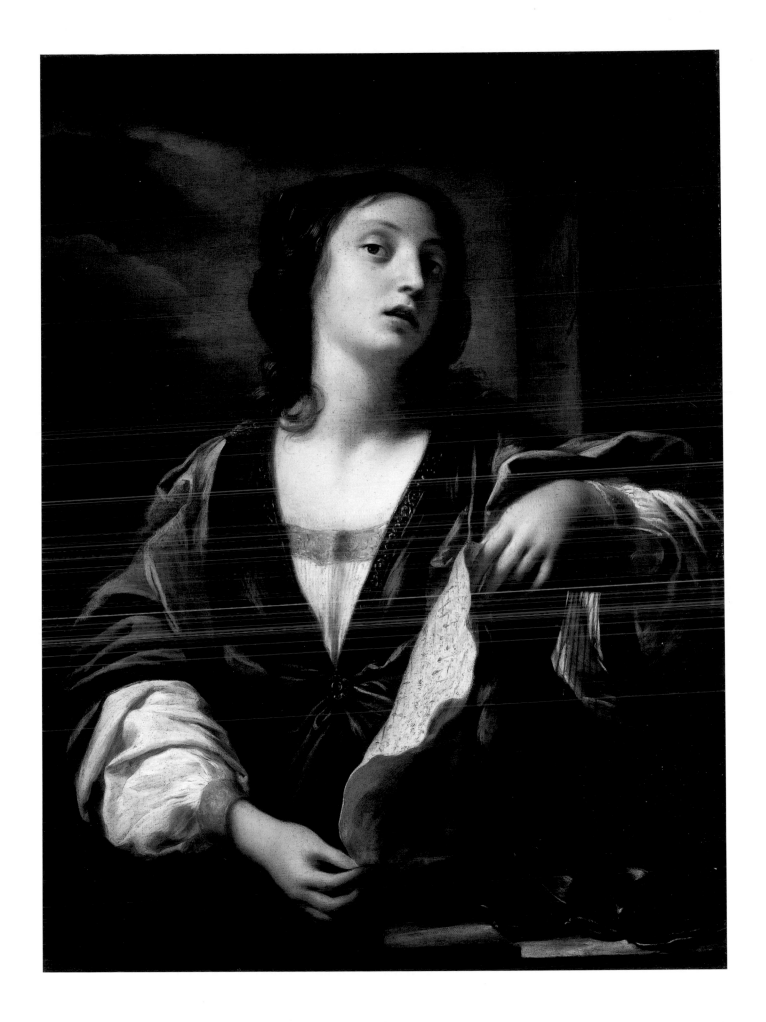

10

Anonymous painter, Italy / Lombardy-Piedmont
(end of seventeenth – beginning of eighteenth century)
Portrait of Maddalena del Grande (1634–1713)

Oil on canvas.
H: 88 cm; W: 73 cm.
Inscription: *1711 /
Maddalena del Grande
Franciulla Nata il di 12 /
Dicembre nel 1634 popolo
della Pie vechia, Fede: /:
Lissima cameriera, e cuoca
dal di primo genn° 1670 / a
tutto il di 26 agosto 1713 che
passo a miglior vita d' / anni
settantanova mesi otto, giorni
14. / Di fedel servtu anni
quarantatre.*
GR 1.86

History:
Munich, Galerie Julius
Böhler, 1968.

The artist who painted this splendid portrait of an old servant woman and the circumstances surrounding the commission remain unknown. The long inscription identifies the model as "Maddalena del Grande, born on December 12, 1634, died at the age of seventy-nine years, eight months, fourteen days on August 26, 1713, after forty-three years of loyal service as a cook and chambermaid". These lines suggest that the portrait was painted for Maddalena's employer, for it would have been impossible for her to pay for the commission. But when? Is the inscription alone posthumous, or the entire painting? These considerations have an influence on the attribution.

The work was certainly done by one of the "reality painters" who emerged from Carravaggism. This trend was especially strong in Lombardy and Veneto at the end of the seventeenth and beginning of the eighteenth centuries. However, Eberhard Keil (1624–1687) not being considered a portraitist, "real portraits" of the common people were rare before Ceruti or Ghislandi. If the entire painting is posthumous, a date from around 1730–1740 can be put for-

ward, and several attributions are possible, including Giovanni Antonio Pianca (1703–1757), Vittore Ghislandi (1655–1745), Giacomo Ceruti (1691 – after 1760), Giovan Antonio Borroni (1684–1772), Antonio Cifrondi (1656–1730) or Paolo Maria Boromino (1703 – after 1779). If the inscription alone is posthumous, the possibilities are fewer and the painting can only be compared to certain works by Pietro Bellotti (1625–1700), such as the *Old Woman* in Warsaw's Muzeum Narodwe or the one in the Nîmes Musée des Beaux-Arts.

The influence of Eberhard Keil can be seen in both of these paintings as well as the one in the Rau collection, in the limited colour range as well the composition showing the figure in the foreground against a solid, dark background. Keil, who studied with Rembrandt in Amsterdam, introduced this type of "Rembrandtesque" portrait to Venice when he lived there from 1651 to 1654. According to his biographer Zanetti, Bellotti was famous for his skill as a caricaturist. If he painted this beautiful portrait of Maddalena del Grande, so full of humanity, it is a fortunate exception in his work.
J.-Ch. B.

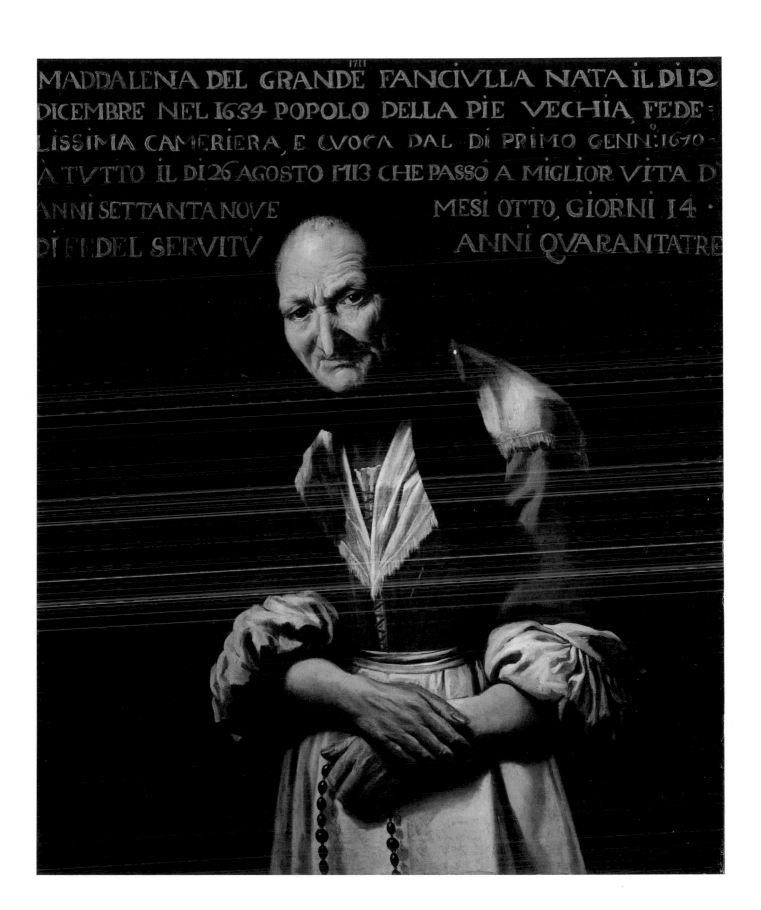

Canaletto (Giovanni Antonio Canal, known as Canaletto, 1697–1768)
Saint Mark's Square, 1740–1750

Oil on canvas.
H: 58.5 cm; W: 103 cm.
GR 1.1017

History:
Bought by Edward Gordon
Douglas Pennat, first Lord
Penrhyn (1800–1886) and
hung in his London
residence; collection of his
grandson, Edward, third Lord
Penrhyn; Sotheby's,
December 3, 1924, no. 60;
[Ellis and Smith]; [London,
Arthur Tooth and Sons,
1925]; [Knoedler]; New York,
John Levy's collection, 1925;
Bloomfield Hills, Michigan,
George C. Booth's collection;
New York, Sotheby's, May 18,
1972, no. 71; private
collection; London,
Christie's, December 9,
1994, no. 59.

Exhibitions:
Toronto, Art Gallery of
Toronto – Ottawa, National
Gallery of Canada – Montreal,
Museum of Fine Arts,
Canaletto, 1964–1965, p. 60,
no. 21, repr.; London, O. and
P. Johnson, *Quintessence of
Civilisation*, 1971, p. 15,
no. 5, repr.

Bibliography:
K. T. Parker, *The Drawings of
Antonio Canaletto in the
Collection of His Majesty the
King at Windsor Castle*,
Oxford-London, 1948, p. 34,
no. 26; W. G. Constable,
Canaletto, Oxford, 1962, vol.
I, pl. 14, vol. II, p. 190,
no. 17; L. Puppi, *L'opera
completa del Canaletto*,
Milan, 1968, no. 183, repr.;
W. G. Constable, *Canaletto*,
2nd ed. revised by J. G. Links,
Oxford, 1976, vol. I, pl. 14,
vol. II, p. 193, no. 17; J.
G. Links, *Canaletto. The
Complete Paintings*, Saint-
Albans, 1981, p. 16, no. 23;
A. Corboz, *Canaletto. Una
Venezia immaginaria*, Milan,
1985, vol. II, p. 649,
no. P300, repr.

*The son of the theatrical painter Bernardo
Canal, Canaletto (Venice, 1697 – Venice,
1768) began as a scene painter, but soon
moved away from this purely decorative
genre. During a stay in Rome in 1719–1720,
where he painted scenes for Scarlatti's op-
eras, he discovered Vanvitelli. On his return
to Venice, his Roman experience was en-
riched through acquaintance with Carlevaris
and Marco Ricci. He then painted a stream
of views of Venice, the* vedute.
*Very soon appreciated by art lovers, in par-
ticular the British, he produced for them a
number of large series of views of Venice.
In 1744 Canaletto dedicated to John Smith,
later British consul, who had become his
"patron-dealer", the series of etched views
which today are counted among the mas-
terpieces of Venetian painting. Between
1746 and 1753 he made several trips to Eng-
land where he painted views of London and
English manor houses. He returned to
Venice, where he finished his career. The
Academy, which had for a long time held
him at arm's length, finally admitted him
in 1763.
Canaletto's work marks an important step
in the development of landscape painting.
Aside from the direct influence he exercised
over Venetian painters such as Bellotto,
Guardi or Marieschi, he opened a path
which, passing through the English land-
scape painters of the eighteenth century and
Constable, led to the nineteenth century and
Corot's landscapes.*

In this painting, Canaletto shows the east-
ern side of Saint Mark's square, with the
basilica's main facade and, slightly set back,
the western facade of the Doges' Palace. On
the right, the Loggetta is plunged in the
Campanile's shadow, which stands out
against the bright background, while part
of the bell tower takes up the far right of
the composition almost to the top of the
canvas. On the left, the northern side of the
square, between shade and sun, recedes to-
wards the houses and the less official part
of the city. The composition centers on a
long horizontal line formed by a series of
different facades. The three poles and the
Campanile create four vertical lines that

give the painting rhythm and are gently
echoed by smaller vertical lines in the
slightest architectural features: pinnacles,
pilasters and columns.
Bathed in late-afternoon sunlight, this *Saint
Mark's Square* features Canaletto's usual
palette of grey, beige, blue and pink. A lu-
minous effect heightens these soft colours
and causes them to vibrate. The square bus-
tles with numerous figures going about
their business, walking and greeting each
other. Children play with dogs; small tents
formed by parasols and cloth stretched over
market-stalls shelter merchants. Constable
dated this painting to the 1740s.
Another, probably earlier version seen from
a slightly higher angle is in the National
Gallery of Art in Washington (F. Shapley,
Catalogue of the Italian Paintings, Wash-
ington, 1979, vol. I, pp. 101–103, vol. II,
pl. 69, fig. 1). In that work, the outlet to
the lagoon between the Doges' Palace and
the Loggetta can be seen. A pen-and-ink
drawing over pencil showing variations of
the same figures, but which is very similar
to the Rau collection painting, is in the Roy-
al Collections at Windsor. The point of view
is similar, but the composition is somewhat
tighter: the houses on the left do not ap-
pear (Parker, 1948, pl. 14).
I. M.

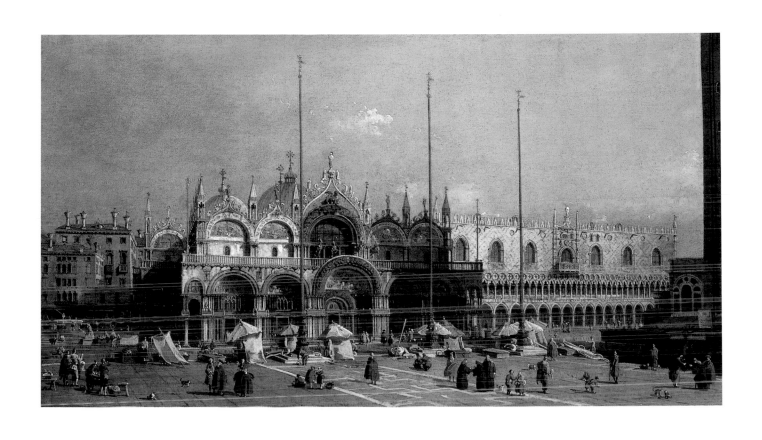

Bernardo Bellotto (1721–1780)
The Tower of Marghera, 1735–1742

Oil on canvas.
H: 43 cm; W: 56.5 cm.
GR 1.861

History:
Sir Hugh Lane's collection;
London (?), Christie's, July 9,
1917, no. 157; Cox
collection; London, art
market, 1956; London,
Christie's, July 29, 1973,
no. 65; London, Christie's,
July 10, 1981, no. 73.

Bibliography:
W. G. Constable, *Canaletto*
[1st ed. 1962], 2nd ed.
revised by J. G. Links,
Oxford, 1976, vol. II, p. 379;
S. Kozakiewicz, *Bernardo
Bellotto*, London, 1972, vol.
II, p. 457, no. Z 289;
E. Camesasca, *L'opera
completa del Bellotto*, Milan,
1974, p. 122, no. 306 A.

Canaletto's nephew, Bernardo Bellotto, also known as Canaletto the Younger (Venice, 1721 – Warsaw, 1780) trained in his uncle's studio from 1735. In 1742 he started to travel around Italy, stopping first in Rome and probably Florence and Lucca as well. He spent 1744 in Lombardy before working in Turin for Charles-Emmanuel III of Savoy in 1745.

As Canaletto's influence on him gradually diminished, he found his own style, giving his urban scenes a naturalistic aspect which is unmistakably his. He developed this style in the great European capitals, where he worked under the patronage of princes. For example, he settled in Dresden in 1747, where Frederic-Augustus II of Saxony appointed him court painter. It was there that he painted some of his most beautiful works, including the many Views of Dresden *and* Views of Pirna *(Dresden, Gemäldegalerie). He worked in Vienna from 1758 to 1761 at the court of Maria-Theresa before moving on to Munich and back to Dresden in 1762. In 1767 he decided to go to Saint Petersburg but stopped in Warsaw where Stanislaw August Poniatowski appointed him court painter. Once settled in Poland, Bellotto lived there until he died.*

The tower of Marghera, the painting's subject, was built in the fifteenth century on one of the many small islands in the southwest of the Venice lagoon. It was demolished during the first half of the nineteenth century. The tower occupies the right-hand side of the painting, with two low houses whose chimneys, typical of Venetian architecture, stand out against a mountainous background. A small landing stage is shown on the left. The Euganean hills are outlined against the sky, forming a shallow diagonal which rises gently up to the tower.

In this early work, which was surely painted during the artist's Venetian period when he worked with his uncle, Bellotto used one of Canaletto's compositions, known today through one of his etchings. The original painting, once in the Dimitri Tziracopoulo collection in Berlin, has been missing since 1939. Besides the etching, two other ver-

sions are known. According to Constable, one is partly a studio painting (once in the collection of Count S. Vitale), the other the work of a follower (Venice, Ca' Rezzonico; Constable, ed. 1976, vol. II, p. 379, no. 369). E. Camesasca and S. Kozakiewicz, who had not seen the picture in the Rau collection when they published their work, agree with Constable's opinion in attributing the work to Bellotto. Bernardo Bellotto's composition differs from the original by its closer viewpoint and changes in the figures, who add life to the scene. In the lower right-hand corner, Bellotto replaced the two workers on the water's edge by part of a pier on which a man is seated. The artist removed the small boats in the foreground, keeping only those moored to the landing stage. He also brought the shore closer to the bell tower and the hills. The rose-tinted, grey-beige tower is delineated against a muted blue sky. Clear lines divide the sun-lit areas from the shadows, but the contrasts are softened by the humid atmosphere in which the shimmering light bathes the scene, a light characteristic of Venetian painting since the Renaissance. A certain abrasion of the paint surface, particularly in the sky, allows the red ochre underpainting of the canvas to show through in places, perhaps accentuating this impression of the colours' softness.
I. M.

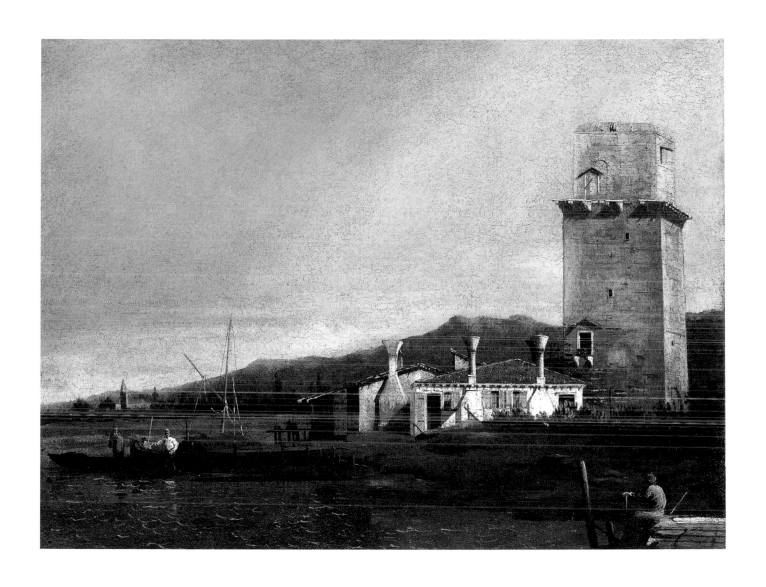

Colyn de Coter (active in Brussels between 1480 and 1525)
Saint Veronica, circa 1510

Oil on wood.
H: 29.5 cm; W: 20 cm.
GR 1.688

History:
Oxon, Cornbury-Park, C.
Vernon Watney's collection;
Munich, Galerie Julius Böhler
(*Gemälde alter Meister
Plastiken Zeichnungen
Kunstgewerbe*, fall 1973,
no. 6).

Bibliography:
V. J. Watney, *A Catalogue of
Pictures [...] at Cornbury*,
Oxford, 1915, no. 66.

Colyn de Coter seems to have come under the influence of the Master of the Legend of Saint Catherine (generally identified with Pieter van der Weyden) during his formative years. Active in Brussels between 1480 and 1525, in 1493 he was sufficiently well-known to receive a commission for decorating the Saint Luke's guild chapel in Antwerp. Nurtured on the models of Robert Campin and Rogier van der Weyden, his vocabulary began displaying the influence of Bernard van Orley in 1515.

In the early twentieth century, this panel belonged to the Vernon Watney family in Oxon, England, which probably acquired it from a French collection. The pictorial surface is in good condition, and the network of craquelures reveals a noticeable difference between the treatment of the figure and that of the landscape, which was probably repainted in the mid-eighteenth century.

The right-hand side and the upper section have been cut. The trace of a hinge on the left-hand side approximately two centimetres from the upper edge, and the direction in which Saint Veronica is facing, demonstrate that the panel is obviously the right wing of a triptych. Veronica is directly inspired by the famous Vienna triptych painted by Rogier van der Weyden around 1440. Dressed in a flowing mantle, she is wearing an opaque veil and delicately holding the sudarium, on which Christ's face appears. A few tears flow down her downcast face, which is intended to arouse compassion in the believing viewer.

A label in French glued to the back indicates that in the late nineteenth century the work was attributed to Lucas Cranach the Elder. Considered a Flemish work by V. J. Watney in 1915, at the Böhler sales the painting was correctly attributed to the Brussels artist Colyn de Coter, a late interpreter of van der Weyden's style.

Characterized by sharp lines and powerful chiaroscuro effects, the work displays many similarities to the Saint Alban retable and, even more so, the Trinity altarpiece in the Louvre (M. J. Friedländer, *Early Netherlandish Painting*. IV. *Hugo van der Goes*, Leiden-Brussels, 1969, nos. 90, 94; C. Périer-D'Ieteren, *Colyn de Coter et la technique picturale des peintres flamands du XVe siècle*, Brussels, 1985, pp. 60–65, 101–106). Therefore *Saint Veronica* must date to circa 1510 and provides invaluable information about Rogier van der Weyden's triptych which, mentioned for the first time in 1659 in Leopold-Wilhelm's Vienna collection, may have been in sixteenth-century Brussels.
F. E.

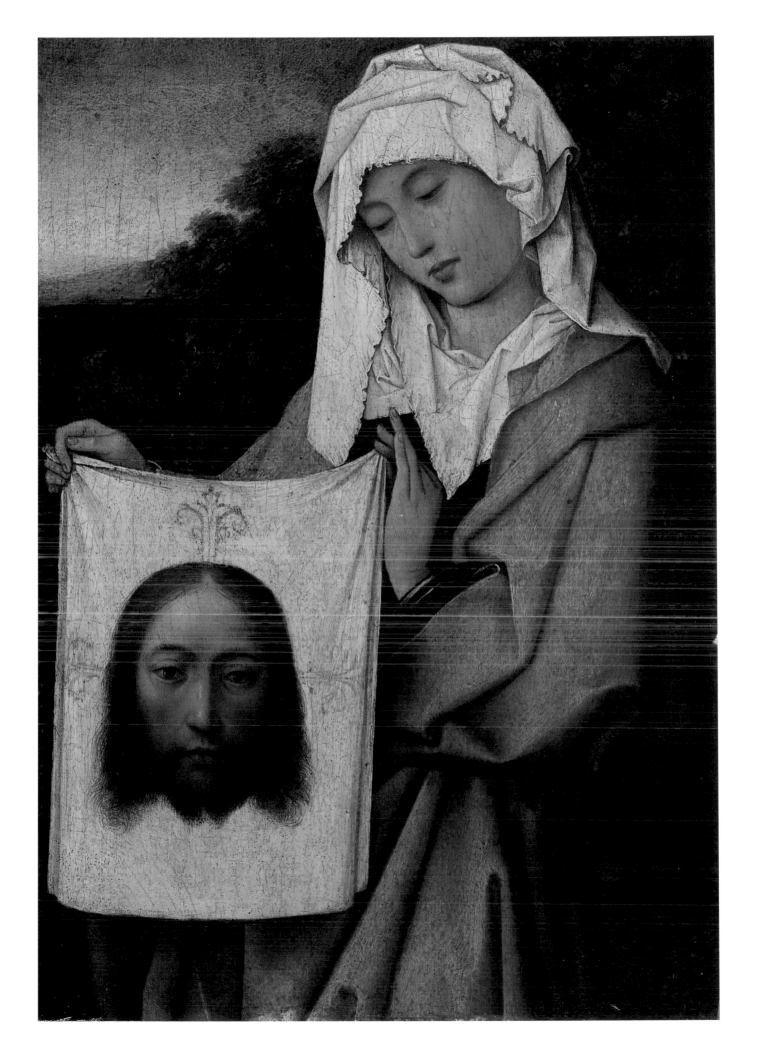

Oil on canvas.
H: 62 cm; W: 53.5 cm.
GR 1.843

History:
Paris, Baron E. de
Beurnonville's collection;
Paris, sale of Baron E. de
Beurnonville's collection,
March 21–22, 1883, no. 423
(wrongly presented as "on
wood"); Geneva, Pereire's
collection; London,
Sotheby's, March 9, 1983,
no. 8; Cologne, sale at Abels,
July 1972.

Exhibition:
Geneva, Musée Rath, *Trésors
des collections romandes*,
1954, no. 26.

Frans Pourbus the Younger (Antwerp, 1569 – Paris, 1622) was the son of Frans Pourbus the Elder and grandson of Pieter Pourbus, who were sixteenth-century painters in Antwerp. In 1591 he became free-master in this Flemish city before being named painter to Archduke Albert and Duchess Isabelle of Austria in Brussels. From 1600 to 1609 he worked for the court of Mantua, travelling often to paint portraits in Innsbruck (1603), Turin (1605), Paris (1606) and Naples (1607). In 1610 Maria de' Medici named him court painter and had him come to Paris, where he was naturalized French in 1618 and spent the rest of his life.

Guillaume Duvair (Paris, 1556 – Tonneins, 1621), Louis XIII's Minister of Justice, was the son of Jean Duvair, a gentleman from Auvergne who was a member of the king's court. Since his father left him nothing but a prebend at the church of Meaux, he became an ecclesiastic and lawyer. In 1584, he became a member of the Parliament of Paris. He remained faithful to Henry IV during the League, quelled the revolt in Marseille and brought the city back under the King's rule. Afterwards he became ambassador to England, and upon his return was named first president of the Parliament of Provence, where he worked for the freedom of the Gallican church, quarrelling with the Archbishop of Aix. In 1616 Louis XIII appointed him Minister of Justice to replace Sillery. Six months later he had to resign because of court intrigues, and he withdrew to the Bernardin monastery. The king recalled him to the same position after the

death of the Marshal of Ancre. In 1617 he was consecrated Bishop of Lisieux. He was close to Louis XIII, accompanying him to Normandy in 1620 and the siege of Clerac in 1621. On one of his voyages with the king he was struck by fever and had to stop in Tonneins, where he died. His body was brought back to Paris and buried in the church of the Bernardins, where Molinier gave the eulogy.

Duvair was a friend of the scientist Peiresc and had a passion for medals and antiques. He wrote treatises on piety and philosophy as well as legal writs. His portrait by Pourbus was certainly painted between 1616 and 1621, a period when he was in Louis XIII's favour and at the height of his political career. Pourbus was an heir to sixteenth-century Flemish artists, adapting their models to the circles he frequented. He painted full-length portraits of King Henry IV and Queen Maria de' Medici, but preferred a less solemn quarter-length format for Guillaume Duvair. Pourbus' style, which is similar to Pulzone's, blended the Flemish and Italian traditions. He gradually loosened up his technique while remaining highly reserved towards the Baroque. The *Portrait of Guillaume Duvair* conveys this quality in the subtle rendering of the soft flesh and especially in the sumptuous colours of the garments, which signify the sitter's position. The facing and plush red vestment stand out powerfully against the black velvet doublet. The Louvre has a very similar portrait (inv. 1712) by the same artist, wrongly considered a studio work until a recent cleaning.
Ph. L.

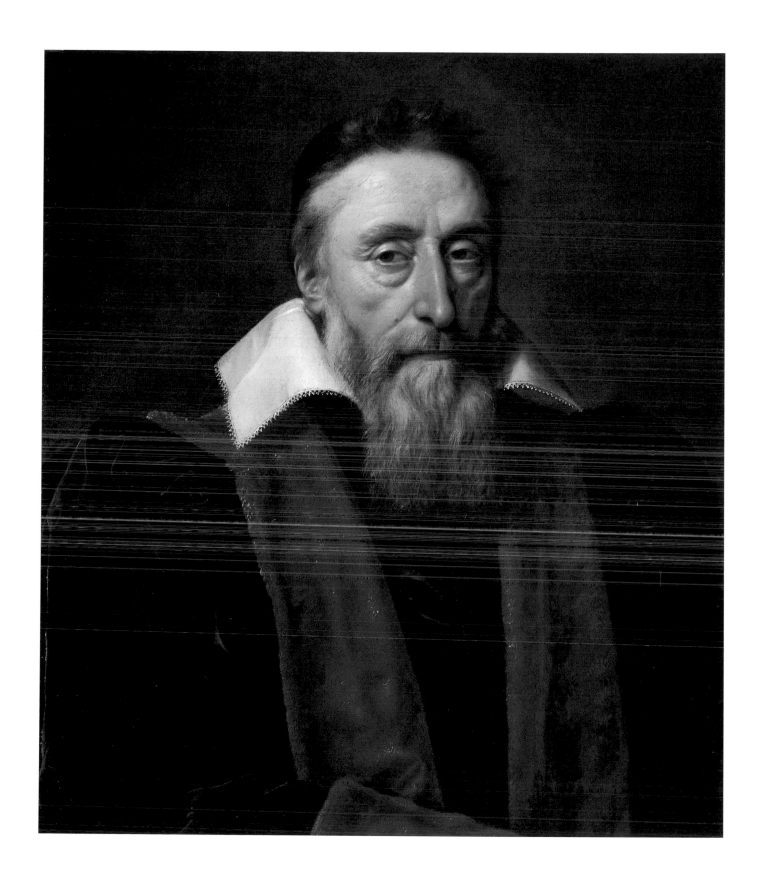

Jan van Goyen (1596–1656)
Storm, 1637

Oil on wood.
H: 23.5 cm; W: 36.5 cm.
Signed and dated lower left:
V.G. 1637.
GR 1.212

History:
Lochem's Gravenhage, Nystad
Antiquairs; Wassenaar,
C. H. Muntz's collection,
1963; London, Sotheby's,
March 16, 1966, no. 108,
repr.

Exhibition:
Dordrecht, Municipal
Museum, *Nederlandse
Landschappen uit de
zeventiende euw*, 1963,
no. 33, fig. 63.

Before entering the studio of Eseias van de Velde in Haarlem for a year in about 1617, which was a decisive and particularly formative stay, van Goyen (Leyden, 1596 – The Hague, 1656) was the student of C. A. Schilderpoort, I. van Swanenburg and J. A. de Man. This painter was very successful, as the number of his imitators demonstrates. He was also a speculator who died ruined by several bad business deals.
From 1620 to 1626 he painted landscapes in the manner of those of Eseias van de Velde, although in many respects they were more Flemish. Towards 1625, on the initiative of Pieter de Molijn and jointly with his master and Salomon van Ruisdael, he developed the Dutch monochrome landscape type: a palette reduced to green, yellow and brown in a composition centered on a light-coloured diagonal which leads back from a dark foreground under a forbidding and heavy sky. As the years proceed his works tend towards a greater monochrome and their rhythm to greater monumentality. In Leyden from 1619 to 1631, he finally settled in The Hague in 1634.

The only person in this painting, a peasant poorly sheltered by a timber lean-to, several sheaves of straw and a bare tree, contemplates a storm in a landscape of dunes. The overall black and yellow tone, undisturbed by any other colour, is typical of van Goyen in the years after 1630. Such restraint in the use of colour is fairly specifically his, as is the grand simplicity of the composition centered on the single figure and his frail shelter, placed on a little rise and violently illuminated by a slightly oblique sheet of lightning. A band of dark ground opens onto the middle area, which stands out from the dim, sketchy background. Movement towards the background is created by the varied strength of contrast and by lively and suggestive brushwork. It is the principle of the diagonal landscape which the artist practised from about 1625. The firmly modelled shapes and the vigorous branches of the tree pushing against the background of sky, which takes up more than three quarters of the panel, finally convince us of its au-thenticity, even if Beck did not include it in his well thought-out catalogue.

The composition of the *Wooden Fence* (1631; Brunswick, Herzog Anton Ulrich Museum) is similar to the Rau panel, but the strong contrasts of light and overall dark tone recall the stormy atmospheres of some of Frans de Hulst's paintings such as the *Haarlem Castle* in the Riom museum.
Van Goyen did not often treat the theme of a storm on land, though he painted many tempests at sea such as that in the Národni Galeri in Prague. In the first half of the seventeenth century seascapes were for him and for the Porcellis the best field for presenting a more realistic view of these picturesque manifestations of nature. Rembrandt, with the *Bridge*, 1637 (Amsterdam, Rijksmuseum) and the *Storm*, 1638–1639 (Brunswick Museum), and Rubens, with the *Shipwreck of Aeneas*, around 1620 (Berlin, Staatliche Museen), gave versions of the storm on land that were more tragic and of almost cosmic scope. Van Goyen is part of a more contemplative, intimist poetic vein.
O. Z.

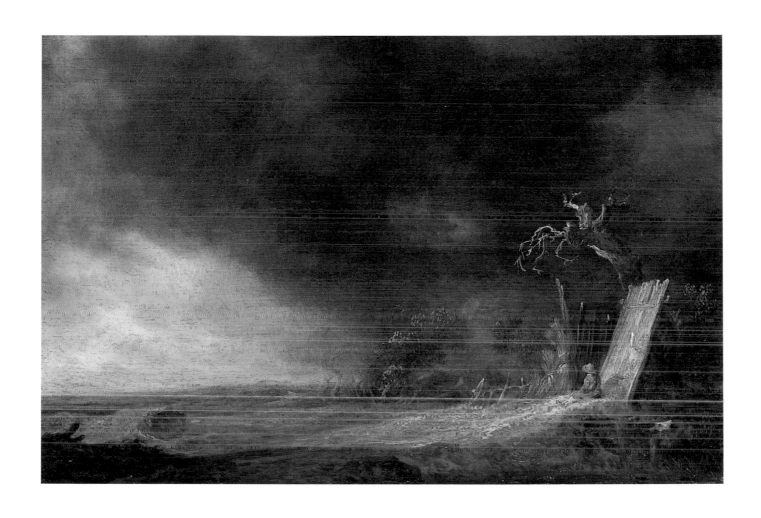

19 Salomon van Ruisdael (after 1600 – 1670)
 River Landscape, 1634

Oil on wood.
H: 26.5 cm. W: 39.5 cm.
Signed and dated lower right:
SvR. 1634.
GR 1.933

History:
Frankfurt, sale
"Mittelrheinische
Standesherren", May 3,
1932, no. 99; Almelo,
Tj. Bendien's collection;
London, Christie's, May 4,
1979, no. 116; London,
Sotheby's, December 19,
1985, no. 67, repr.

Bibliography:
W. Stechow, *Salomon van
Ruysdael*, Berlin, 1975,
pls. 136, 137, no. 442.

Salomon van Ruisdael (Naardem, after 1600 – Haarlem, 1670) was the brother of Isaack van Ruisdael and the uncle of Jacob van Ruisdael, both great landscape painters. It is not known where he was trained, but in 1623 he registered in the guild in Haarlem, and painted his first landscape in 1626, when Pieter de Molijn, van Goyen and Eseias van de Velde were inventing the naturalist monochrome landscape. After 1640, he moved towards a more decorative style. His few still lives are similar to van Aelst's.

In 1631 Salomon van Ruisdael began painting river banks, perhaps following the example of Jan van Goyen, who was a little ahead of him in this way. A signed picture, the *River Landscape*, dates from this period, and only the relative lack of imagination and undifferentiated brush strokes allow it to be distinguished from other contemporary works and the same subject painted by van Goyen.

The banks of a calm stream on a fine day are a constant motif for van Ruisdael. A dark area of the river acts as a foreground and emphasises the diagonal which gives the picture depth. This is also suggested on the next plane by the clear streak of water and the dark screen of the bank and its trees, while the sky occupies two thirds of the picture. This composition is similar to the style developed by van Goyen and de Molijn in the years 1625–1630 and adopted by van Ruisdael in 1627. No less characteristic is the almost monochromatic grey-green, olive green colour scheme simply brought to life by a blue nuance in a sky that is lighter and more serene than in most of van Goyen's works.

The date and style of the Rau work make it comparable with the *Boat Ride on the River* (1632; Hamburg, Kunsthalle), the *River Bank* (1633; The Hague, Mauritshuis). The Rau picture is a forerunner of the works of the 1640s, taking greater liberty with the principle of the diagonal. The painting's dominant line, marked by the bank, is balanced by the central tree, whose arabesque clearly stands out from the foliage, and by the boat's vertical mast, slowing down the eye's movement to the bottom of the horizon. Here van Ruisdael manages to express the omnipresence of water in the atmosphere. The ray of sunlight crossing the clouds lights the big tree in the centre and, further away, the side of one of the nude fishermen on the riverbank. The subtlety of the luminous touches as well as their scarceness are worthy of the master.

O. Z.

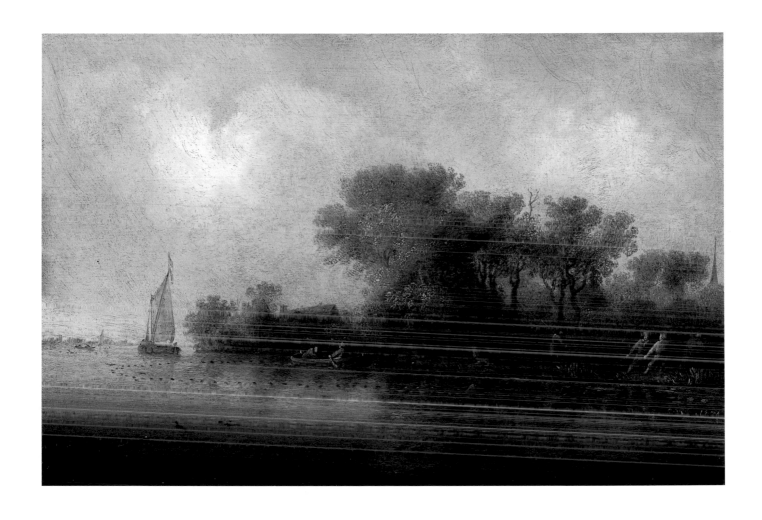

Judith Leyster (1609–1660)
Young Girl with a Straw Hat, 1630–1640

Oil on wood.
H: 36.2 cm; W: 31 cm.
GR 1.285

History:
Bulwero Quebec House, East
Dereham (presented as Frans
Hals on a label on the back of
the painting); presented by
the Galerie Meissner at the
14th Swiss Fair of Antiques
and Art in 1973; Zurich,
Galerie Meissner, 1974.

Exhibitions:
Haarlem, Frans Halsmuseum
– Worcester, Mass., Worcester
Art Museum, *Judith Leyster:
A Dutch Master of the Golden
Age,* 1993; Washington, The
National Museum of Women
in the Arts, *Judith Leyster:
Leading Star,* 1993–1994.

Bibliography:
Pantheon, 1973, no. 22,
p. 220, repr.

*Judith Leyster (Haarlem, 1609 – Amster-
dam, 1660) was born with the family name
Willemsz. She acquired the nickname
Leyster because that is what her father's bar,
"The Lodestar", was called. Ampzing's work
on Haarlem mentions Judith Leyster as a
painter as early as 1626–1627. In 1628 the
artist and her family left for Vreeland, near
Utrecht, before settling in Zaandam, near
Haarlem, in September 1629. In 1631 she
was present at the baptism of one of the chil-
dren of Frans Hals (1580/1585–1666).
Their friendship went back to at least 1629,
if we are to judge by the artist's influence
on her work. In 1633 she became a mem-
ber of the Haarlem painters' guild. On Jan-
uary 1, 1636, she married the painter Jan
Miense Molenaer (around 1609 – 1668) and
in 1637 they left for Amsterdam, where they
lived for eleven years. In 1648 the couple
settled in Heemstede, near Haarlem, where
Judith Leyster spent the rest of her life.*

The painting illustrates Frans Hals' influ-
ence on Judith Leyster. Sometimes the stu-
dent did as well as her teacher, and it is
difficult to tell their work apart. This is the
case of the Rau collection painting, as the
label on the back indicates. The model can
be found in another, similar painting by
Leyster (oil on wood, diameter 31 cm;
Rouen, sold on June 2, 1970, no. 34, repr.).
In the circular painting, the little girl's hair
is unkempt and she is looking to the
right. The technique is even sketchier than
in the Rau collection work, which gives it
a more spontaneous character.
This yellow and brown-toned painting
perfectly renders the scene's sunniness with
an astonishing, refreshing naturalness.
Leyster contrasted textures. She painted the
shirt and light brown jacket with broad, vis-
ible brushstrokes, giving the former a lacy
effect with a few intertwining white lines.
The face is handled differently, with re-
flections of light provided by the white im-
pasto on the chin, edge of the lips and nose.
The expression is no less lively, as the firm-
ly drawn corners of the lips as well as the
vitality in the child's eyes demonstrate. The
most beautiful, most delicate part of the
painting is the golden curls, where some
yellow impasto accents stand out against
strokes that are first blurred, then dark,
providing the hair with a sense of volume.
The composition fills the frame because of
the hat, which combines elegance and rus-
ticity. This painting surely dates from the
1630s, the period when Leyster and Hals
were the closest to each other. Dr Bisboer,
director of the Frans Halsmuseum in Haar-
lem, has pointed out that the handling of
the hair and face is characteristic of Leyster.
The artist found inspiration for her early
works in the genre scenes of the Utrecht
Caravaggists. By 1629 she was under Hals'
influence, although she never attained the
master's smooth, expressive technique.
Nevertheless, this *Young Girl with a Straw
Hat* proves that Leyster could equal her
contemporary in a small work with an in-
dividualized subject. Her style remained
more conventional in more elaborate
paintings. After 1630 she and Frans Hals
lost touch with each other, and her work
became more similar to that of Dirck Hals
and Jan Molenaer.
Ph. L.

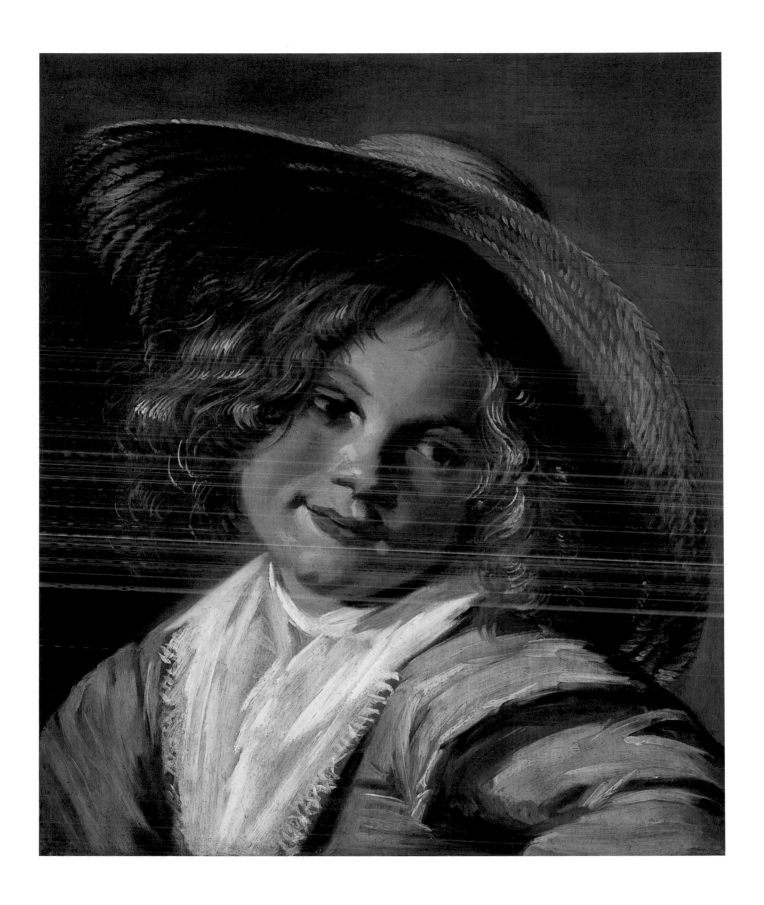

Gerard Dou (1613–1675)
The Cook, 1660–1665

Oil on wood, polished.
H: 29 cm; W: 23.2 cm.
GR 1.207

History:
Paris, sale of Baron
Delessert's collection,
March 15, 1869, no. 19;
Paris, sale of Baron
Narischkine's collection,
April 5, 1883, no. 12
(engraved by Daniel
Mordant); Paris, Baron
Erlanger's collection; Vienna,
Galerie Sankt-Lukas, 1931;
Stuttgart, at Bühler's, 1958.

Bibliography:
J. Smith, *Catalogue raisonné*,
supplement, London, 1842,
p. 22, no. 72; C. Hofstede de
Groot, *Beschreibendes und
kritisches Verzeichnis der
Werke der hervoragendsten
holländischen Maler des XVII.
Jahrhunderts*, Esslingen-
Paris, 1907, vol. I, p. 399,
no. 175; W. Martin, *Gerard
Dou: des Meisters Gemälde in
247 Abbildungen*, "Klassiker
der Kunst", vol. XXIV,
Stuttgart-Berlin, 1913,
p. 102, repr.

Gerard Dou (Leiden, 1613 – Leiden, 1675) trained with the engraver Dolendo and the glass painter Pieter Couwenhorn before working with his father, who was also a glass painter. In February 1628 he joined Rembrandt's workshop, which was very close to his home, where he rubbed shoulders with Jan Lievens and Joris van der Vliet until the Master left for Amsterdam in 1631–1632. Dou joined the Saint Luke's guild, which had just been founded in Leiden, in 1648. From 1641 the Swedish diplomat Spiering gave him a generous annual allowance which gave him first refusal of the painter's works. In 1660 the Dutch states bought three paintings from the artist, including the Young Mother *in The Hague's Mauritshuis as a gift to Charles II of England, who was visiting the Dutch capital. Gerard Dou's became so renowned that a permanent exhibition of twenty-nine of his paintings belonging to the collector Jan de Bye was held in the house of the painter Hannot from 1665. Dou, who founded the School of Fine Arts in Leiden, had many pupils, including Gabriel Metsu, Frans van Mieris the Elder, Pieter van Slingelandt, Godfried Schalken, Dominicus van Tol, Carel de Moor and Naiveu.*

The monogramme *Dou* mentioned by Walther Bernt in his appraisal, and which shows up clearly in old photographs at the base of the window frame below the pot, is a falsification which was removed when the work was restored. Today only a circle remains, painted as if it had been carved into the stone. The two letters *o* and *u* had been added to them in order to lend the work greater authenticity. However, this painting is so typical of Gerard Dou's work of the years 1660–1665 that it did not need such treatment.
The model of an old woman was inherited from the studies Rembrandt made during his Leiden period of the heads of old people, who were usually the artist's parents. They were reworked by the young Dou and can also be seen in the *Spinning Woman*, which is in the Hermitage in Saint Petersburg. In this work the woman is wearing glasses and working on a skein of wool. The same model can be found once again in the *Old Woman at the Window* in Vienna's Kunsthistorisches Museum (inv. 624), a painting dating from between 1660 and 1665. Here the old lady, facing left, is holding a pitcher. Lastly, she appears in the *Woman Watering Plants* in the English Royal Collection.
Dou was admired for small pictures of this kind, painted with a finesse that remained famous because it lent its name to the School of Leiden. He reworked elements borrowed from Rembrandt, such as the window painted in *trompe-l'œil*, which frames the painting and makes it more realistic, and the old woman's picturesqueness. He updated them for working-class scenes showing simple people going about their daily occupations. The *Cook* is a mature work that is still similar to Rembrandt's style. It does not have the coldness and excessive precision of later works. Dou made the old woman more lifelike by depicting her against a dark background brightly lit in the embrasure of the false window. The details of the wrinkled, toothless face with its flaccid flesh are astoundingly realistic. Similarly, the play of light on the varnished, three-legged clay pot, achieved by using white impasto on its charred brown surface, is worthy of one of Rembrandt's students.
Ph. L.

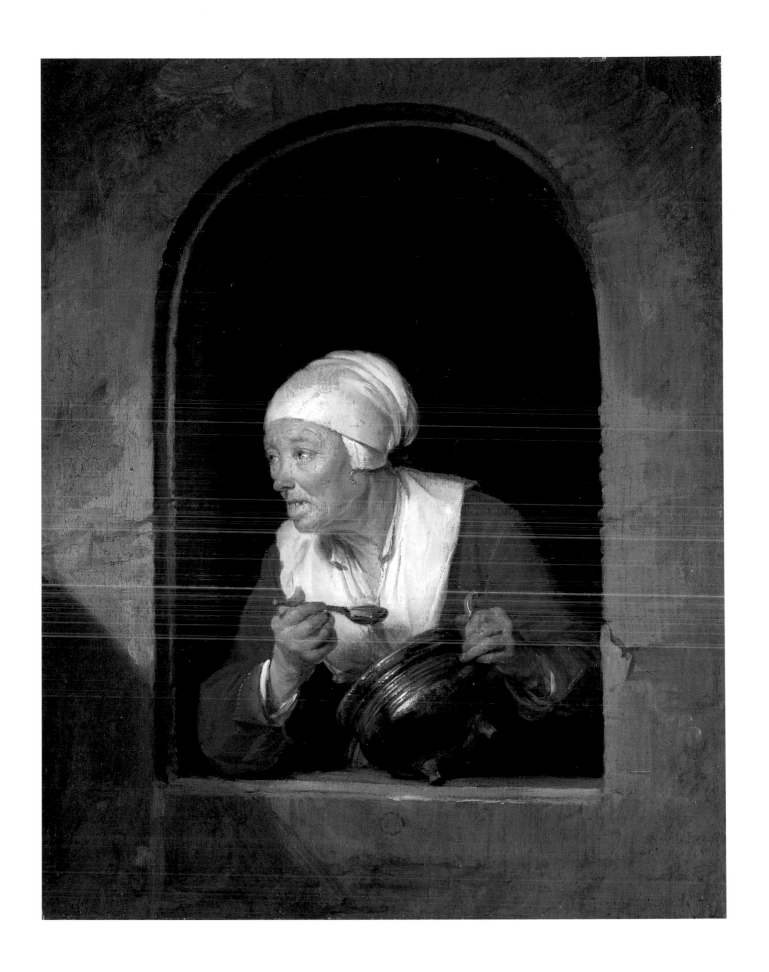

Emmanuel de Witte (1615/1617–1691/1692)
Interior of the Oude Kerk, Amsterdam, circa 1655

Oil on wood.
H: 47 cm; W: 58 cm.
GR 1.526

History:
Tsarkoje Selo, princely
collection; Berlin, sale at
Lepke's of the Saint
Petersburg museums, June 4,
1929, no. 100, repr., pl. 35;
Aerdenhout (Netherlands),
sale at Moser's; New York,
1952; Silvano Lodi's
collection, 1973.

Exhibition:
Rotterdam, Boymans-van
Beuningen Museum, *Vermeer
Oorsprender Invloed
Fabritius, de Hooch, De Witte*,
Rotterdam, 1935, no. 53.

Bibliography:
H. Jantzen, *Das Niederländische
Architekturbild*, Leipzig, 1910
(new ed. Würtzbourg, 1979),
no. 689; E. Trautscholdt, in
Thieme-Becker, 1947, vol.
XXXVI, p. 124; I. Manke,
*Emmanuel de Witte,
1617–1692*, Amsterdam,
1963, no. 76.

Emmanuel De Witte (Alkmaar, 1615/1617 – Amsterdam, 1691/1692) was trained by Evert van Aelst, brother of the celebrated still life painter also represented in the Rau collection. He registered with the Alkmaar guild of Saint Luke in 1636 before working in Rotterdam (1639–1640), Delft and, after 1656, Amsterdam. He painted portraits and historical pictures until 1650, afterwards specializing in church interiors.
He was influenced by Gerard Houckgeest's works of 1650–1651, abandoning Pieter Saenredam's axial, monochrome view for a more colourful and diagonal alternative showing only a corner of the building. De Witte would paint an increasing number of real or imaginary churches. He focused especially on expressing the softness of the light, which looks like it comes from outdoors. His depiction of light is similar to Carel Fabritius' and Pieter de Hooch's.
The same soft, peaceful atmosphere can also be found in his few genre scenes.

The *Interior of the Oude Kerk, Amsterdam* was one of de Witte's favourite themes. Here a view from the early fourteenth-century Gothic church's choir aisle and north transept is shown. Jantzen, Manke and Walther Bernt (certificate dated 1973) attribute this painting to de Witte. Liedtke implicitly agrees by not mentioning it in his corrections of Manke's lists. This work, which harks back to Houckgeest and van der Vliet, is characterized by a greater concentration on the refined treatment of the light, which firmly models the bodies, and a refusal to provide the painting with depth by giving the same tones to the choir screen and transept. The golden chiaroscuro and straightforward bursts of light surrounding the dark patches, making them vibrate like those near the foreground figures, are worthy of Fabritius. Manke dates this picture to around 1655 and notes that the little organ on the left is a model from before 1659. The awkwardness of the perspective's construction, both in the transept and ambulatory, is evidence for such a dating. The *Oude Kerk in Amsterdam* in the Musée des Beaux-Arts in Strasbourg, also dated to around 1655 by I. Manke (1963, no. 66), is very similar to the Rau picture, although the contrasts between light and dark are more accentuated. In both cases the central column of the north wall of the nave has been omitted, and the column supporting the pulpit has a diaphragm arch in the Strasbourg example that is missing here. This is proof that de Witte interpreted his motifs, probably both for aesthetic and plastic reasons. Another panel of the same subject, also attributed to this artist (55 × 49 cm, signed; Cologne, Lempertz sale, November 14, 1974, no. 208, fig. 45), is less symmetrically organized, but still depicts the choir and transept from a fairly similar angle and includes similar figures.
O. Z.

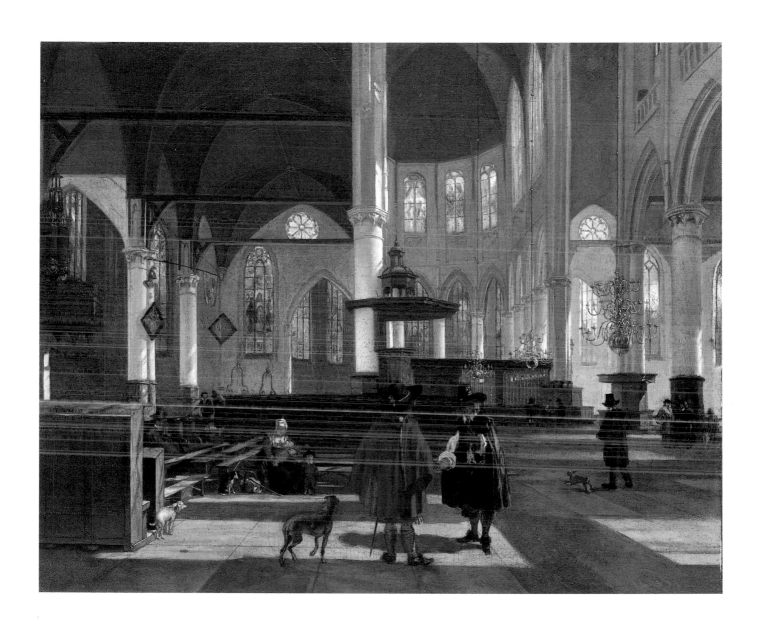

Gerard Ter Borch (1617–1681)
Portrait of a Gentleman, 1670

Oil on wood.
H: 40 cm; W: 34.5 cm.
GR 1.895

History:
Geneva, François Tronchin's collection, circa 1750; Geneva, Bessinge cabinet, Tronchin family; Haras de la Flocellière (Vendée), Marquis de Hillerin (born Tronchin), until 1953; Paris, Dr Benedict's collection; London, Julius Löwenstein's collection; private collection; London, Christie's, December 2, 1983, no. 118, repr.

Exhibition:
Rome, Palazzo delle esposizioni – Milan, Palazzo Reale, *Mostra di pittura olandese*, 1954, no. 32.

Bibliography:
C. Hofstede de Groot, *Beschreibendes und kritisches Verzeichnis der Werke der hervoragendsten holländischen Maler des XVII. Jahrhunderts*, Esslingen- Paris, 1913, vol. V, no. 293; S. J. Gudlaugsson, *Gerard Ter Borch*, The Hague, 1951, vol. I, pl. 229; 1960, vol. II, no. 229.

Like his brother and sister Moses and Gesina, Gerard Ter Borch (Zwolle, 1617 – Deventer, 1681) was pushed into an artistic career by his father, himself an artist. He apprenticed with Pieter de Moijn in 1633 before becoming master in the painters' corporation in Haarlem two years later. From 1637 to 1640 he travelled from England to Italy, then to Spain, before going to France. On his return to Holland he did not settle at Deventer until 1654. He painted mostly portraits, especially full lengths, and, from the 1650s, genre scenes illustrating middle class life. Isolated from painters in Leiden or Delft, such as Dou, Mieris, Metsu, de Hooch or Vermeer, Ter Borch brought himself up to their level by practising an intimate and intense kind of painting, in which each object shown becomes essential.

This portrait, which has long been attributed to Gerard Ter Borch (Hofstede de Groot, 1913) has an exceptional history. It comes from the first picture gallery of the Geneva collector François Tronchin (1704–1798), in which the Northern European schools were already predominant. It was neither part of the sale to Catherine II of Russia in 1770, nor of the 1801 auction in Paris, as it belonged to the Tronchin heirs' Bessinge cabinet. François Tronchin, a great lover of Dutch art, had chosen a highly characteristic portrait by Ter Borch from the years 1660–1670, when the painter attained great virtuosity in the use of grey, blue and violet nuances.

S. J. Gudlaugsson dates this work to about 1670 because of the shape of the sitter's hat and points out that it is one of the first examples of a half-length figure in which a table appears nearby. *Nicholas Pancras* in the Kunstalle in Hamburg (oil on canvas, 38 × 31 cm, signed, dated 1670) and *Adriaen de Graeff* (oil on canvas, 40,5 × 30 cm, signed, dated 1674; private collection) are highly comparable works, also painted at this time, when the artist above all painted portraits. Like the genre scenes which Ter Borch gave up at this time, they feature smooth brushwork, a play of tone on tone and a strong concentration on the sitter, who mysteriously emerges from the dark, neutral background, where only the table can be discerned. The model, who is still unknown, is psychologically well characterized and seen with Ter Borch's customary distancing, which does not stress the features.

O. Z.

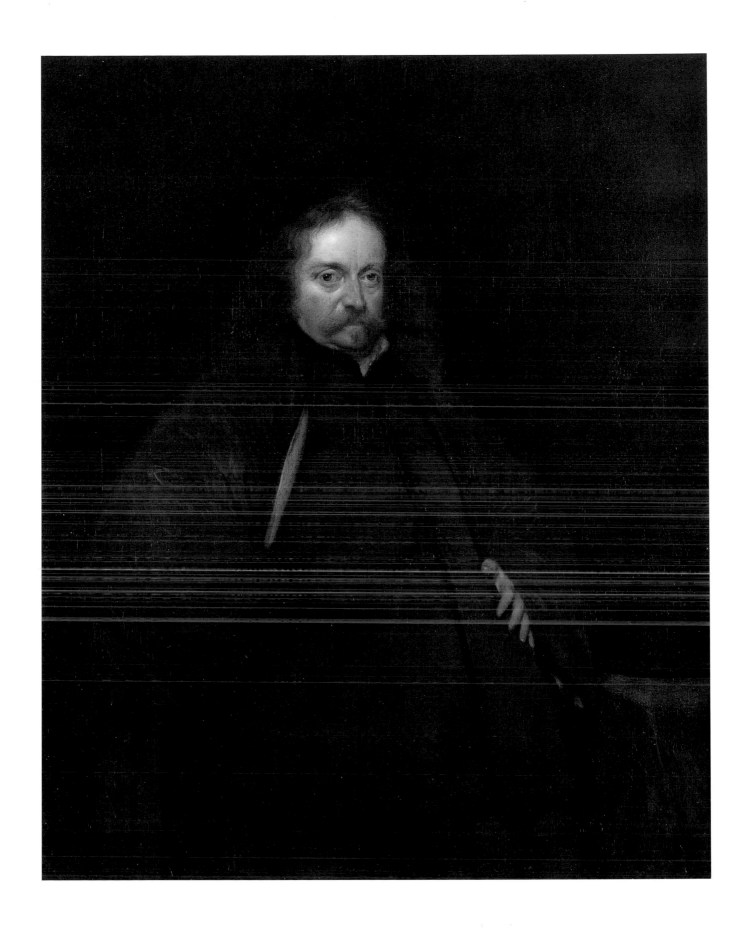

Jan Siberechts (1627–1703)
The Art Lover's Cabinet, 1661–1672

Oil on canvas.
H: 57 cm; W: 64 cm.
GR 1.502

History:
Vienna, A. Kleinschmidt's
collection (presented as
David II Teniers); Vienna,
Clerck's collection, 1845
(presented as David II
Teniers); Budapest, Georg
Rath's collection, 1870;
Vienna, Max Strauss
collection, 1872; Vienna, sale
at Wawras of the Strauss
collection, March 22–23,
1926, no. 37, repr., bought
by Vienna's Schnitzler;
London, sale at Sotheby's of
the van Pölnitz collection,
December 12, 1973, no. 106,
repr.

Exhibition:
Vienna, Königliches
Österreichisches Museum,
*Ausstellung von Gemälden
alter Meister aus dem
Privatbesitz*, 1873, no. 140
(Strauss collection).

Bibliography:
O. Eisenmann, *Zeitschrift für
Bildende Kunst*, IX, 1874,
p. 60 (presented as Gonzales
Coques); Th. Frimmel,
Gemalte Galerien, p. 36;
Th. Frimmel, "Das Sittenbild
des Siberechts in der
königlische Galerie zu
Copenhagen", in *Blatter für
Gemäldekunde*, III, p. 20;
W. Suida, *Kunstschätze der
Galerie Max Strauss in
Vienne*, 1921, p. 61;
R. Eigenberger, *Catalogue
de la vente Strauss*, Vienna,
1926, no. 37, repr.;
G. Von Terey, *Trésor de
l'art belge au XVIIᵉ siècle.
Mémoire de l'exposition d'art
ancien à Bruxelles*, Brussels,
1911–1912, p. 258; T.
H. Fokker, *Jean Siberechts*,
Brussels-Paris, 1931, p. 119;
The Burlington Magazine,
November 1973, no. 848,
repr.

*The landscape painter Jan Siberechts
(Antwerp, 1627 – London, 1703) was mas-
ter in his native city in 1648 or 1649. He
certainly travelled to Italy before working
in Antwerp again until 1673, when he was
invited to London by the Duke of Bucking-
ham. His early style was influenced by the
Italianate Dutch landscape artists Both and
Berchem. From 1661 to 1672 he created an
original style showing countryside, farmers
and animals in a cold, glittering light.*

For a long time art historians believed this
painting to be the work of Teniers or Co-
ques. The attribution to Siberechts was
based on obvious stylistic similarities with
a signed interior scene painted in 1671 (oil
on canvas, 60 × 57 cm; Copenhagen,
Statens Museum for Kunst; Fokker, 1931,
p. 91, pl. 20), which makes it possible to
date the Rau collection picture to the years
between 1661 and 1672. Until 1864 the
Boymans-van Beuningen Museum in Rot-
terdam had a similar *Young Girl at Her Toi-
let*. The similarity of styles is unmistakable.
All three have a low viewpoint of a side-lit
room designed like a cube.
The *Art Lover's Cabinet* demonstrates an es-
pecially keen interest in depicting
light. Here it is warm and not cold, as in
the landscapes from the years 1661–1672.
It also reflects the painter's desire to ren-
der the bodies' round volumes, which is so
striking in the landscapes and genre paint-
ings mentioned above.
This type of interior scene was highly pop-
ular in seventeenth-century Antwerp, but
it is rare for an artist like Siberechts. There
are only four known examples in his body
of work. The *Art Lover's Cabinet* shows a
couple surrounded by their collection of
paintings and sculptures which Fokker and
Eigenberger have identified as works by ac-
tual artists. The Dutch-style *Seascape* may
be by the Flemish painter Bonaventura
Peeters. The picture of a *Woman Milking
a Cow* is typical of Siberechts' own "land-
scape-genre scenes" from the years
1661–1672. Similarly, Siberechts showed
two of his own paintings hanging on the
walls in the works in Copenhagen and Rot-
terdam. The still life with fish may be by

Alexander Adriaenssen. The portrait held
by the young woman recalls Thomas Key
and Pourbus and the chiaroscuro beauty of
the very decorative, busy still life of fruit,
game, a monkey and a cat evokes Jan
Fyt. Finally, Eigenberger has identified the
grisaille above the cabinet with van Dyck's
Samson Being Arrested in Vienna's Kun-
sthistorisches Museum. The sculptures
are patterned after ancient models. The
painting is dominated by Flemish art be-
fore 1660, reflecting the content of col-
lections in Flanders.
Eigenberger argues that in this picture
Siberechts portrayed himself with his fam-
ily before his departure for London. Beyond
its anecdotal interest, this wonderful, rare,
gold-toned painting unifies the colours of
the paintings and walls covered in em-
bossed Cordova leather. It demonstrates
Siberechts' concern for observing light, so
typical of Dutch painting but so original in
Flanders. It is a superb example of his rare
interior scenes, upon which he conferred
the monumentality found in his depictions
of rural life.
O. Z.

The German School

In the fifteenth century, two great outside events brought the German painters to seek out a new way: the use of oil painting in Flanders and the outbreak of the first Renaissance in Italy. The influences which followed are clear in the works of the Master of the Life of Mary, and in those of Stefan Lochner, both active in Cologne. During the years 1470–1490, a wave of anguish and anxiety swept through people's minds due to the climate of religious intensity. This phenomenon is fully realized in Martin Schongauer and Matthias Grünewald's works. The latter became a master of the fantastical, capable of representing pain to an extraordinary degree (the *Isenheim Altarpiece*, Colmar, Musée d'Unterlinden).

In the sixteenth century, Dürer's art in itself embodies the synthesis between the German tradition and Italian innovations. His contemporary, Lucas Cranach the Elder, was noteworthy for having introduced, in spite of his fervent Protestantism, female nudes with extreme grace and sensuality. It should be noted that among those painters there was a great taste for the strange and the dreamlike. Furthermore, a pagan sensuality is curiously mixed in with a profound religious fervour. Holbein the Younger was mainly a portrait painter. His quest for truth, and his sharp sense of observation led him to an almost scientific rigour, which made him one of the best in his field at that time.

In the seventeenth century, Germany's contribution to the Baroque movement is mainly in the field of architecture, whereas painting showed a taste for genre scenes, still lives and allegories, such as Vanities.

In the eighteenth century, German painting came under a double influence: that of French painting as well as the taste for, and rediscovery of, antiquity, which led some years later to the appearance of Romanticism.

Oil on wood.
H: 57 cm; W: 40.5 cm.
GR 1.127

History:
Vienna, E. Engländer's
collection; Vienna, Baron
Ferstel's collection; Berlin,
sale at Ball and Graupe's,
May 12, 1930, no. 29;
London, sale at Sotheby's
of the Ingram's collection,
March 11, 1964, no. 125,
repr.; London, Hallsborough
Gallery, May 1965.

Exhibitions:
Cologne, Wallraf-Richartz-
Museum, Meister zu Köln,
Herkuntt-Werke, *Stefan
Lochner*, Wirkung, 1993,
p. 380, no. 70; Zurich,
Schweizerisches
Landesmuseum – Cologne,
Wallraf-Richartz-Museum,
*Himmel, Hölle, Fegefeuer.
Das Jenseits im Mittelalter*,
1994, no. 131.

Bibliography:
G. Troescher,
"Weltgerichtsbilder in
Ratshäusern und
Gerichtsstätten", in *Wallraf-
Richartz-Jahrbuch*, 1939,
vol. XI, pp. 139–214, fig. 170;
A. Stange, *Deutsche Malerei
der Gotik*, Munich-Berlin,
1952, p. 47, fig. 75; "The
Hallsborough Gallery
Exhibition", in *Apollo*, May
1965; *Connoisseur*, May
1965, no. 3, repr. (detail);
Die Weltkunst, June 1, 1965,
repr.; H. M. Schimdt, *Der
Meister des Marienlebens und
sein Kreis*, Dusseldorf, 1978,
fig. 41; A. Stange, *Kritisches
Verzeichnis der deutschen
Tafelbilder vor Dürer*, 1978,
vol. I, no. 187.

Around 1460–1465 this painter and draughtsman from Cologne created a series of eight panels depicting the Life of Mary *in his native city's Saint Ursula's church. Seven of them are in Munich's Alte Pinakothek (inv. WAF 618–624), and one in London's National Gallery. Other paintings that are now in Augsburg, Berlin, Cologne, Nuremberg etc. have been linked to this body of work, making it possible to recontruct the master's artistic personality. The strong Dutch influence on his work suggests that he travelled to the Low Countries. His style is very similar to that of the Master of the Lyversberger Passion. These two artists, often confused, were the most talented representatives of the Cologne school during the second half of the fifteenth century.*

The composition of this *Last Judgement* is divided into two scenes. In the upper section is a crowned, open-armed Christ enthroned in His Glory dressed in red robes and surrounded by a halo of golden light. On either side, angels announce His victory by blowing trumpets. The saints surrounding him, bearing the symbols of their martyrdoms, are divided into two groups. On the left, Mary the Mother of Christ can be recognised among the women in the first row. Around her is Saint Barbara, holding a tower, and Saint Catherine of Alexandria, with a sword and a book, together with Saint Agnes and the lamb in the second row. Seated on the right-hand side are Saint Peter with his key, Saint John the Baptist dressed in an animal skin and with a lamb on his book, Saint John the Evangelist holding the poison cup and Saint Matthew holding a sword. Behind them are Saint Augustine in bishop's dress holding a flaming heart and Saint Lawrence holding a grille. In the lower section Saint Peter, shown a second time, and two angels welcome the Chosen, who are going to heaven on the left. On the right, two devils are pushing the Damned to Hell. In the centre of the composition a landscape stretches into the distance, with a view of a town and some living figures accompanied by either angels or demons. The meaning of the scene is clear: eternal life depends upon life on Earth; those who are led by angels will go to Paradise, the others, guided by demons, will suffer in the fires of Hell.
This painting, formerly attributed to the fifteenth-century French School, was linked by Max J. Friedlander to the work of the Master of the Life of Mary. Stange clarified this attribution by seeing in this piece the hand of a studio assistant influenced by the paintings of Stefan Lochner, who was active in Cologne from 1442 to 1451. The composition was inherited from this artist's, but the figures, particularly that of Christ, and landscape are very similar to the works of the Master of the Life of Mary. A studio copy of this painter's *Last Judgement* is in the Wallraf-Richartz-Museum in Cologne.
Ph. L.

Jeremias van Winghe (1578–1645)
Servant in a Kitchen, 1635

Oil on wood.
H: 115 cm; W: 85 cm.
Monogrammed and dated,
lower centre: *I. F. 1635.*
Marked with the stamp of the
Kaunitz's collection, Vienna,
lower right.
GR 1.957

History:
Vienna, Kaunitz's sale,
March 13, 1820, no. 197;
Paris, sale at Palais Galliéra,
December 10, 1962, no. 115,
repr.; Monaco, Sotheby's,
June 20, 1987, no. 351, repr.
(presented as *Monogrammiste
I. F.* with the date 1635).

Bibliography:
E. Greindl, *Les peintres
flamands de nature morte au
XVIIᵉ siècle*, Brussels, 1983,
pp. 89, 370, no. 1, fig. 161
(presented as *Monogrammiste
I. F.* with the date 1655;
private collection, Paris);
S. Segal, *A Prosperous Past:
The Somptuous Still Life in
the Netherlands 1600–1700*,
The Hague, 1988, p. 57,
fig. 4.1 (attributed to Jeremias
van Winghen with the date
1615); C. Grimm, *Stilleben:
Die niederlandischen und
deutschen Meister*, Stuttgart-
Zurich, 1988, fig. 129,
p. 201 (attributed to Jeremias
van Winghen with the date
1615).

Jeremias van Winghe (Brussels, 1578 – Frankfurt, 1645) specialized in still lives, portraits and genre and market scenes. He was active in Frankfurt, where his father, the painter Joducus van Winghe, brought him in 1584 to flee anti-Protestant persecutions. He studied under his father before training with Frans Badens in Amsterdam. Van Winghe was clearly influenced by Beuckelaer and Aertsen, and recalls the decorative innovations of Rubens' Flemish followers. He may have known Snyders, among others. Sam Segal has recently attributed high quality works to this almost forgotten master.

There is a weak copy of this painting (oil on wood, 115.5 × 86.5 cm; Paris, sale at the Théâtre des Champs-Elysées, November 22, 1987, no. 24, repr.; attributed to the studio of the *Monogrammiste I. F.*). It and the Delff of the Rau collection belonged to the famous Kaunitz collection in Vienna. For a long time the inscriptions were attributed to the *Monogrammiste I. F.* The date was read as *1635* for the 1987 sale and *1655* by Edith Greindl, who considered this anonymous painter a follower of Frans Snyders and the earlier painters Aertsen and Beucklaer (Greindl, 1983, p. 89) and attributes two other still lives to him (ibid., nos. 2, 3). In 1988 Sam Segal read the date as *1615* and convincingly established a link between this work and the *Kitchen* in Frankfurt's Historisches Museum, signed and dated *Jeremia. Van. Winghe. Fecit. 1613* (oil on canvas, 115.5 × 146 cm; inv. 1972).

The similarities are obvious. The Beuckelaer-style composition features background scenes in the same spirit as the drinking men in the Rau collection painting. The identical motifs of the fish in a plate and cutting board on the tub appear in both works. Finally, the handling of the objects, especially the pewter plate, is the same. Sam Segal has shown that the *I* in the monogram stands for *Jeremias* and the *F* for *fecit*. Claus Grimm also argues that the *I* is the initial for Jeremias, but that the *F* is for *Francoforte*, van Winghe's nickname. The clothing of the figures in the back-

ground differ in the two works. The garments in the Frankfurt painting correspond to those of the early seventeenth century, while those in the Rau collection picture are later, from the 1630s. The date should therefore be read as *1635* rather than *1615*; the upper downstroke of the 3 has been effaced. The year 1655 would have been too late. This hypothesis is confirmed by the style of the Rau collection panel, which is more modern than that of the Frankfurt painting. The still life's monumental forms and dynamic organization, with the cat reaching for the slab of meat, go beyond Aertsen's and Beuckelaer's styles, which recall Snyders', who in 1635 had been active for a long time and whom, furthermore, van Winghe probably knew. The background scene is similar to those found in paintings by the Flemish artists Simon de Vos and Christophe van der Lamen. This current was practised by van Winghe's early German teachers Binoit, Flegel as well as the Strasbourg painter Stosskopff. In the end this sombre, warmly coloured and splendidly executed *Servant in a Kitchen* brings to mind Samuel Hoffmann, the German artist who worked with Rubens in 1622.

O. Z.

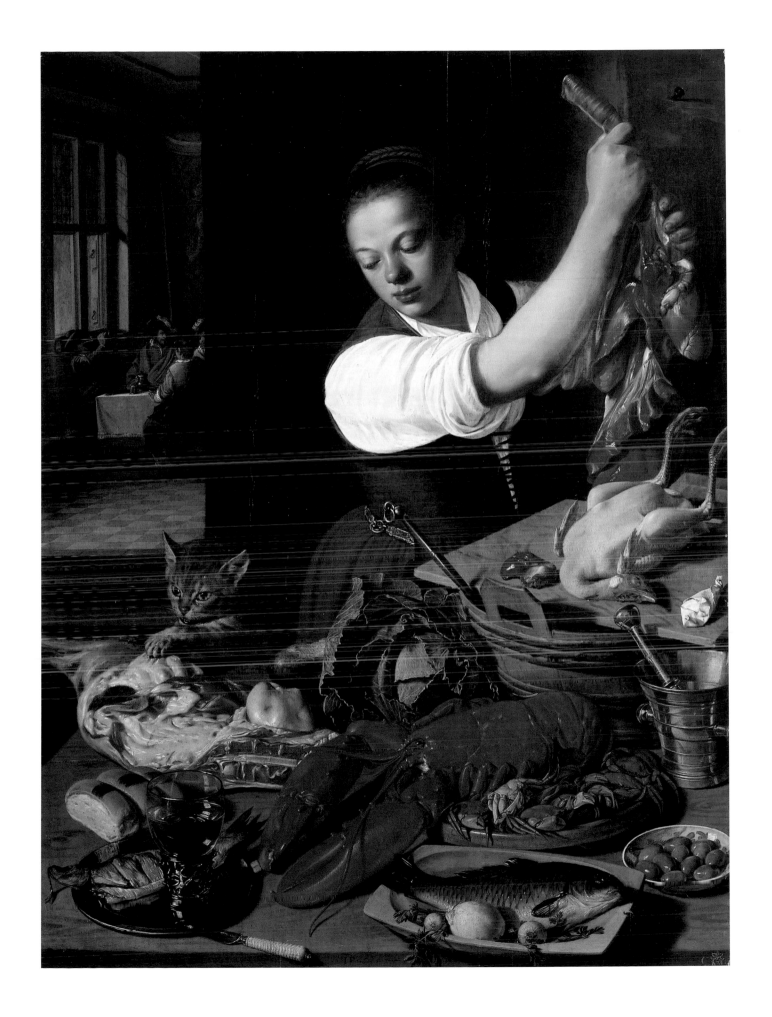

Philippe de Champaigne (1602–1674)
Portrait of Doctor Boüin, 1625

Oil on canvas.
H: 60 cm; W: 47 cm.
Ancient inscription upper
left: *n (?) Boüin docteur / ppal
de poitier / an 1625.*
GR 1.896

History:
Great Britain, private
collection, 1976; Paris, sale
at Palais d'Orsay, June 16,
1977, no. 60, repr.; London,
Gallery Colnaghi and Co Ltd,
1978; London, Christie's,
December 2, 1983, no. 36,
repr.

Exhibition:
London, P. and D. Colnaghi
and Co Ltd, 1978, *Paintings
by Old Masters*, no. 24, repr.

Bibliography:
B. Dorival, *Philippe de
Champaigne 1602–1674*,
Paris, 1976, vol. II, p. 388,
no. 2051, repr. p. 518,
fig. 2051A.

Philippe de Champaigne (Brussels, 1602 – Paris, 1674) received his earliest training in Brussels and in 1621 settled in Paris. In the French capital he met the young Poussin on the eve of his departure for Italy, where he would never go. He worked for Lallement and Nicholas Duchesne, whom he succeeded and whose daughter he married in 1628. Champaigne was granted French nationality in 1629 and became one of the favourite painters of Louis XIII and Richelieu, of whom he painted several portraits. He was a founding member of the Royal Academy in 1648 and painter of the Paris aldermen. He was also a church painter and formed a special bond with Port Royal and the Jansenists. He painted many altarpieces imbued with a grave and sober religious sentiment, but was also a fashionable portraitist, sought after by his contemporaries.

Nothing is known about Dr Boüin's life except that he belonged to a well-known family in Poitou. Bernard Dorival notes a portrait of a *Madame Boüin*, drawn by Daniel Dumonstier, dated 1641, in the Cabinet des Estampes in the Bibliothèque Nationale (J. Adhémar, "Les Dessins de Daniel Dumonstier du Cabinet des Estampes", in *Gazette des Beaux-Arts*, March 1970, p. 149, no. 94, ill.).
The clumsy inscription in the painting's upper left corner makes it difficult to date the work. It provides a piece of information about the life of the model, who was undoubtedly appointed chief doctor of Poitiers in 1625, but has led the London exhibition catalogue's author to consider this portrait one of the artist's early works. Bernard Dorival argues that it is a late work painted around 1645. It is closely related to the *Portrait of Philippe de la Trémoïlle* (Amsterdam, Rijksmuseum; Dorival, 1976, vol. II, no. 172) which dates from around 1643. Furthermore, the sitter's moustache and goatee as well as his costume are characteristic of the fashion in the years 1640–1645: slashed sleeves, sombre doublet decorated with lace, buttoned up high below the collar and opening lower over the shirt, the collar fastened with a tasselled cord.
Philippe de Champaigne used a limited colour range. The three-quarter figure stands out against a light grey and beige background. The golden white of the sleeves and shirt and the colder, almost transparent white of the collar set off the black doublet. The artist concentrated his attention on the model's face and psychology. He painted the pink complexion, the greyer zones where the beard appears below the skin, the half-opened ruby lips, and the lively, sparkling look which directly addresses the spectator with precision and delicacy.
I. M.

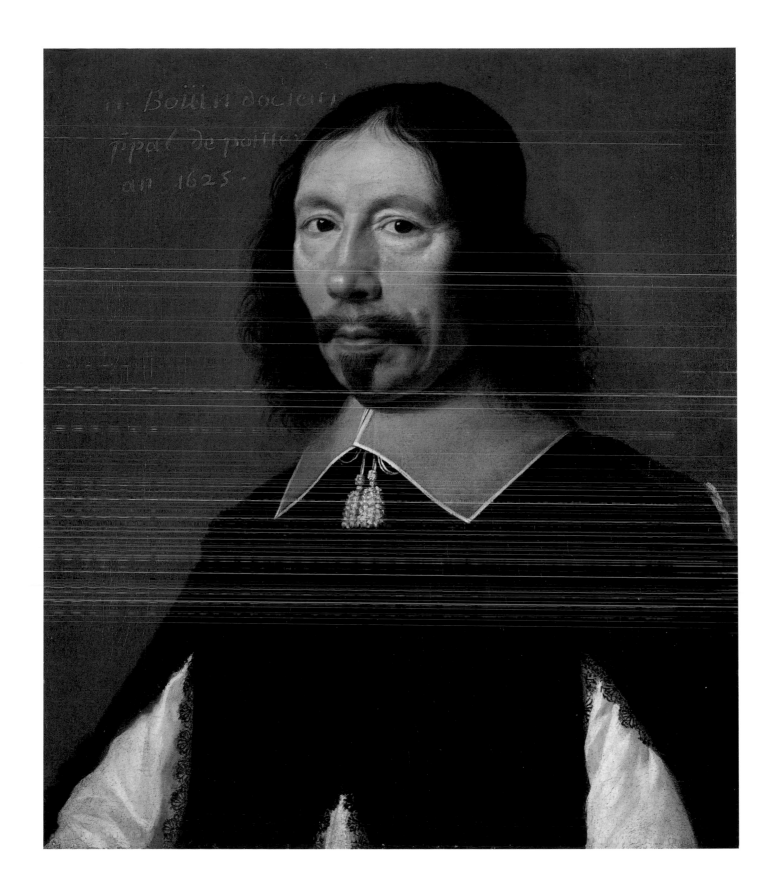

Oil on canvas.
H: 47 cm; W: 38.9 cm.
Signed and dated upper
right: *J. B. Greuze. 1760.*
GR 1.542

History:
Mr. C. J. West's collection,
1835; London, Christie and
Manson's, 1835; Louis Paraf's
collection, 1909; London,
C. J. Galloway's collection;
Paris, Baron d'Erlanger's
collection; Paris, sale at
Drouot's, May 21, 1941,
no. 12, repr.; Paris, Baronne
Lopez-Tarragoya's collection;
London, Christie's, June 29,
1973, no. 89, repr.

Exhibitions:
London, Guild Hall, 1898,
no. 79; Paris, Palais de
Bagatelle, *Exposition
rétrospective de portraits
de femmes sous les trois
Républiques*, 1909, no. 90,
repr.

Bibliography:
J. Smith, *Catalogue Raisonné
of the Works of the Most
Eminent Dutch, Flemish and
French Painters*, London,
1837, vol. VIII, and
Supplement, London, 1942,
no. 114; J. Martin, Ch. Masson
and C. Mauclair, *Jean-
Baptiste Greuze*, Paris, 1906,
p. 37, no. 532; G. Mourey,
"Exposition rétrospective
de portraits de femmes",
in *Les Arts*, July 1909, no. 91,
p. 30, repr. p. 22; "Le mariage
malheureux de Jean-Baptiste
Greuze", in *Connaissance des
Arts*, July 1955, pp. 14–17,
repr. p. 15.

*Jean-Baptiste Greuze (Tournus, 1725 – Paris,
1805), who was born in Burgundy, did not
arrive in Paris until around 1750. In 1755
he was admitted to the Academy. The same
year he exhibited at the Salon for the first
time and was acclaimed by the critics. His
moralising genre scenes made an impres-
sion on the public and ushered in the be-
ginnings of a new aesthetic. His portraits,
which were at every exhibition, were
no less popular and his renown earned him
official commissions. Greuze was a good
businessman who understood all the ad-
vantages that dissemination of his works
through printing could bring, and he en-
couraged engravers to make copies of his
works.*

The many surviving portraits of Madame
Greuze suggest that she is the artist's young
model in the Rau collection painting. Edgar
Mulhall confirmed this traditional identi-
fication in a written statement dated Feb-
ruary 25, 1992. On February 3, 1759
Greuze married Anne-Gabrielle Babuti
(1732 – around 1812), the daughter of a
Paris bookseller, in Saint-Médard's church
in the French capital. In August 1793
Greuze and Gabrielle divorced after a
stormy twenty-six years together.
In a letter to the sculptor Falconet dated
August 1767, Diderot, who nevertheless
found the young woman charming, de-
scribed the couple's relationship in these
terms: "I enjoy hearing him speak to his
wife. It is a spectacle where Punch beats
back the blows, which makes the fellow
meaner" (*Correspondance*, annotated by G.
Roth, 1955–1970, vol. VIII, p. 104).
The catalogue of the June 29, 1973 sale af-
firms that the painting was exhibited at the
1761 Salon under number 99, entitled *Por-
trait of Madame Greuze as a Vestal*. Its size
(64.8 × 48.6 cm) as well as Diderot's de-
scription (p. 134) make it a distinctive work.
The catalogue of the May 21, 1941 sale
compared the painting to one of those ap-
pearing under number 104 and of which
Gabriel de Saint-Aubin did a sketch (E.
Dacier, *Catalogues de ventes et livrets de Sa-
lons illustrés par Gabriel de Saint Aubin*,
1907, vol. VI, p. 64, repr. p. 25). Howev-

er, this small drawing does not seem to ex-
actly match the Rau collection painting. The
young woman's body is turned in another
direction and she is wearing a bonnet tied
under her chin. It may be possible that the
painting, dated 1760, was exhibited at the
1761 Salon under the number 104, *Sever-
al Heads Painted under the Same Number*.
However, neither descriptions nor the size
specified makes it possible to confirm this
hypothesis. These small portraits did not
attract the attention of the critics, who were
overwhelmed by number 100, *Village Har-
mony*. A laconic Diderot was the only crit-
ic who mentioned it, saying: "There are sev-
eral very life-like heads by Greuze" (p. 135).
Nevertheless, this charming figure is eye-
catching. The young, round, child-like face
is caught in a natural pose. The light im-
pasto of the cheeks provide it with life and
substance, while the subtle glaze of the veil
covering the shoulders underscores the
young woman's fragile grace. A few touch-
es of colour add a fresh, delicate note.
Diderot, recalling the past, described
Gabrielle flatteringly: "A white doll straight
as a lily, red as a rose" (*Œuvres completes*,
édition critique et annotée, H. Dieckman,
J. Proust and J. Varloot, 1979, "Salon de
1765", p. 152), G. Mourey quoted the En-
lightenment philosopher as describing "a
child's face, a round, unified forehead, eye-
brows high above the eyes that lend her
physiognomy a naive expression, a straight,
alert little nose of a young girl, a moist,
well-outlined, coquettish, oval, still full
mouth, soft, delicate flesh, an amiable
roundness, a little air of feeling heighten-
ing and enlivening what was a little too
sheepish about the face" (quoted by
Mourey, 1909).
C. B.

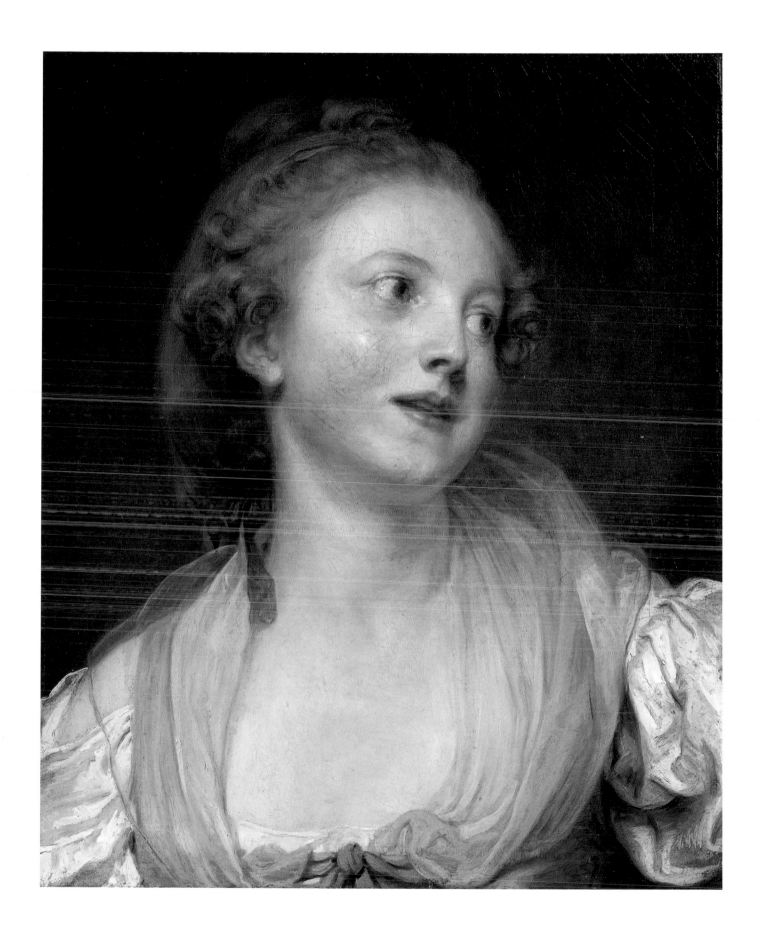

Chevalier Volaire (Pierre-Jacques Volaire, known as Chevalier Volaire, 1729 – before 1802 or 1790)
Still Waters, Fishermen, 1766

Oil on canvas.
H: 55 cm; W: 72 cm.
Signed and dated lower right, partly effaced: *le [c]he[valier] Volair[e] / Roma 176…*
GR 1.115

History:
Vienna, Czernin's collection, 1926; Vienna, Sankt Lucas Gallery, 1963.

Bibliography:
Catalogue of the Czernin collection, pp. 94–95, no. 157; F. Ingersoll-Smouse, *Joseph Vernet, peintre de marine*, Paris, 1926, vol. II, p. 47, no. 1235A (presented as Joseph Vernet).

Pierre-Jacques Volaire (Toulon, 1729 – Naples, before 1802 or Lerici, 1790?) came from a family of artists. His early training was probably dispensed by his father, Jacques, official painter of the city of Toulon. In 1754 Joseph Vernet, whom the King had commissioned to paint a series of the Ports of France, *arrived in Toulon and took the young Volaire under his wing. Volaire followed his teacher from port to port, leaving him in 1763 to return to his home town for a while before going to Rome, where he lived until 1769 and painted works that were very similar to Vernet's. Afterwards he left for Naples where he seems to have lived until his death, the date of which has not been clearly established.*

Volaire remained with Joseph Vernet for eight years, helping him with his commissions, especially the *Ports of France*. This experience marked his style for the rest of his life. These two pendants, for example, were considered to have been painted by Vernet, as Ingersoll-Smouse's catalogue demonstrates, until a restoration in 1989 revealed Volaire's partially effaced signature. The works are extremely similar to Vernet's. The same composition, with one side filled with land and architecture and the other opening out on to the sea and ships, the same big, cloudy sky taking up two-thirds of the canvas, the same soft, orange-tinted morning light contrasting with the violent midday storm and even the same small, gesticulating figures in the foreground, so characteristic of Vernet, can be found in Volaire's Rau collection paintings.
The figures, especially in paintings of shipwrecks, were very popular during the eighteenth century because of their dramatic aspect. The poses of the barely escaped women weeping or squeezing their children, the lifeless figures and tired, desperate faces not only won viewers' hearts, but liven up the foreground of this quasi-theatrical scene as well. Everything in the two scenes is contrasted. *Still Waters* is characterized by a static composition of horizontals and verticals and the stiff poses of the figures, who are unveiled by the light of a warm, pink morning sun. The

Storm at Sea furiously rocks to the rhythm of curves and obliques which seem to embody the wind of the tempest. A harsh light models the landscape and bitterly illuminates the little group of unfortunate shipwreck victims and their saviours. Lively colours and a marked chiaroscuro round off the painting, which is imbued with a tragic flavour. Many compositions that could have inspired Volaire can be found in Vernet's work. For example, *Still Waters* and *Storm at Sea* are very similar to two famous works, *Morning, Calm Weather* and *Midday, Shipwreck*, part of a series of decorative works entitled the *Four Parts of the Day*, commissioned by the Marquis de Marigny for the Dauphin's library at Versailles. They were painted in 1762 and are still in their original location (oil on canvas, 83 × 135 cm; Ingersoll-Smouse, 1926, nos. 763, 764, repr.).
Volaire, who probably helped paint these scenes, may have remembered them four years later when he did these two pendants in Rome. The choice of the times of day, the organization into contrasting light and dark scenes and the location of the paintings' various elements are similar. The same spirit can be found in the *Storm* by Vernet, which was certainly painted after the Rau collection works and exhibited at the 1769 Salon (private collection; *Diderot et l'art de Boucher à David*, Paris, Hôtel de la Monnaie, 1984–1985, p. 395, repr.).
This comparison demonstrates the close relationship between the master's work, which changed little over time, and his student's. The influence remained powerful until at least 1769, when Volaire settled in Naples and the landscapes of Campania and eruptions of Mount Vesuvius breathed new life into his style. These new subjects became his specialty and perpetuated his fame.
C. B.

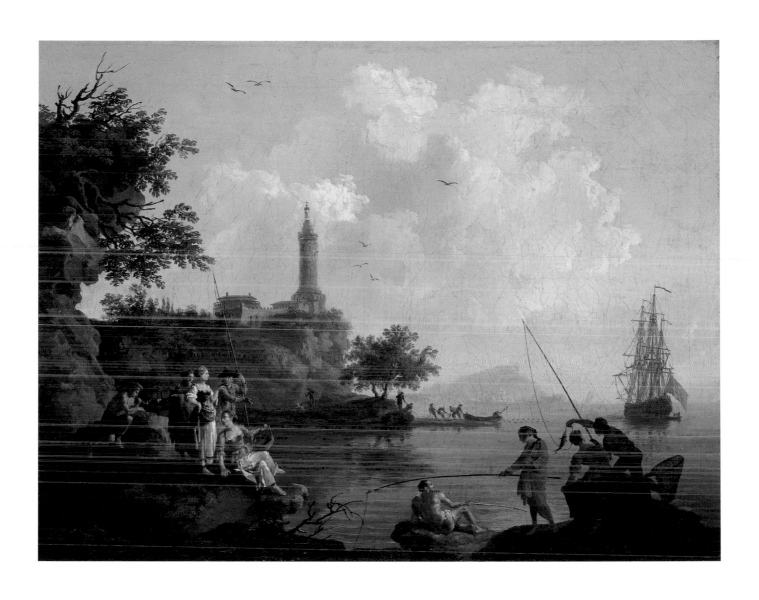

Jean-Honoré Fragonard (1732–1806)
Portrait of François-Henri, Duke of Harcourt, circa 1769

Oil on canvas.
H: 81.5 cm; W: 65 cm.
GR 1.560

History:
Duke of Harcourt's
collection; London,
Sotheby's, December 8,
1971, no. 21, repr.

Exhibitions:
Paris, Musée des Arts
Décoratifs, *Exposition
d'œuvres de J.-H. Fragonard*,
1921, no. 90 (catalogue by
G. Wildenstein); Paris, Musée
Carnavalet, *Le Théâtre à
Paris*, 1929, no. 31, Paris,
Gazette des Beaux-Arts,
*Le siècle de Louis XV vu par
les artistes*, 1934, no. 133;
Bern, Musée des Beaux-Arts,
Fragonard, 1954, no. 22;
Paris, Galerie Charpentier,
*Cent chefs-d'œuvre de l'art
français, 1750–1950*, 1957,
no. 33; Paris, Galeries
Nationales du Grand Palais –
New York, Metropolitan
Museum of Art, *Fragonard*,
1987–1988, no. 140, repr.
(catalogue by P. Rosenberg).

*Born in Provence, Jean-Honoré Fragonard
(Grasse, 1732 – Paris, 1806) was ten years
old when his parents settled in Paris, where
he briefly studied under Chardin and, more
successfully, Boucher. Winner of the Prix de
Rome in 1752, he left for Italy in 1756. Con-
tact with Antiquity and works by the great
masters of painting rounded out his train-
ing. He was influenced by Hubert Robert
with whom he worked a great deal, and be-
friended the abbot of Saint-Non, his first pa-
tron.*

*On his return to France, as a recognised
painter, he hesitated between an official ca-
reer (Corésus and Callirhoé, 1765; Paris,
Musée du Louvre) and lighter works, likable
or gallant genre scenes which carried on the
tradition of Boucher and fanciful figures
where the freedom of the brush reached its
heights. Forgotten in the first half of the
nineteenth century, Fragonard has since re-
gained an undying celebrity.*

The *Portrait of François-Henri, Duke of Har-
court* is one of the fifteen fanciful figures
by Fragonard known today. Painted around
1769, these identically sized paintings have
not yet yielded all their secrets. The patrons
and most of the figure's costumed models
are unknown, but the Rau collection por-
trait is still one of the least mysterious.
Mentioned for the first time in 1921, the
Portrait of François-Henri, Duke of Harcourt
and its pendant, the *Portrait of the Duke of
Beuvron* (Paris, Musée du Louvre), were not
separated until 1971. The Fragonard ex-
hibition in Paris and New York in
1987–1988 reunited them, with P. Rosen-
berg offering a full study. The models were
identified from 1921. They include
François-Henri, Duke of Harcourt, Gover-
nor of Normandy (1726–1802) and his
younger brother, Anne-François d'Harcourt,
Duke of Beuvron (1727–1797). Exhibited
and published, they have often been mixed
up, with the one taken for the other. Re-
cent studies, and notably the comparison
between Fragonard's work and a portrait of
François-Henri d'Harcourt drawn by Anicet-
Charles-Gabriel Lemoinier (Rouen, Musée
des Beaux-Arts), have confirmed the iden-
tification of the model (Rosenberg and

Compin, 1974; Rosenberg, 1989). The sug-
gestion of this is given by an old inscrip-
tion stuck to the back of the picture: "[...]
Duc d'Harcourt né le 11 janvier 1726 / lieu-
tenant général de Normandie en 1764 /
Gouverneur du Dauphin sous Louis XVI,
Ambassadeur du Roi Louis XVIII en An-
gleterre / pendant la Revolution Française
/ mort a Selaine canton de [...] juin 1802 /
Il avait épousé Catherine Scholastique /
d'Aubusson de la Feuillade morte à Paris
rue de Babylone / le 18 novembre 1815"
(Duc d'Harcourt born January 11, 1726 /
Lieutenant General of Normandy in 1764 /
Governor of the Dauphin under Louis XVI,
Ambassador of King Louis XVIII to Eng-
land / during the French Revolution / died
at Selaine, canton of [...] in June 1802 / He
had married Catherine Scholastique /
d'Aubusson de la Feuillade who died in
Paris, rue de Babylone, / November 18, 1815.)
Dressed in a sea-green jerkin and a red and
black short cape, his sword at his side, the
Duke of Harcourt is holding a hat with a
white plume in his right hand, proudly
clamped on his hip, and is clutching a fine
gold chain. The face stands out against a
white ruff, a reminder of portraits by
Rubens. The garment is brushed in an al-
most transparent manner, dominated by
brown tones. The coloured accents are
marked by heightenings of pure colour, a
dazzling red for the folds of the cape and,
for the sleeves, an almond green lightened
by a single yellow note at the hollow of the
left arm. The lively touch and free brush,
which runs over the canvas in large, rapid
strokes, gives the portrait its dynamism.
Fragonard was keen to express the vitality
of his model, surprised at the moment he
turns round.
I. M.

Bibliography:
G. Wildenstein, "L'exposition
Fragonard au Pavillon de
Marsan", in *Revue de l'Art
français*, July 1921, no. 7,
p. 360; L. Reau, *Fragonard*,
Brussels, 1956, pp. 88, 174
pls. 93, 181; *Journal de
l'Amateur d'Art*, 10 May
1957, detail reproduced on
cover; G. Wildenstein,
The Paintings of Fragonard,
Aylesbury, French ed., 1960,
pp. 16–17, no. 240, pl. 36;
J. Wilhem, *Fragonard*
(unpublished monograph),
1960, p. 113, Ch. Sterling,
*Portrait of a Man (The
Warrior), Jean-Honoré
Fragonard. An Unknown
Masterpiece by Fragonard*,
Williamstown, 1964, p. 86;
J. Thuillier, *Fragonard*,
Geneva, 1967, pp. 79, 86;
Y. K. Zolotov, *Le portrait
français du XVIIIᵉ siècle*,
Moscow, 1968, p. 160, repr.;
D. Wildenstein and
G. Mandel, *L'opera completa
di Fragonard*, Milan, 1972,
no. 256, repr. (presented as
portrait of Anne-François);
P. Rosenberg and I. Compin,
"Quatre nouveaux Fragonard
au Louvre", in *Revue du
Louvre*, no. 3, 1974,
pp. 184–186, fig. 4; *Art de
Basse Normandie*, no. 78,
1979, p. 34; J.-P. Cuzin,
Fragonard, vie et œuvre,
Fribourg-Paris, 1987,
pp. 113, 192, no. 176, fig. 133
p. 106; P. Rosenberg, *Tout
l'œuvre peint*, Paris, 1989,
no. 205, repr.; M. D. Scheriff,
Fragonard. Art and Eroticism,
Chicago-London, 1990,
pp. 183–184, notes 45–46
pp. 245–246.

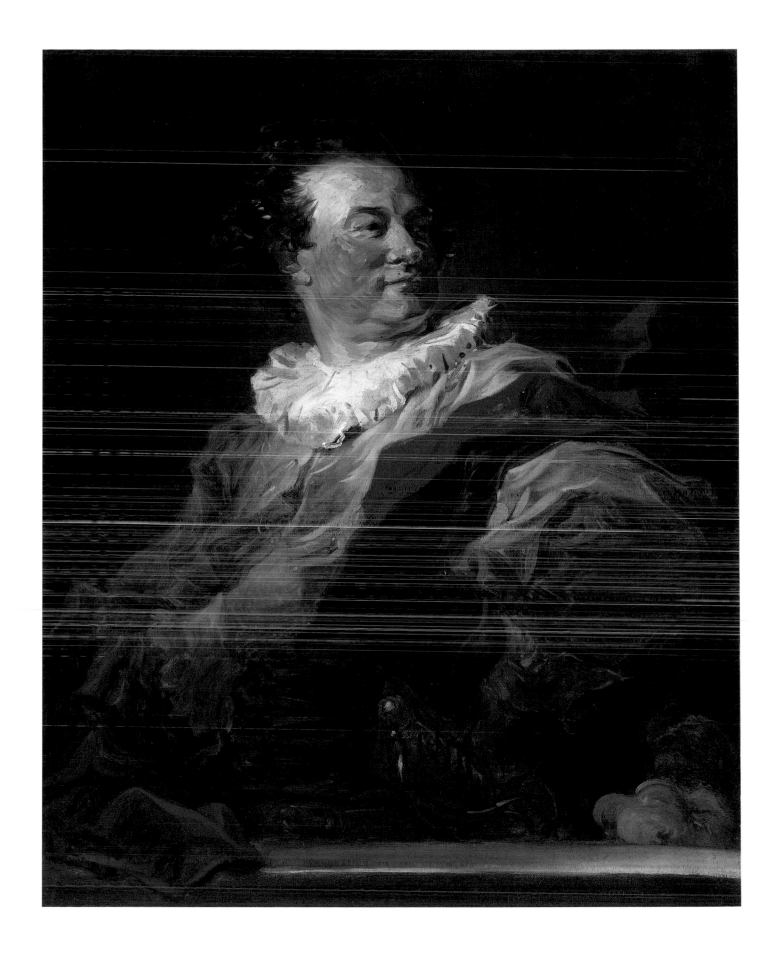

sun [..] with a film of filth that made my skin look like an Ethiopian's" (*Epistola XXII ad Eustochium*).

This version strives to accurately illustrate the subject in accordance with Counter-Reformation instructions. It is dated 1636, in the middle of de Ribera's fully mature period, shortly before he received the major commission for the San Martino charterhouse. The painting belonged to Count Johan Matthias von der Schulenburg, a German field marshall who entered the service of the Republic of Venice in 1715 and, beginning in 1724, gathered together a huge collection of more than 950 works, most of them by earlier and contemporary Italian artists. The number 112, which can be seen on the painting's lower left, was added during a gallery inventory carried out in French after the marshal's death. An original inscription reading *Giusepe di Ribera, zugenannt lo Spagnoleto. Px St. Hyeronimus. N. 112* appeared on the back of the old canvas reinforcement, which was removed during restoration in 1970.

O. D.

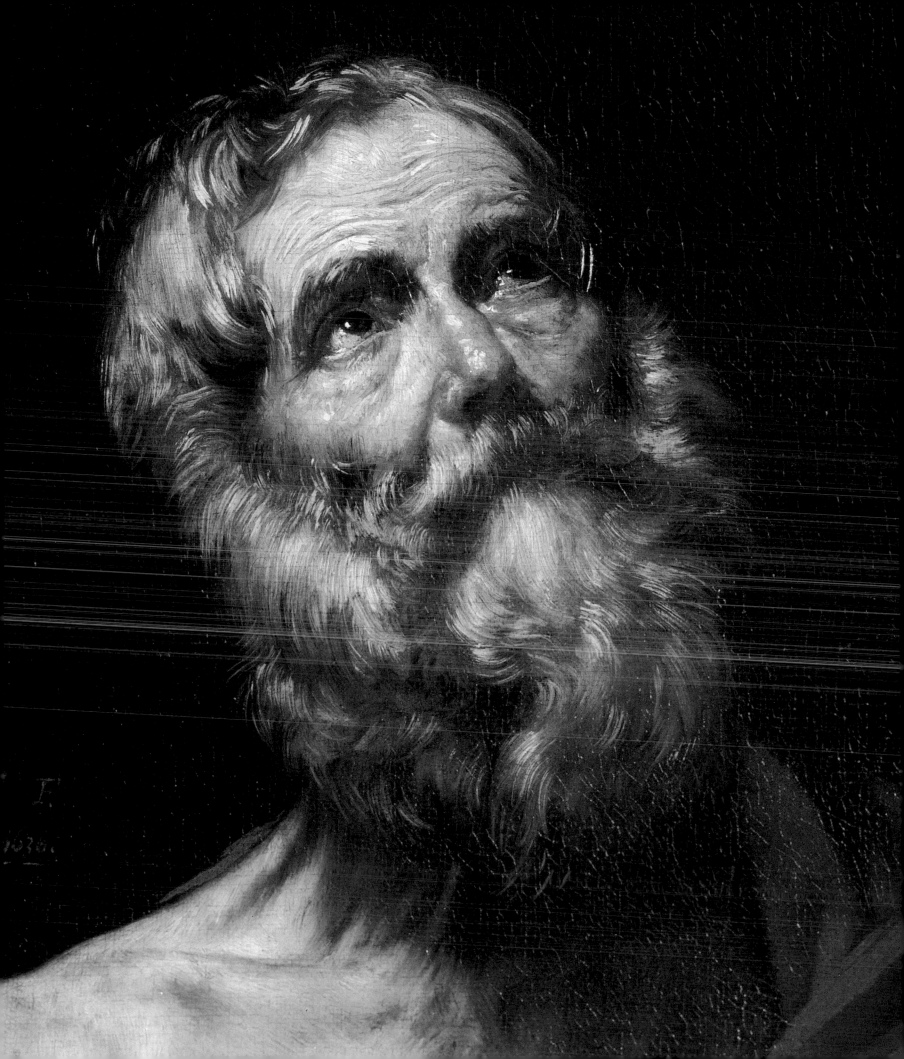

The British School

British painting, compared to that of France or Italy, received very little support in the way of patronage from individuals or institutions. It was only in the eighteenth century that the first English academies came about. One of the begetters of academic training was the painter Reynolds. Anxious to promote his country's art in the face of France and Italy, he developed what he called a "grand style", i.e. painting devoted to portraits, according to the classical canons of antique statuary. But Reynold's most basic innovation in British painting, was to have used as models people from different social classes. Unlike Gainsborough, who was self-taught, and who carried out, following van Dyck, fashionable portraits which he placed within the English countryside. His refined style borrowed from the Rococo a clear and luminous chromatic scale, along with a certain lyricism. If these two artists signify the apex of Classicism in England, their influence nonetheless opened the way for Romanticism.

John Michael Wright (1617–1694)
Portrait of Sir Hugh Wyndham, 1670–1680

Oil on canvas.
H: 125.5 cm; W: 102 cm.
GR 1.948

History:
London, Christie's,
November 18, 1983, no. 34;
London, Anthony Dallas,
1984; London, Sotheby's,
November 19, 1986, no. 29.

Exhibition:
London, Anthony Dallas and
sons Ltd, *British Paintings*,
1984, no. 4.

Bibliography:
Apollo, December 1984, p. 27
(advertising for the exhibition
mentioned earlier, only
existing colour reproduction
of the painting).

John Michael Wright (London, 1617 – London, 1697) apprenticed with the painter Jamesone in Edinburgh before going to Italy. From 1642 to 1656 he lived in Rome. On his way back to London he became Archduke Leopold William's antiques buyer. His long stay on the continent imbued his work with a French and classical flavour unknown in England, which earned him the favors of Charles II. Between 1660 and 1670 he was a successful portraitist, but in Restoration England his sometimes austere naturalism and Catholic convictions prevented him from playing the leading role, which fell upon Sir Peter Lely.

The model for this portrait was the eighth son of Sir John Wyndham of Orchard Wyndham. Sir Hugh (1603–1684) was brought up at Wadham College, Oxford and made sergeant-at-law in May 1654. Although this promotion to the magistrature was declared illegal during the Restoration, he not only kept his position but in June 1660 was named judge and in June 1670 Exchequer. He was married three times, first to Jane, daughter of Sir Thomas Wodehouse of Kimberley, then to Elisabeth, daughter of Sir William Minn of Woodcott and, in 1675, to Katherine, widow of Sir Edward of Beveridge. This portrait, which can be dated to after 1660 because the model is wearing a judge's robes, features Wright's main trademarks: discreet sobriety and elegance as much in the figure's pose as in the setting which, reduced to the basics, enhances the absolutely truthful, psychologically realistic face. This painting is similar to Wright's more famous portraits, such as *Brian Duppa, Bishop of Winchester* (1660; Oxford, Christ Church) and *Colonel John Russell* (1659; Ham House, Victoria and Albert Museum). Between 1671 and 1675 Wright painted twenty-two full-length portraits of judges who had settled the difficult legal questions arising from the Great Fire of London in 1666. These works, which are in Lincoln's Inn, London, include the *Portrait of Sir Wadham Wyndham* (1610–1668), Sir Hugh's brother. This commission may have persuaded Sir Hugh to have Wright paint his own portrait, which would date it to between 1670 and 1680 or so. Sara Stevenson, who has suggested the same date, has confirmed the Rau collection painting's traditional attribution to Wright (oral statement, 1992).

J.-Ch. B.

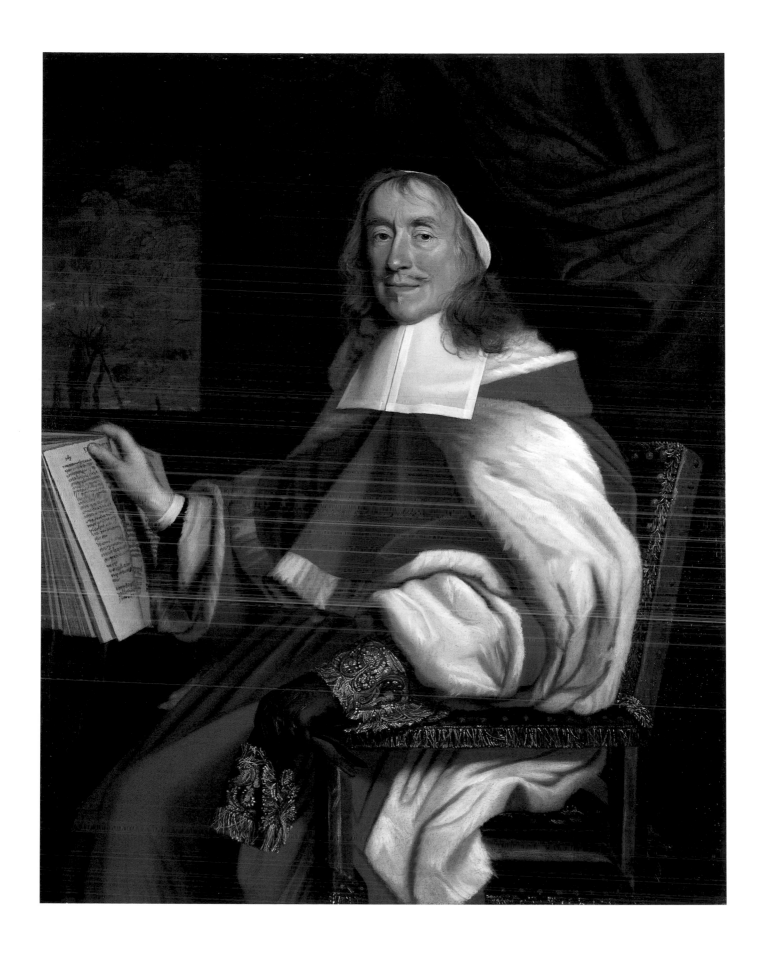

Thomas Gainsborough (1727–1788)
Portrait of Mrs. Gainsborough

Oil on canvas.
H: 75 cm; W: 62 cm.
GR 1.902

History:
Margaret Gainsborough until her death in 1798; Margaret Gainsborough, her daughter, until her death in 1820; by legacy to Elisabeth Green (born Gardiner), her first cousin; Rev. William Green, her husband; Miss Laetitia Green, a relative, second wife of Mr. Thorne; John Mills Thorne, his son, 1859; Rev. William Edward Green, son of William Green, 1876; bought in 1876 by John Heugh; London, Christie's, May 10, 1878, no. 236, bought by Thomas at Agnew & Sons Ltd; Sir Robert Loder, 1882; sale, May 29, 1908, no. 528, bought by Asher Wertheimer; Rio de Janeiro, E. Guinle, 1911; Paris, Galerie Charles Brunner, 1912; Toronto, bought by Georges A. Morrow, 1917 (1927); Toronto, Waddington's, Mac Lean & Co. Ldt, June 1983; Monaco, Sotheby's, June 26, 1983, no. 512, repr.; London, Sotheby's, July 5, 1984, no. 274, repr.

Exhibitions:
London, British Institution, 1859, no. 135; London, Royal Academy of Arts, *Old Masters*, 1882, no. 12; London, Grosvenor Gallery, *Gainsborough Exhibition*, 1885, no. 175; London, *Japan-British Exhibition*, 1910, no. 17; Paris, Galerie Charles Brunner, 1912, vol. III, no. 14, repr.; London, Pembroke Galleries, 1921; Toronto, Art Gallery, 1927, no. 27.

Thomas Gainsborough (Sudbury, 1727 – London, 1788) was born in Suffolk. He was always sensitive to the landscapes of his youth, which he would later work into his great portraits of English society painted in the grand manner. He apprenticed in London from 1740 to 1748, settling definitively in the capital city in 1774. Once famous, he painted numerous official portraits, both of members of the Royal family and the aristocracy. The outstandingly simple portraits he painted of his family or friends, devoid of all artifice, present an alternative facet of his work. They bear witness to his virtuosity and consummate skill in the art of portraiture and in the rendering of expression and personality.

Thomas Gainsborough married Margaret Burr in the summer of 1746. Adrienne Corri recently published an article revealing the young woman's origins ("Gainsborough's Early Career: New Documents and Two Portraits", in *The Burlington Magazine*, April 1983, pp. 212–214; *The Search for Gainsborough*, London, 1984). Born in Holland around 1728, Margaret was the illegitimate daughter of Frederick, Prince of Wales, son of George II, who gave her an annual allowance of £ 200 a year through the intermediary of Henry, Duke of Beaufort. Despite strong personality differences, the couple was inseparable and had two daughters: Mary, born in 1748, and Margaret, born in 1752. Gainsborough often executed portraits of his family. He painted his wife every year on their wedding anniversary, but few of these works have survived (*Gainsborough*, Paris, Grand Palais, 1981, p. 147).

Until the Heugh sale of 1878, the Rau collection painting had the same provenance as the portraits of *Mary* (77.5 × 65 cm; London, Tate Gallery, no. 5638), dated 1777, and *Margaret Playing the Lute* (76 × 67.3 cm; formerly in the Adolf Hirsch collection). However, it would seem that the latter is more likely a painting of Mary. It is still difficult to determine whether they were produced in the same year, but their free and easy execution nevertheless certainly makes them very close in date. All the artist's tenderness towards his sitter shows through in this work. The artist very carefully depicts her handsome face with its rather sad, tired expression which is in marked contrast with the rapid, spirited handling of her costume. The warm brown and red tones and the vibrant, confident touch make this a moving, lively and realistic portrait. The *Portrait of Mrs. Gainsborough* in the Courtauld (oil on canvas, 77 × 64 cm), painted circa 1778, is very close in spirit to the Rau collection piece, whilst the *Study of a Woman* in New Haven (19.5 × 13.7 cm; New Haven, Yale Center for British Art), from the model's pose, the costume and the dating, could well be a preparatory study for it. Yet another version of this portrait exists – a copy or an autograph work – which came up for sale in London, in 1920 (Christie's, December 3, lot 114).
C. B.

Bibliography:
E. Marshall, published letter in *Notes and Queries*, 19 February 1876, p. 155; W. Armstrong, *Gainsborough and His Place in English Art*, London, 1899, p. 195; "Gainsborough's Portrait of his Wife and Daughter", in *The Times*, 20 October 1908; E. Waterhouse, "Checklist of Portraits by Thomas Gainsborough", in *Walpole Society*, XXXIII, 1953, p. 46, no. 2 ; E. Waterhouse, *Gainsborough*, London, 1958, pp. 69–70, no. 298; M. Davies, *National Gallery Catalogue. The British School*, 2nd ed. 1959, pp. 41–42, no. 5638.

The Impressionist Revolution

Started by Courbet and his disciples, and by Delacroix, the pictorial revolution which overtook art during the nineteenth century was to continue during the following century. The complete change in the artist's statute meant that he was no longer a simple artisan who carried out commissions. From then on, the artist was an independent agent, free to paint and above all, to choose the motifs and the place where he carried out his paintings. In 1874, the first group show of Impressionist painters organized by Degas in the studio of Nadar, the photographer, signals the effective birth of the movement.

Described as "impressionistic" by the critic Leroy, these artists wanted, like their predecessors (Courbet, Corot), to unmask the conventions which tended to turn painting into a faithful projection of reality. To achieve this, they abandoned the artificial lights in their studios to work outdoors. This approach, *in situ*, allowed them to capture the instantaneous and fugitive nature of light. This method, which had already been tried by the Barbizon painters, necessitated new techniques: as undertaking a painting in this way meant that it was now subjected to light vibrations, the painter had to place paint directly on the canvas with quick little brushstrokes, the mixing of colours no longer carried out on the palette, but directly on the canvas. This principle of "division" and of the optical mixing of colours already recommended by Delacroix is the basis of the Impressionist revolution.

Considered subversive, the movement was under attack from virulent critics: they were reproached for leaving their pictures unfinished, imprecise, slapdash. And so painters such as Manet, Pissarro, Sisley, Bazille, Degas, Renoir, Guillaumin, Morisot, all gathered around Monet and, refusing to exhibit in the official Salon, made up an Independent Artists' Society. United in the notion that light submits every object to its own variations, these painters gave up the values on which, until then, the act of painting had been based: outline, modelling, chiaroscuro, perspective. However, each of them took different paths. Monet, who followed Boudin's advice and painted in the open air, soon became the leading light of the movement. The series representing the Saint-Lazare railway station, the Rouen cathedral, the haystacks, a bend in the Seine, views of London and Venice, as well as the waterlilies in his garden in Giverny, make up as many themes and motifs, which Monet immortalized by capturing an instant's luminousness, at any hour, and regardless of its quality. His landscapes can be compared to those of Sisley and Bazille. On the other hand, Manet, Degas and Caillebotte's works represent indoor scenes, in which different social classes are shown. The research carried out by the Impressionists on the visual perception of light was to reach a pinnacle with a small band of artists grouped around Signac and Seurat. Basing themselves on optical studies carried out by Chevreul and Charles Henry, these two artists wished to create a rational definition and a scientific method concerning the optical divisions of colour. It was in that context of theoretical experiments that the Neo-Impressionist movement came about.

Alongside Signac and Seurat, were painters such as Pissarro, Cross and Luce. Their technique was based on pointillism or division of colour: it was applied in small dots and the mix becomes exclusively optical. At the start of the twentieth century, Severini's first paintings were in the Neo-Impressionist manner, before he joined the Futurist movement.

Jean-Baptiste Camille Corot (1796–1875)
Path Leading Towards a House in the Country, 1864

Oil on canvas.
H: 33 cm; W: 41 cm.
Signature lower left: *Corot*.
Written on the frame:
Donné à mon ami Camus le 22 dècembre 1864. C. Corot (Given to my friend Camus on December 22, 1864.
C. Corot).
GR 1.585

History:
Given by Corot to his friend Camus of Arras in 1864; Arras, sale of Camus collection, 1878, bought back by family; Paris, sale of the Patin collection, 1892, no. 9 (*Route de village*); Paris, sale Mme X., December 16, 1916, no. 7; M. Tinet's collection, bequeathed by the latter to his daughter, Mme Villiers; Galerie Hector Brame – Jean Lorenceau, 1971.

Bibliography:
Manuscript documentation of Alfred Robaut, Bibliothèque Nationale, Département des Estampes et de la Photographie, vol. V, fol. 273; A. Robaut, *L'œuvre de Corot. Catalogue raisonné et illustré*, Paris, 1905, vol. II, no. 975.

Jean-Baptiste Camille Corot (Paris, 1796 – Paris, 1875) was encouraged by his masters, the landscape painters Michallon (1796–1822) and Jean-Victor Bertin (1767–1842), to paint nature. It is there that he learned his best lessons. Three trips to Italy marked the evolution of his style. The first and longest (1825–1828) put him in contact, in Rome, with painters from all over Europe. The decisive phase of his training took place in the midst of naturally, harmoniously organized sites. He frequented a circle of artists who scorned historical landscapes but were committed to the creative depiction of light. He painted countless Italian views suffused with the feelings he would remember later, when he executed landscapes during his tireless hikes in the French countryside.

On return from his third trip to Italy in 1843, his art took a new direction against the mainstream. Possibly alarmed by the tendencies of the young forerunners of Impressionism, he became a lyrical landscapist inspired by Claude Lorrain and Watteau's Fêtes Champêtres (Souvenirs de Mortefontaine). His works, for a long time derided, nowadays receive justly merited acclaim. But the great Corot remains the painter of sometimes small landscapes that communicate an inner feeling, and the painter of Figures, often dressed in Arab garb, and for which he has no equal. Because of his immense success he was the painter most imitated by followers and also, unfortunately, by counterfeiters.

In his manuscript notes, A. Robaut added to the title of the picture: *Smallholding at Saint-Lô*. There is no reason to doubt that the location is correct, but the date of 1855 which he gives in the corpus of *L'Œuvre de Corot* must be put back. The artist actually only returned to the Normandy town between 1862 and 1866 for an annual stay, after an absence of twenty-five years. It is therefore correct to date the painting to between 1862 and 1864, the latter year being that of Corot's gift, according to the inscription on the stretcher. The work is very typical of those which Corot painted during this period, in which he imbued these open air landscapes with a foggy atmosphere where the filtering sun brings a pearly luminosity with a success that is still Corot's secret.

This little painting, in spite of the modest nature of its scope, must be related by its handling to Corot's great masterpieces at this time, such as the *Church at Marissel* (1864; Paris, Musée du Louvre), the various landscapes at Mantes, views of the cathedral or of the bridge (Paris, Musée du Louvre; Reims, Musée des Beaux-arts, etc.) and the *Ponds in Ville-d'Avray* from the end of his career. The limited colour scheme, lightness of hand and simplification of the organization supported by the leaning tree seen on the right, bear witness to the special emotion felt by Corot when he painted a rural universe in this often-imitated manner of which he was the originator.

Corot was far removed from the concerns of his friends, the Barbizon School landscape painters, who were devoted to a pantheistic cult and overloaded their paintings in an unrequited metaphysical quest. Far away too are the "trowellings" of a Courbet, the apostle of Realism, building trees like rocks. His aim is not lesser, it is different. Corot, as an onlooker moved by woods, meadows and rustic cottages, was the minstrel of a peaceful nature in which man must find his happiness. His landscapes are usually inhabited. A shepherd, a girl cutting wood, a simple passerby, as in this picture, give a human dimension to his work. In his own words, he was happy to hum a little song, but his work, as his admirers knew, is a "miracle of the heart and spirit".
H. T.

51 Jean-Baptiste Camille Corot (1796–1875)
Algerian Woman

Oil on canvas.
H: 79 cm; W: 60 cm.
Lower left: stamp from the
Corot sale.
GR 1.553

History:
Paris, Corot sale, 1875,
no. 178, bought by Jean
Dollfuss; Paris, sale at Galerie
Georges Petit of the Dollfuss
collection, 1912, no. 11,
bought by antique dealer
Florine Ebstein-Langweil;
given by the latter to her
daughter, Berthe, wife of
painter André Noufflard
(1885–1968); sale Berthe
Noufflard, 1970; sale at
Hector Brame Gallery, 1972.

Exhibitions:
Paris, Salon d'Automne,
Portraits du XIX⁰ siècle, 1912,
no. 61; Paris, Galerie
Rosenberg, *Camille Corot.
Figures et paysages d'Italie*,
1928, no. 42; Paris, Galerie
Hector Brame, *Corot*, 1957,
no. 25; Bern, Kunstmuseum,
Corot, 1960, no. 83; Paris,
Musée Jacquemart-André,
*Chefs-d'œuvre dans les
collections françaises*, 1961,
no. 38; Paris, Musée du
Louvre, *Figures de Corot*,
1962, no. 65; Marseille,
Musée Cantini, *Daumier et
ses amis républicains*, 1979,
no. 98; Paris, Musée du
Grand Palais – Ottawa,
Musum of Art – New York,
Metropolitan Museum of Art,
Rétrospective Camille Corot,
1996.

The *Algerian Woman* is one of Corot's best-known figure paintings. It apparently owes its title only to the North African garment worn by the model. As time went on Corot demonstrated an increasing interest in interpreting the human figure. He used various approaches, and his intentions are often difficult to comprehend. Early on, he was inspired by figures met by chance on his travels, such as the many picturesque Italian figures he brought back from his stays in Rome. He depicted these people in small paintings full of tenderness, which fit into the portrait tradition.

In 1845 he began conveying new feelings inspired by his female models, which he painted nude or dressed in reinvented costumes where Antiquity, the Orient and medieval Italy meet in a curious blend. These seated or standing figures are in pensive or even melancholic poses, endowing them with an abstract, timeless character. The *Algerian Woman*, which was painted during the last decade of Corot's life, is one of the "figures" series' most significant examples. The painter feared painting outdoors, the way he used to do, but he achieved some of his finest works in the studio. They have acquired a monumentality that he had not yet sought.

Many contemporary paintings make it possible to recognize the model who sat for the *Algerian Woman*. They include the *Sibyl* (1870; New York, Metropolitan Museum of Art), *Albanian Woman* (1872; New York, The Brooklyn Museum), *Woman with the Yellow Sleeve* (circa 1872; private collection) and the problematic *Woman with Pearl* at the Louvre. The latter has turned out to be a copy painted by a student of an original which has disappeared (photograph at the Prints Department of the Bibliothèque Nationale). It echoed the *Algerian Woman* owned by the collector Jean Dollfuss, the first individual to have bought a Corot after the artist's death. These works were similarly inspired and are almost the same size. The composition is also the same, with the half-length model standing out against a dark but vibrant background. The faces express the same melancholy. Nevertheless, each of these figures pos-

sesses her own identity. All of them demonstrate Corot's inventive vigour. The artist revitalized his work by varying the presentation and constantly changing the technique.

In this series, the *Algerian Woman* stands out strongly because of its greater modernity, which is made possible by a nimble, allusive stroke and a very particular search for tonality. The artist's concern for modulating values in a very limited range can be perceived. Here, the master of silvery symphonies has pushed the experiment to the point where colour is eliminated, replaced by variations of more or less tinted whites, browns and ochres. His virtuosity shines through in this risky exercise. The painting reflects the desire for dreamlike escape. The choice of an exotic costume, for example, eloquently expresses a yearning for lost happiness symbolized by the evocation of a far-off world. The line is uninterrupted, which is often the case with Corot. The book slipped between the woman's fingers expresses meditation awakened by thought of the other. It is known that the old artist was soothed by reading ancient writers, a feeling which is communicated when his paintings are contemplated.
H. T.

Bibliography:
Manuscript documentation of
Alfred Robaut, Bibliothèque
Nationale, Département
des Estampes et de la
Photographie, vol. XXV,
fol. 44; A. Robaut, *L'œuvre
de Corot. Catalogue raisonné
et illustré*, Paris, 1905, vol.
III, no. 1576; C. Bernheim
de Villers, *Corot peintre de
figures*, Paris, 1930, no. 273;
J. Meier-Graefe, *Corot*,
Munich, 1913, rcpr. p. 96;
D. Baud-Bovy, *Corot*, Geneva,
1957, p. 29; G. Bazin, *Corot*,
3rd ed. Paris, 1973, p. 115;
*André et Berthe Noufflard.
Leur vie, leur peinture, une
évocation par leurs filles et
leurs amis*, Paris, 1982,
p. 272.

Gustave Courbet (1819–1877)
Bacchante

Oil on canvas.
H: 65 cm; W: 81 cm.
GR 1.549

History:
Paris, Alexandre Dumas;
Paris, sale at the Galerie
Georges Petit of Émile
Pacully's collection, May 4,
1903, no. 2 (note saying that,
according to Mme Courbet,
this is a youth work painted
at the time of *Amants dans
la campagne*); Paris, Lair-
Dubreuil, auctioner;
Kneinberger, Henri Hase,
expert, sale for 3,400 francs;
Amsterdam, Mulder's House,
bought by Mme van Pierop,
circa 1915; Amsterdam,
collection of Louis Ph. van
Nierop Fils; New York,
Knoedler; London, Lefevre
Gallery; London, Reid and
Lefebvre, July 3, 1973.

Exhibitions:
Paris, Rond Point de l'Alma,
1867, no. 102; Paris, Ecole
des Beaux-Arts, *Gustave
Courbet*, 1882, no. 31; Paris,
Bibliothèque Nationale, *Un
siècle de vision nouvelle*,
1955, no. 61; London, Alex
Reid & Lefevre, *The 19th and
20th Centuries: French
Paintings*, 1968, no. 8; Tokyo,
Lefevre at Takashimaya,
*Marsterpieces of Modern
French Paintings*, March
1971, no. 2; Tokyo,
Bridgestone Museum of Art,
Gustave Courbet, 1989,
p. 1127, no. 6, repr. p. 50;
Ornans, Musée Gustave
Courbet, *Courbet. L'Amour*,
1996, no. 18, p. 61.

Jean Désiré Gustave Courbet (Ornans, 1819 – La Tour-de-Peilz, 1877) was born into a family of wealthy farmers. His parents sent him to Besançon to study philosophy at the Collège Royal, where he learned the basics of drawing. He decided to settle on art as a career and moved to Paris in 1840. He was a frequent visitor to Steulen's studio before enrolling in the Académie Suisse, where he worked from live models and copied paintings at the Louvre by masters such as Velázquez, Veronese, Zurbarán, Rembrandt, Hals, Géricault and Delacroix. Very early on, Courbet revealed his ability to master various genres, but his early years were especially marked by portraits of the people around him and self-portraits.

A free thinker and a politically committed artist, Courbet was one of the painters who best conveyed the mood of the Second Empire. He became friends with Corot, Daumier, Baudelaire, Proudhon and, later, Boudin, Monet and Whistler. The Burial, which was rejected by the 1850 Salon, triggered a huge scandal and ushered in a long series of quarrels set off by the painter and his work. The public, already offended by his choice of topics, called the realism of his nudes indecent.

Courbet is first and foremost a sensual artist. His paintings' depth and complexity make him one of the greatest poets of the nineteenth century. The years after 1850 were as glorious as they were productive. In 1855, Courbet said he was "in a position to translate the mores and the ideas of my era, according the way I see them, and to be not only a painter but, even more so, a man, to make, in a word, living art. That is my goal".

Hungering after fame, Courbet kept himself in the limelight by creating one sensation after another. However, not too much importance should be accorded to the painter's eccentricities and thundering statements, which make up a considerable part of his legend. Asserting his talent in the face of one and all – the public, the regime and critics – he became an indispensable figure on the Paris scene, a favorite subject for caricaturists, leading his career with an innate sense of public relations. Unfairly accused

of participating in the destruction of the Vendôme column, the Council of War sentenced Courbet to six months' imprisonment and a 500-franc fine after a hateful trial that caused his mother to die of sorrow. Released in March 1872, he returned to his studio to try and recover paintings that had been stolen from him. In 1873, when the earliest symptoms of dropsy were appearing, the trial was reopened and Courbet was sentenced to paying for the rebuilding of the Vendôme column at a cost of 323,000 francs. His property was confiscated.

It is often forgotten that he helped save the Louvre when revolutionaries set the Tuileries on fire during the Paris Commune in 1871. In the end, Courbet's persona got the better of his art. Forced into exile, he left for Switzerland. With his father at his bedside, he died in La Tour-de-Peilz on December 31, 1877. His body was moved to Ornans in 1919.

Courbet was a forerunner of modern art: he painted the way he wanted, without caring about whether anyone liked his work, and was the first artist to work entirely with a knife. He had an unquenchable thirst for freedom. He was fond of saying, "I start where others leave off."

Courbet painted nudes with an unprecedented desire for expression. He treated the subject with realism, which aroused the public's and critics' indignation, giving his paintings a lively tension. This *Bacchante* embodies the grace and voluptuousness that Courbet saw in the female body. The palette exalted all the emotion he felt. Though based on the contrast between green and red in the foreground and sinks into the shadows in the woods in the background, the chromaticism remains warm. Courbet painted swiftly. He enjoyed working the paint with a knife, often transforming pure tones, giving the trees a soft, coppery hue, a languid woman an alabaster body and her legs light shadows. Realistic details such as the earring, the bunch of grapes and the grape leaf recalling the presence of Bacchus punctuate the scene. Light creates and defines each parcel of space, a process which enhances the clearing on

Bibliography:
Ch. Leger, *Courbet et son temps*, Paris, 1948, p. 33, fig. 2; *Les amis de Courbet*, Paris, 1955, no. 16; *The Times*, April 20, 1968; S. Williams, *Antique Weekly*, November 23, 1965, repr.; "The Pick of Courbet", in *Illustrated London News*, December 1968, repr.; *The Studio*, December 1968, repr.; *Art and Antiques Weekly*, March 6, 1971, p. 9, repr.

the right. Painting outdoors one day with Max Claudet, Courbet said about his method of working, "you're surprised that my painting is dark and black; I'm doing the same thing as light, illuminating the high, prominent features". Black expresses depth, the muted life that rises to the surface of the sometimes massive vegetation and rocks. Courbet enjoyed protected, secret places. Here he depicts the forest in Franche-Comté that he loved so much. Like a sacred offering to nature, the diagonal of the woman's body gives the work dynamism. In the letter to his students (July 25, 1861) Courbet wrote, "the beautiful is contained in nature, and meets itself in reality in the widest variety of forms... Like truth, beauty is relative to the time in which one lives and to the individual capable of conceiving it."

The themes closest to the painter's heart – nature and woman – are simple pleasures.
Baudelaire considered Courbet a fanatic of "positive, immediate outdoor nature" and infinite tenderness suffuses this work: the half-closed eyes, the head resting on a cushion of moss, the body offered to the viewer's gaze, the hand letting go of a cup of wine, the beautiful woman who seems to be overcome by slumber and the world of dreams. Women slowly being overcome by sleep is a recurring theme in Courbet's work. The body's abandonment to sleep becomes an ode to freedom. What was sometimes considered indecent in these nudes was none other than the full expression of flesh quivering with sensuality and exhilaration.
F. K.

Oil on canvas.
H: 81 cm; W: 59 cm.
Signed lower left: *Claude Monet*.
GR 1.844

History:
Paris, Daussyl; Paris, Galerie Bernheim-Jeune, 1923; London, Independent Gallery, 1929; Bradford-on-Avon, Great Britain, Esher's collection, 1936; London, Arthur Tooth and Sons, no. 2872; Great Britain, Mr. and Mrs. Clifford Curzon's collection, 1952; London, Christie's, November 29, 1982, no. 7.

Exhibitions:
London, Arthur Tooth and Sons, *Monet*, 1936, no. 24; London, Royal Academy of Arts, *Landscape in French Art*, 1949–1950, no. 231; Edinburgh, Royal Scottish Academy – London, Tate Gallery, *Claude Monet. The Early Years*, August-November 1957, no. 3, pl. 16F; London, Royal Academy of Arts – Tokyo, Sezon Museum of Art – Nagoya, Matsuzakaya Museum of Art, *From Manet to Gauguin. Masterpieces from Swiss Private Collections*, 1995–1996; Vienna, Österreichische Galerie, Schloss Belvedere, *Claude Monet*, 1996; Basel, Kunstmuseum, on permanent loan, 1997–1999.

Bibliography:
D. Wildenstein, *Claude Monet. Biographie et catalogue raisonné*, Lausanne-Paris, 1974, vol. I, p. 142, no. 58, repr.

In 1858 Claude Monet (Paris, 1840 – Giverny, 1926) met Eugène Boudin, who encouraged him and introduced him to outdoor painting. He studied at the Académie Suisse before going back to Le Havre, where he worked with Boudin and Jongkind. Back in Paris in 1862, he enrolled in the Gleyre studio, where he met Bazille, Renoir and Sisley. In 1863 he began painting landscapes of Fontainebleau forest, in the Barbizon school tradition, before going to Normandy. Shortly afterwards, in 1865, the Salon accepted his first painting. During the Franco-Prussian War of 1870, he stayed with Pissarro in London.

He lived in Argenteuil from 1872 to 1878, a period which was marked by the actual birth of Impressionism. In 1874 he helped initiate the group's first exhibition at Nadar's. He was deeply affected by the death of his wife, Camille, and went through a dark period in Vétheuil from 1878 to 1883, when he withdrew to Giverny, where he bought a house in 1890. In the meantime he had painted his great same-subject series, including Haystacks *in 1890 and* Rouen Cathedral *in 1892–1893. Aside from trips to Norway in 1895, Madrid in 1904 and Venice in 1909, he remained in Giverey, where he worked on the* Water Lilies *series until his death.*

In the spring of 1865 Monet moved to the small village of Chailly-en-Bière, located a few kilometers from Barbizon on the edge of Fontainebleau forest. At the time, artists came to the forest in search of a refuge away from civilization. Monet stayed with Father Barbey at the Lion d'Or hotel. As during his first stay in Chailly in 1863, the artist worked outdoors, painting many landscape studies.

The traditional composition of a forest road can be found in the Rau collection work, which dates from Monet's second stay. At the time, he greatly admired the works of Corot, Courbet and Daubigny. The use of greens and browns here shows how much he owed to the Barbizon masters, but the artist demonstrates greater freedom in the overall handling, especially in the way he rendered the foliage with a nimble superimposition of strokes. This work preceded and undoubtedly paved the way for the ambitious *Luncheon on the Grass*, which Monet began painting during the summer of 1865. Monet sought to transfer the same contrasts of light he achieved in studies painted outdoors to the monumental work, but it was through integrating the figure into the landscape that he would attempt to deal with the problem of light and colour in *Luncheon on the Grass*.

He may have been inspired by the preceding generation's depiction of a docile nature, but he nevertheless broke with the spirit of Barbizon. He emptied his work of romantic and moral connotations, focusing his interest on the reality of what he saw. Like Bazille, Pissarro and Sisley at the same time, Monet inherited a great landscape painting tradition. However, the attention he paid to light provided his work with a modern character that foreshadowed the innovations of the 1870s.
Ch. D.

Oil on canvas.
H: 70 cm; W: 100 cm.
Signed lower right:
C. Pissarro.
GR 1.519

History:
Lord Ivor Spencer Churchill's
collection; Paris, Mme
Balsan's collection.

Exhibitions:
Paris, Galerie Manzi-Joyant,
*Camille Pissarro: exposition
rétrospective des œuvres*,
March 1914, p. 29, repr.;
Paris, Musée du Louvre
(Orangerie), *Centenaire de
la naissance de Camille
Pissarro*, February-March
1930, no. 36, repr.; London,
Royal Academy of Arts,
French Art, 4 January –
5 March 1932, no. 422;
Jerusalem, The Israel
Museum – New York, Jewish
Museum, *Camille Pissarro:
Impressionist Innovator*,
October 1994 – July 1995,
no. 27, repr.; London, Royal
Academy of Arts – Tokyo,
Sezon Museum of Art –
Nagoya, Matsuzakaya
Museum of Art, *From Manet
to Gauguin. Masterpieces
from Swiss Private
Collections*, 1995–1996,
no. 41; Basel, Kunstmuseum,
on permanent loan; Tokyo,
Isetan Museum of Art –
Fukuoka, Mitsukoshi
Museum of Art – Mle,
Prefectoral Art Museum –
Yamaguchi, Prefectoral Art
Museum, *Camille Pissarro
and the Pissarro Family*,
1998; Basel, Kunstmuseum,
on permanent loan,
1998–1999.

*Jacob Abraham Camille "Pizarro" (Saint
Thomas, 1830 – Paris, 1903) was born on
the Caribbean island of Saint Thomas, a
Danish dependency where his parents
owned a thriving hardware shop in the port
town of Charlotte-Amélie. At the age of
eleven (1841), he left to study in France. Five
years later he began studying business while
taking up drawing at the same time. In
1855, the year of the Universal Exhibition,
Pissarro moved to Paris, where he discov-
ered Delacroix, Courbet, Daubigny, Ingres
and above all, Corot.*
*He first studied painting in the studio of An-
ton Melbye, then at the Ecole des Beaux-Arts,
and on-and-off at the Académie libre (Rue
Cadet) and the Académie Suisse, where he
met Monet (1859), Cézanne and Guillaumin
(1861). In 1866, he became a frequent vis-
itor to Bazille's studio and met Renoir and
Sisley, painters with the same tastes and
affinities who later formed a group that
came to be known as the Impressionists
(1874). Pissarro was always one of the
movement's catalysing forces. Loyal to the
core, he was the only painter who took part
in every Impressionist exhibition and unre-
servedly supported artists as different from
each other as Degas, Cézanne, Gauguin, van
Gogh and Seurat. Receptive to new ideas
and gifted with a highly flexible mind, his
work developed, his style grew more au-
thoritative and he became something of an
elder statesman. Other artists sought him out
for advice, which he offered with kindness
and simplicity. "He was such a good men-
tor", said Mary Casatt, "that he could have
taught stones to paint."*
*The circle of Paris painters widened and Pis-
sarro frequently saw Manet, Fantin-Latour,
Zacharie Astruc and Emile Zola. When Prus-
sia invaded France in 1870, he left for Lon-
don, where he found Monet, who introduced
him to his future dealer, Durand-Ruel. Dur-
ing that stay, in 1871, he married his long-
time companion Julie Vellay. They were to
have eight children. After the war, Pissar-
ro returned to the environs of Paris, where
he spent the rest of his life, living in Pon-
toise for a long time. Towards the end of his
days he lived in Eragny-sur-Epte.*
Pissarro had an inquisitive mind and was

*always looking for new techniques. From
1885 to 1890, he was an adept of Seurat's
and Signac's Pointillisme, returning to "his
Impressionism" the richer for the experience.
Pissarro had a large family to support and
was beset by financial woes that, however,
affected neither the quality of his work nor
his cheerful personality. Cézanne said that
"Pissarro was humble and colossal, and he
had something like the dear Lord about
him". Despite an eye disorder diagnosed in
1888, he mastered water-colours, drawings,
etchings, oils and lithography equally well.
At the end of his life he was somewhat bet-
ter off financially and travelled to England,
the Netherlands and throughout France, dis-
covering the attraction of cityscapes. His last
series were views of Paris, Rouen and Le
Havre, but interior scenes account for most
of his work.*

The *View of L'Hermitage, Jallais Hill in Pon-
toise* (1867) belongs to a series of large land-
scapes Pissarro painted northeast of Pon-
toise, where he lived from 1866 to 1868. All
of them show the hamlet where the her-
mitage is located, nestled at the foot of a tall
hill named Le Jallais. The scene is viewed
from a high point. The level foreground con-
trasts with the steep hill in the background.
Pissarro emphasized structure, underscored
by the almost geometric roofs painted with
broad, even strokes. Painted directly on the
canvas, this landscape heralded the start of
the artist's pre-Impressionist period, a di-
rection encouraged by Daubigny and Mon-
et. Still under the influence of Corot, Pis-
sarro divided the surface into horizontal
strips and a geometric order.
The art of Cézanne, with whom Pissarro
worked for a while, echoes this type of com-
position. The fields on the hillside are
drawn in such a way as to create a uniform
area that further accentuates the painting's
flatness and authoritatively orders the com-
position. This method of organization un-
derscores a sense of continuity, the even-
ness of the spaces between the elements ac-
centuating the colours and values. This
process provides an optical perception of
volume and space. The brightness prevents
us from making out specific details, while the

Bibliography:
M. Hamel, "Camille Pissarro:
exposition rétrospective
des œuvres", in *Les Arts*,
no. 147, March 1914, p. 26;
L. R. Pissarro and L. Venturi,
*Camille Pissarro, son art, son
œuvre*, Paris, 1939, p. 57,
no. 10; "The Churchill
Collection", in *The Times*,
June 27, 1928, repr.;
J. Rewald, *Pissarro*, Paris, 1939,
no. 14, repr.; "C. Pissarro",
in *Apollo*, November 1992,
p. 287, no. 1, repr.

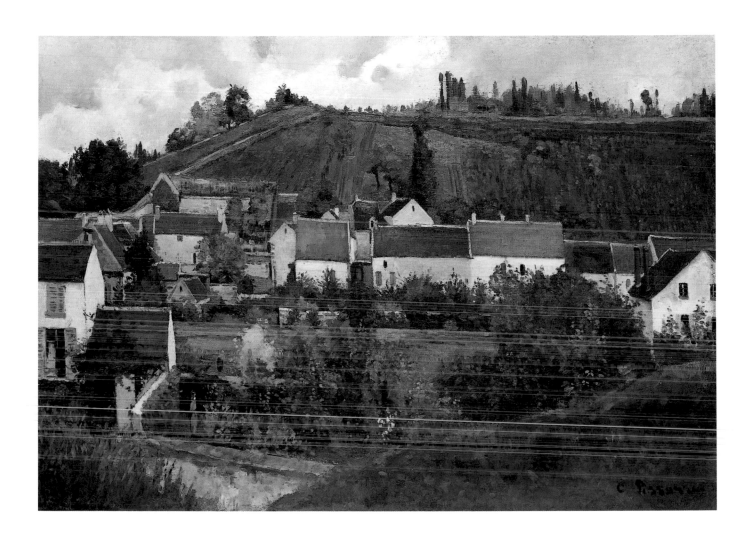

simplified drawing of the characters – their faces are blurred – and the handling of the grass and foliage in the foreground foreshadow the painter's interest in chromatic and optical effects.

At the 1860 Salon, Zola called Pissarro the ideal representative of the "naturalist" landscape. About Le Jallais he wrote, "it is the modern countryside. You sense that man has been there, digging into the soil, cutting it up, saddening the horizon. And this glen, this hill are so simple, so heroically stark. Nothing would be more commonplace if it were not so big. The painter's temperament has created a rare poem of life and force from ordinary truth" (E. Zola, "Mon Salon, III. les naturalistes", in *L'événement illustré*, May 19, 1868). This painting bears witness to Pissarro's mastery of execution and composition, accurate powers of observation and subtle sensibility.
F. K.

68 Camille Pissarro (1830–1903)
The Road from Saint-Germain to Louveciennes, 1870

Oil on canvas.
H: 38.5 cm; W: 46.5 cm.
Signed and dated lower left:
C. Pissarro 1870.
GR 1.626

History:
Henri Rouart, Paris; Paris,
sale at Galerie Manzi-Joyant,
December 9–11, 1912, no.
260; Bremen, Senator
H. Rodawald; New York, Sam
Salz.

Exhibitions:
Paris, Galerie Durand-Ruel,
L'œuvre de Camille Pissarro,
April 7–30, 1904, no. 8; New
York, Wildenstein & Co,
Camille Pissarro, 1965, no. 5;
London, Royal Academy of
Arts – Tokyo, Sezon Museum
of Art – Nagoya, Matsuzakaya
Museum of Art, *From Manet
to Gauguin. Masterpieces
from Swiss Private
Collections*, 1995–1996.

Bibliography:
Th. Duret, *Les peintres
impressionnistes*, H. Floury,
Paris, 1923, repr.;
Ch. Kunstler, *Camille
Pissarro*, Paris, 1930, repr.;
L. R. Pissarro and L. Venturi,
*Camille Pissarro, son art, son
œuvre*, Paris, 1939, no. 74.

In 1869, Camille Pissarro left Pontoise for Louveciennes without giving a genuine reason, but he probably went there to paint with Monet, Sisley and Renoir, all of whom were living nearby and represented a new generation of landscape artists. Pissarro depicted the landscape around Louveciennes, showing the predilection for roads that he had already displayed in previous works (*Road to Louveciennes*, 1870; Paris, Musée d'Orsay; *Coach at Louveciennes*, 1870; Paris, Musée d'Orsay and the *Road from Versailles to Louveciennes*, 1870; Zurich, Bührle Foundation). The *Road from Saint-Germain to Louveciennes* (1870) is part of that series. Seen here just as it leaves the village, the road from Saint-Germain is the continuation of the route from Versailles where the Pissarro family lived. The "straight highway" (as this painting was entitled the first time it was sold in 1912) lined by trees and houses fades into the background, two pedestrians walk behind a canvas-covered wagon and a woman on the right shoulder comes towards the viewer. At the time he painted this work, Pissarro was establishing a pictorial dialogue with Monet and moving towards a new style. He chose smaller formats, a range of ochre, pink, green and blue tones that enhanced his already-bright palette and a freer technique. Pissarro used a palette-knife to make broad, fresh, increasingly supple strokes (for example, the kerbstones in the foreground). Air circulated more lightly and space grew brighter.

Although there was a great amount of affinity between Pissarro and Monet, the two artists had no direct influence on each other's work. Each developed his own style. At the time he painted this picture, Pissarro was fourty (Monet ten years younger) and had already mastered his technique. Although Pissarro and Monet painted the scene from the same point of view (in 1869 and 1870), they achieved very different results. However, both artists were working towards what later came to be known as Impressionism: putting impressions of the landscape on canvas. Perhaps understandably, this was deemed ludicrous and absurd at the time: by definition, impressions are impossible to depict because they belong to the immaterial realm. The practice of open-air painting continued gaining ground and its exponents boldly asserted new techniques. They were emerging their studios armed with tin tubes of colours, which were mass-produced since 1820, and unsized canvases. Material reasons explain the choice of small formats: they were easier to carry.

Shortly after Pissarro painted this work in late September 1870, the Prussian advance compelled the family to flee Louveciennes. Leaving furniture and art works behind, they found refuge with their friend Ludovic Piette in Montfoucault and finally reached London in early December, where they met Monet, who had also gone into exile in England. When Pissarro returned at the end of June 1871, he found a ransacked house. Few of his works from this period survive, the Prussians having destroyed most of them during the war. Soldiers used his paintings to walk across the courtyard without getting their feet wet on rainy days. This work, then, is a rare example of the studies on reflections the artist painted at the time.
F. K.

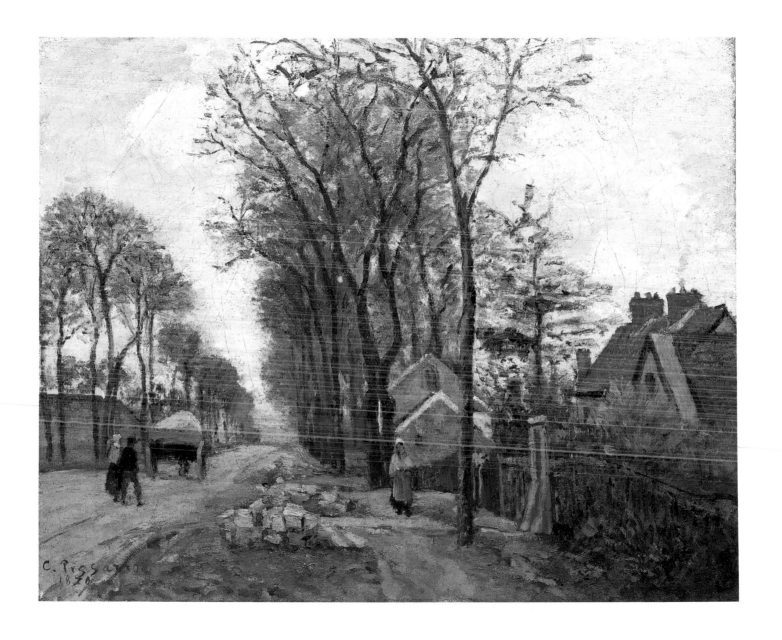

Pastel on brown paper.
H: 72.4 cm; W: 53.4 cm.
Signed lower left: *Mary Cassatt*.
GR 1.949

History:
Bought from the artist by Mrs. d'Alayer de Costermore, April 1899; France, Alayer's collection; London, Sotheby's, December 2, 1986, no. 11, repr.

Exhibitions:
Manchester-Paris, Galerie Durant-Ruel, *Group of French Impressionists*, 1907–1908, no. 44; London, *Marie Cassatt*, 1953, no. 9; Tokyo, Isetan Museum – Hiroshima, Museum of Art – Osaka, Takashimaya Art Gallery, *Les femmes impressionnistes: Morisot, Cassatt, Gonzales*, 1995, no. 47; London, Royal Academy of Arts – Tokyo, Sezon Museum of Art – Nagoya, Matsuzakaya Museum of Art, *From Manet to Gauguin. Masterpieces from Swiss Private Collections*, 1995–1996; Chicago, Art Institute of Chicago – Boston, Museum of Fine Arts – Washington, National Gallery of Art, *Mary Cassatt Retrospective*, 1998–1999.

Mary Cassatt (Pittsburgh, 1844 – Le Mesnil-Théribus, 1926) was born in the United States and settled in France at a young age to pursue her artistic career. After discovering the classical masters in Italy, Spain and Belgium, she frequented Chaplin's studio in Paris. Noticed by Degas, Cassatt soon became acquainted with the Impressionists and joined their circle. In 1879, she took part in the group's fourth exhibition, and displayed her work at the first Impressionist show in New York in 1886. Under the influence of Renoir and Degas, Cassatt became a prominent member of the Impressionist movement, producing many pastels, drawings and engravings featuring intimate subject matter until the end of her life. Aside from her career as an artist, she played a leading role in popularizing French Impressionism in the United States.

Critics have often hailed this pastel depicting a noble image of motherhood as a genuine masterpiece. Women and children play an essential role in Mary Cassatt's work and were her main source of inspiration. The artist sought to grasp the deep-seated feelings that sustained her models as if guided by a profound intuition of motherly love. She composed and recomposed the theme of motherhood, varying the forms and the means of expression.

In this painting, a sturdy woman seated in profile is looking down at her child. The model, who has been identified as Louise Fissier de Fresnaux, posed several times for the artist. She can also be seen in a similar composition in a drypoint engraving where the artist used a more linear technique. Towards the late nineteenth century, Cassatt used pastels increasingly often to depict childhood scenes.

This work, which dates from 1899, displays her outstanding, confident draftsmanship and rich, surprising tones. The bright bodice and the delicate modelling of the light tones, which are heightened by a few discreet black outlines, stand out against the background's mauve nuances. The search for feeling combined with subtle chromatic harmonies make this pastel one of the most representative works by Cassatt, an artist with a strong personality who contributed an original feminine sensibility to Impressionism.
Ch. D.

Bibliography:
C. Mauclair, "Un peintre de l'enfance, Miss Mary Cassatt", in *L'Art décoratif*, vol. VIII, no. 47, August 1902, p. 179, repr.; G. Geffroy, "Femmes artistes, un peintre de l'enfance, Mary Cassatt", in *Les Modes*, vol. IV, February 1904, p. 5, repr.; A. Mellerion, "Mary Cassatt", in *L'Art et les Artistes*, vol. XII, November 1910, p. 70, repr ; A. Segard, *Un peintre des enfants et des mères, Mary Cassatt*, Paris, 1913, p. 68, repr.; *Good Housekeeping Magazine*, vol. LVIII, February 1914, p. 152, repr.; E. Valerio, *Mary Cassatt*, Paris, 1930, p. 9, pl. 12; *La Renaissance*, vol. XIII, February 1930, pp. 55–56, repr.; F. Watson, *Mary Cassatt*, New York, 1932, p. 35, repr.; A. Bresskin, *Mary Cassatt. A Catalogue Raisonné of the Oils, Pastels, Watercolors and Drawings*, Washington, 1970, p. 138, no. 311, repr.

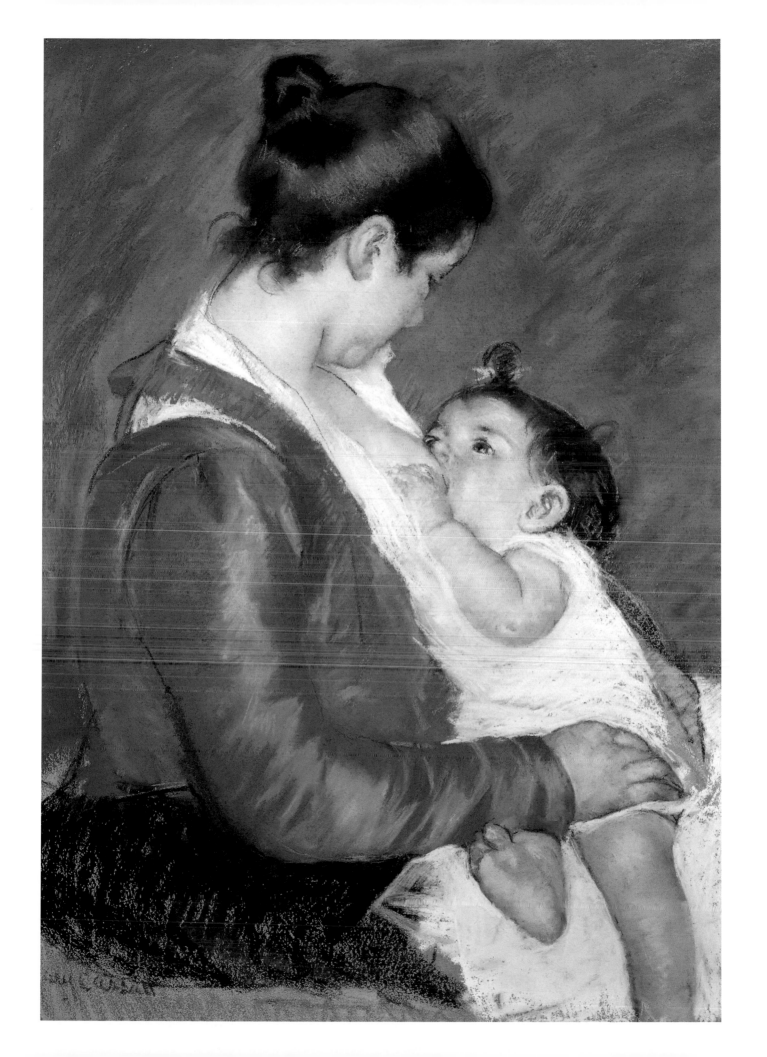

191

Max Liebermann (1847–1935)
Playtime at the Amsterdam Orphanage, 1876

Oil on canvas.
H: 45 cm; W: 72 cm.
Signed and dedicated lower
left: *à Mr. Backer / Souvenir
affectueux / de M. Liebermann.*
GR 1.565

History:
Kept in a private collection in
Breslau until 1945; Cologne,
Galerie Abels, March 22,
1973.

Exhibitions:
Berlin, Nationalgalerie,
Staatliche Museen
Preußischer Kulturbesitz,
*Max Liebermann in seiner
Zeit*; Munich, Haus der Kunst,
1979–1980, no. 27,
pp. 194–195, repr.

Bibliography:
Kunst und Kunst, June 1923,
repr.; W. Rainer, "Die
Tugend der puren Malerei",
in *Stuttgarter Zeitung*,
no. 208, September 8, 1979,
repr.

From 1866 to 1868, Max Liebermann (Berlin, 1847 – Berlin, 1935) studied in the city of his birth under Karl Steffeck, who introduced him to a sober brand of realism. Afterwards, and until 1872, he took classes with Thumann and Pauwels at Weimar's School of Fine Arts. The Goose Pluckers of 1873 was the first in a long series of paintings depicting the labours of farm and factory. In 1872, he met Munkácsy in Dusseldorf. Liebermann lived in Paris from 1873 to 1878, visiting Barbizon where he met Daubigny, Corot and, most importantly, Millet.
He subsequently moved to Munich, where the realism of Jesus Among the Doctors, *painted in 1879, was deemed blasphemous and triggered a public outcry. In 1884, the artist settled permanently in Berlin, becoming a member of the city's academy in 1898. He co-founded the XI group in 1892 and the Berlin Secession in 1898, of which he was president from 1899 to 1911, and the Deutscher Künstlerbund in 1904.*

Max Liebermann spent the summer of 1876 in Haarlem, where he painted copies of works by Frans Hals, before moving into the Amsterdam orphanage for a few months. In his work on the artist (1914, p. 112), E. Hancke writes that Liebermann was so struck by the orphan girls' dresses in black and red, the colours of the city of Amsterdam, that he wanted to use them as a pictorial theme. The city orphanage was located in the old Saint Lucien's cloisters, founded in 1520, rebuilt in 1634, and decorated with paintings by seventeenth-century Dutch masters such as Jacob Backer, Jürgen Ovens and Abraham de Vries. Liebermann obtained permission to set up his atelier inside the orphanage and painted numerous studies, all of a similar nature. The first (formerly in the Bode collection; Hancke, 1914, p. 114, repr.) is now in the Nationalgalerie in Berlin. It is very similar to the Rau collection painting, although slightly larger. The dedication, written in French in the bottom left-hand corner of this picture, takes on a clear meaning only when it is understood that *Mr. Backer* was Jonkheer Jacob Back (Utrecht, 1820 – Amsterdam, 1905), director of the

orphanage from 1855 until his death. Liebermann and Back communicated in French, which was still the international language in artistic circles at the end of the nineteenth century. The chain of events can then be easily reconstructed. The artist first painted the piece now in Berlin. It must have pleased the director of the establishment, and to thank him for his hospitality Liebermann gave him a slightly smaller version in which he put more detail into the young girls' faces, giving the work a more finished look. He painted these two studies in 1876.
In 1881 Liebermann reworked the theme of the young orphan girls in the courtyard, adding some very interesting light effects, in a study now in the Bremen Kunsthalle (*Max Liebermann*, 1979–1980, fig. 327) and a painting sold at Christie's on June 28, 1977 (no. 36, repr.). The composition differs to some extent in that the perspective is shifted to the left. All these innovations culminated in the painting of 1881–1882, now in the Frankfurt Städelsches Kunstinstitut, whose composition and technique are more finished.
Ph. L.

Paul Signac (1863–1935)
The Sea. Saint-Briuc. The Guérin Guard. Saint-Lunaire.
Opus 211, 1890

Oil on canvas.
H: 65 cm; W: 81.5 cm.
Signed and dated lower left:
P. Signac 90.
Inscription, lower right:
Op. 211.
GR 1.520

History:
Paris, given to Arsène
Alexandre; Paris, Georges
Petit's, A. Alexandre's
collection, May 18–19, 1903,
no. 59; Paris, Bernheim-
Jeune; Paris, Marcel Norero;
Paris, Drouot's, M. Norero's
collection, February 14,
1927, no. 91; New York,
J. Stonborough's collection,
1940; New York, Parke
Bernet's, October 17, 1940,
no. 59; New York,
Wildenstein Institute; Zurich,
Marianne Feilchenfeldt.

Exhibitions:
Brussels, Musée de Peinture
(now Musée d'Art Moderne),
Salon du cercle des XX, 1891;
Paris, *Salon de la Société
Nationale des Artistes
Indépendants*, 1891,
no. 1114; Copenhagen,
*Exposition d'art francais du
XIX^e siècle*, 1914, no. 193;
Cologne, Wallraf-Richartz-
Museum – Lausanne,
L'Ermitage, *Pointillismus:
Auf den Spuren von Georges
Seurat*, 1997–1998.

In June 1880, when he was seventeen, Paul Signac (Paris, 1863 – Paris, 1935) visited the La Vie Moderne *exhibition devoted to Claude Monet. That was when he decided to become a painter and adopt the Impressionists' technique. Signac was the oldest son of a wealthy family that did not oppose his wishes. He started working from real life in Montmartre, and soon discovered the pleasures of sailing at Asnières. In 1883 Signac, impassioned by a love of the sea that would remain with him for the rest of his life, purchased the first of the thirty-two boats he would own. It was named after three of the most fiery figures of the time: Manet, Zola, Wagner. His first seascapes at Port-en-Bassin in Brittany, where Seurat had painted before him, date from this period.*
In 1884 he played an active role with Redon, Cross and Angrand in founding the Société des Artistes Indépendants. That was when he met Georges Seurat, with whom he developed the theoretical foundations of Neo-Impressionism.
The year 1885 was marked by two encounters, with Camille Pissarro in April and Claude Monet at Giverny. He would remain friends with Monet for the rest of his life.
Paul Signac was very interested in the theories of Michel Eugène Chevreul, whom he had met at the Société des Indépendants. When Charles Henry (1859–1926) published his Introduction à une esthétique scientifique *in 1886, he was fascinated by the scientist's research on "the rhythms and measurement of lines and colours", becoming a leading advocate of Neo-Impressionism. Seurat, who was working in a similar spirit, completed the same yea,* Sunday Afternoon on the Island of La Grande Jatte *(Chicago, Art Institute of Chicago), which was the concrete expression of these scientific theories and soon became the symbol of nascent Divisionism. Signac would be the link between Camille Pissarro, Georges Seurat and Theo van Rysselberghe and the Symbolist writers Félix Fénéon, Gustav Kahn, Maurice Maeterlinck and Emile Verhaeren. In 1899 he published an account of this period in a book-manifesto entitled* D'Eugène Delacroix au néo-impressionnisme, *whose influence was felt as far as Fauvism and Cubism.*

This large painting belongs to a series of four works painted in Brittany in 1890 and exhibited in 1891 at the Brussels Salon des XX under the title *The Sea*. It was shown with *Opus 209* (United States, private collection), *Opus 210* (New York, private collection) and *Opus 212* (Moscow, Pushkin Museum). Until 1894 Signac gave his paintings the designation *Opus*, demonstrating his essentially Symbolist search for a parallel between the luminous waves of painting and the sound waves of music. The painter was an excellent sailor who identified with the sea and knew it perfectly. His grand-daughter, Françoise Cachin, recalled "that he loved quoting his beloved Stendhal's axiom: Nearness to the sea destroys smallness" (Cachin, 1971, p. 103).
In the Rau collection work he used an even, Pointillist technique consisting of fine, tightly-knit strokes more to accentuate the contrasts of light than the intensity of colour. He defined the painting's composition with the divided strokes, optic mixture and contrast of complementarities that he borrowed from Neo-Impressionism. Sobriety, simplification and the splitting up of strokes appear in his large beaches, contrasting with the blue sea and yellow grass. Signac expresses rhythm more than vision by contrasting these two dominant colours. The sharp observer in him recreated a luminous landscape with calm, harmonious lines evoking "the exquisite goldenness" of his seascapes, as Félix Fénéon described them in 1887. Signac was also intent on expressing the lines' decorative and synthetic values. That is undoubtedly why some people have seen in the Saint-Briac seascapes the influence of japonisme, which was highly esteemed by French artists at the time. Several prints by Hokusai and Hiroshige had been exhibited in Paris the same year.
F. K.

Ignacio Zuloaga y Zabaleta (1870–1945)
Portrait of the Picador "El Coriano", 1897

Oil on canvas.
H: 80 cm; W: 60 cm.
Signed and dated lower left:
*Souvenir à Madame Bulteau /
I. Zuloaga.*
GR 1.945

History:
Given to Mrs. Bulteau by the
artist in 1895; collection of
Maxime Dethomas; bought
from Mrs. Dethomas in 1934
by an anonymous collector;
London, Sotheby's, June 18,
1986, no. 228.

Exhibition:
Madrid, *Exposición National
de Bellas Artes*, 1897,
no. 1165.

Bibliography:
A. Alexandre, "M. Ignacio
Zuloaga", in *Le Figaro
illustré*, April 15, 1903, p. 7;
J. M. de Cossío, *Los toros.
Tratado técnico e histórico*,
1947, vol. II, p. 895, repr.
p. 986; E. Lafuente Ferrari,
Ignacio Zuloaga, San
Sebastian, 1950, pp. 44, 181,
217, 218, nos. 64 and 70
(no. 10 of the "livre de
raison" of the artist);
re-ed. Barcelona, 1972,
1990, pp. 75, 76, 245, 492,
nos. 64, 70.

*Ignacio Zuloaga y Zabaleta (Eibar, 1870 –
Madrid, 1945) was born into a family of
renowned Basque country goldsmiths and
gunsmiths. He was attracted to painting and
in 1887 discovered the Spanish masters of
the Golden Age at the Prado. They had a
definitive impact on his painting. At the age
of twenty, he went to Paris, frequented the
studio of Gervex, who introduced him to the
work of Courbet and Manet, and became a
friend of avant-garde artists such as Degas,
Gauguin and Rodin. He lived in Spain as
much as in France, but it was in Paris that
his portraits and paintings, inspired by
everyday Andalusian life, were successful
during the early years of the twentieth cen-
tury. Exhibitions in Dusseldorf (1904) and
New York (1909) crowned a reputation that
had become international. His portraits
would soon make him rich. In 1914, he per-
manently settled in the twelfth-century
monastery at Zumaya (today the Zuloaga
Museum), where he was the curator of ma-
jor art collections. He died in Madrid in 1945
at the height of his fame.*

What a wonderful rediscovery *Portrait of the
Picador "El Coriano"* is. It was one of Zu-
loaga's earliest successes, but his biogra-
phers thought it lost. Antonio González "El
Coriano", undoubtedly born in Coria del
Rio, was a rather mediocre picador. He
worked mostly with his brother, the some-
what successful torero Francisco González
"Faico" (de Cossío, 1943, vol. III, p. 390).
The young artist painted this work in 1897,
at the height of his Andalusian period. The
ostensibly dedicated portrait is irrefutable
proof of the role played by Madame Bul-
teau in the Basque artist's Paris success. Un-
published documents have enabled Mayi
Milhou (*Ignacio Zuloaga et la France*, 1981,
pp. 51, 81–83) to establish that the
Spaniard had links with Maxime De-
thomas, whom he met at Gervex's studio,
very early in his career. The young French
painter introduced Zuloaga to Paris artis-
tic circles and helped him successfully ex-
hibit six *espagnolades* in 1895 at Le Barc
de Bouteville's. In 1899, Ignacio married
Maxime's sister, Valentine Dethomas. This
event strengthened the friendship be-

tween the two artists, which made it pos-
sible for Zuloaga to enter the highly
renowned salon of Augustine Bulteau,
wife of novelist Jules Ricard. Later, he
would often see his famous models there,
Maurice Barrès and the Countess of
Noailles.
Madame Bulteau was a cultivated, generous
woman who had a real influence on
Parisian newspapers, especially *Le Figaro*,
which in 1903 helped launch Zuloaga's ca-
reer by devoting a special issue to him.
Maxime Dethomas, whom Madame Bulteau
considered her "dear child", inherited the
Portrait of the Picador "El Coriano".
In spite of a few flattering articles in the
press, Zuloaga never managed to make a
living as a painter in Paris. He discovered
Andalusia in 1892, staying a long time in
Seville where he had many jobs and en-
rolled in Manuel Carmona's bullfighting
school. He practised this sport for four
years and developed a passion for it. He re-
mained an *aficionado* throughout his life,
became a friend of the greatest matadors
and painted unforgettable portraits of
them (*El Corcito, Belmonte, Domingo Orte-
ga*). Rustic and down-to-earth Andalusian
life, and encounters with gypsies, bull-
fighters, manolas, poets and farmers pro-
vided his powerful personality with typical
subjects. He handled them with a broad,
very colourful style inherited from the
Spanish pictorial tradition of El Greco,
Velázquez and Goya, but combined with the
"modern" vision of nineteenth-century re-
alist painters.
El Coriano is a simple half-length figure on
a neutral background. It fixes the image of
the picador, whose bitter mouth and
fierce, sunburned features are painted with
a remorseless, brisk stroke. The thick paint
is spread on in large flat areas. The colour
range is reduced to silvery greys and beige-
ochre monochromes livened up by the in-
tense pink of the embroidered bolero. It is
a trademark of this artist, who said that his
only teachers were "nature and museums".
O. D.

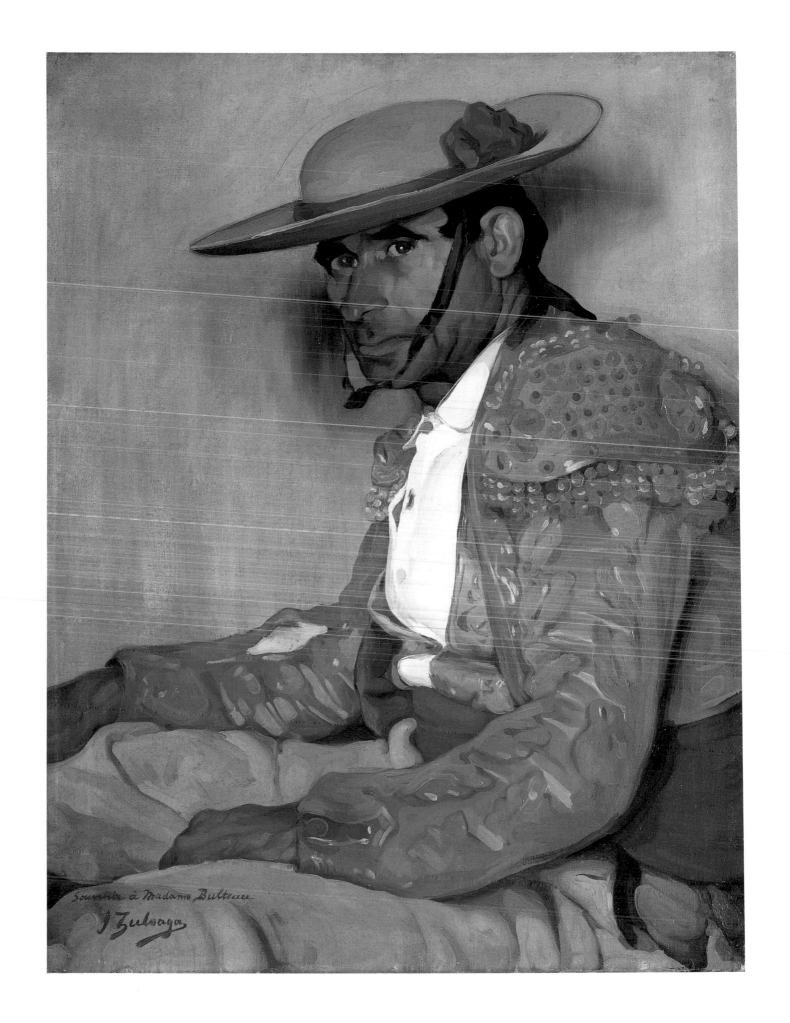

Souvenir à Madame Bulteau
I Zuloaga

83 Odilon Redon (1840–1916)
Apollo's Chariot

Oil on canvas.
H: 60 cm; W: 73 cm.
Signed lower right: *Odilon Redon.*
GR 1.663

History:
New York, Adelaide Milton de Groot; New York, Metropolitan Museum of Art; New York, sale at Sotheby's of the Parke-Bernet collection, October 25, 1972, lot 9, repr.; Japan, Pola's collection, circa 1973; London, Sotheby's, December 5, 1979, no. 25, repr.

Exhibition:
Kamakura, Prefectural Museum of Modern Art – Nagoya, Aichi Art Gallery, *Odilon Redon*, 1973, no. 16.

Bibliography:
K. Berger, *Odilon Redon, Phantasie und Farbe*, Cologne, 1964, p. 193, no. 156; *World Collectors Annuary*, 1972, vol. XXIV; J.-J. Lévêque, *Les Années de la Belle Epoque, 1890–1914*, Paris, 1991, repr. p. 570; A. Wildenstein, *Odilon Redon: catalogue raisonné de l'œuvre*, Paris, 1994, vol. II, p. 60, no. 868, repr.

In this work, Odilon Redon painted a patch of sky set ablaze by Apollo and his quadriga. The course of the Sun is drawing to a close: its couriers are coming back down to Earth. At the end of his life, Redon was passionate about the theme of Apollo, painting ten works on the subject between 1905 and 1914. Delacroix's ceiling in the Louvre's Apollo gallery was probably the source of his interest. "It is the triumph of light over darkness," he wrote. "It is the joy of broad daylight opposed to the bleakness of the night and its shadows, and like the joy of a happier sentiment that comes after anguish" (O. Redon, *A soi-même. Journal (1867–1915)*, Paris, 1961, p. 175). The emotion he felt before *Phaeton's Fall*, a watercolour by Gustave Moreau which he saw at the 1878 World's Fair, probably also fuelled his passion for the myth of Apollo. Describing the work, he wrote, "There is a grandeur, an excitement and, in a way, a fresh astonishment in the brightness of these billowy clouds, in the bold divergence of the lines, in the harshness and mordancy of the vivid colours."

Did Redon use some of the figures he admired in the preceding works? The Sun god and his chariot seem to be made of an incandescent material. The clouds around them take on all sorts of warm tones, from red-ochre to mauve. They exalt the turquoise blue that dominates the canvas. The god's passage cleaves the clouds into a V-shape, opening them up as his fiery mount streaks through. The play of shadow and light delicately models the horses, and a brown outline traces their contours. The air around them is still light before the Sun's passage. The thin, yellow clouds let the turquoise blue show through where it does not emerge. Following in his forerunners' footsteps, Redon gave the sky a bright colour that fills the viewer with joy.

In his other works, Apollo's chariot has not yet begun its descent; sometimes the artist chose to surround it with nothing but sky (New York, Metropolitan Museum of Art). The ether radiates peace and tranquillity, contrasting with the divine quadriga's speed.

In these paintings, including the one in the Rau collection, Redon still treated the sky in a realistic manner. In fact, he enjoyed painting studies of the sky from the motif. The ones he did in Peyrelebade, his family home in the Landes, are in the Musée d'Orsay, Paris. In other works, especially pastels, the sky takes on fantastic tones, and the compositions are filled with Python's corpse, a tall mountain or butterflies and flowers (Paris, Musée d'Orsay; Bordeaux, Musée des Beaux-Arts). In the early twentieth century, Redon revitalized mythological scenes with a breath of fresh air.
F. de V.

208

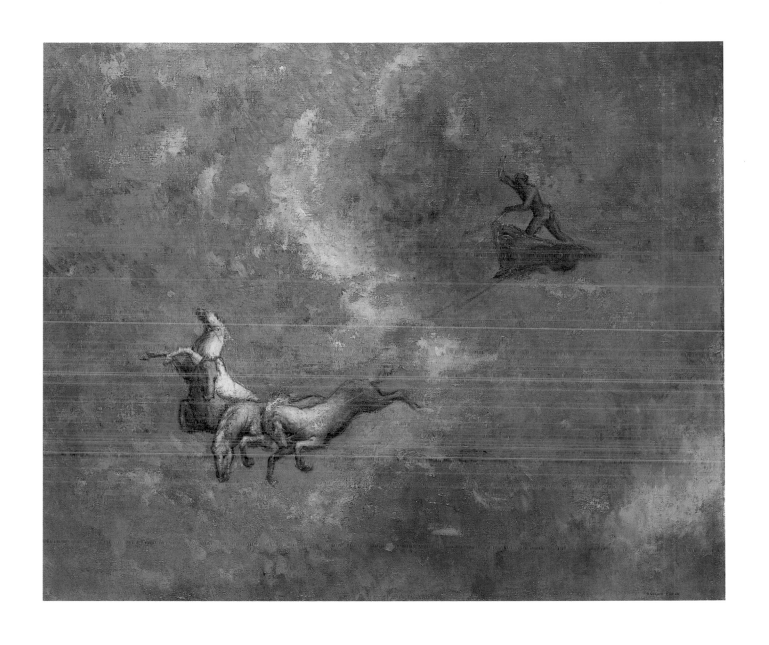

Ferdinand Hodler (1853–1918)
Portrait of a Lady, 1884–1890

Oil on canvas.
H: 55 cm; W: 46 cm.
GR 1.2

History:
Collection of the painter's
daughter and heiress,
Paulette Marquerat-Hodler;
Bern, sale Kornfeld and
Klipstein, June 20, 1973,
no. 335, repr.

Between 1867 and 1870 Ferdinand Hodler (Bern, 1853 – Geneva, 1918) trained under Ferdinand Sommer (1812–1901), the painter of Swiss views. In 1872 he went to Geneva, where he studied under Barthélémy Menn (1815–1893), a student of Ingres and professor at the School of Fine Arts. In 1877 he went to Paris and in 1878–1879, Madrid. From 1890 he was recognized as the master of mural painting with the execution of major monumental commissions including the famous Retreat from Marignan *for the Swiss Kunsthaus in Zurich. Invited to exhibit in 1903 by the Vienna Secession, he received international recognition. Hodler was adopted by Germany, which did not keep him from taking a stand against his host country following the bombardment of Rheims cathedral in 1914. As a result he was excluded from all the German academies.*

Dr Huggler has dated this picture, whose sitter has not been identified, to around 1905, which is not appropriate for stylistic reasons. The *Portrait of a Lady* should be placed at the beginning of the artist's career, when he was painting portraits in a style that was, if not traditional, at least hardly innovative.
In a *Portrait of Berthe Jacques* (Küsnacht, private collection), painted in 1898, Hodler used a very pronounced line and visible brushwork, which demonstrate a more advanced stylistic effort. In the years after 1904 he painted mostly portraits of Valentine Godé-Darel, employing from then on a more modern technique, made up of small dashes of colour. On the other hand, in 1884 Hodler had done a drawing of a melancholy sitter, the *Beautiful Augustine in Thought* (Bern, Kunstmuseum; *Ferdinand Hodler (1853–1918)*, 1983, no. 11), similar to the *Portrait of a Lady*. Moreover, the smiling young woman in the Rau collection painting could well be this same Augustine Dupin whom Hodler met in 1884 and who was his companion until 1908, when he met Valentine Godé-Darel. Augustine died the next year, and Hodler, moved by her suffering, painted her on her death-bed.
He did a portrait of Augustine (Zurich, Kunsthaus; *Ferdinand Hodler (1853–1918)*, 1983, no. 23) in 1887 which shows the massive, thick-featured face of a woman who is much older than the woman in the 1884 drawing and a long way from the *Portrait of a Lady*. Did she change so suddenly or is the sitter for the Rau painting a different woman? In this case, the casual clothing and largely decolleté, open blouse suggests it was a close friend. In any case the portrait must have been painted during the years 1884–1890.
These identification and dating problems in no way detract from the work's outstanding quality. A lack of ornamentation characterizes this portrait, which is painted exclusively in brown tones. It expresses the unity which Hodler spent his entire life trying to capture. The artist focused all his attention on the face, extraordinary in its sweetness, liveliness and spontaneity, which enhances the almost uniform background.
Ph. L.

Edouard Vuillard (1868–1940)
The Chestnut Trees, Rue Truffaut, circa 1900

Oil on cardboard.
H: 42 cm; W: 36 cm.
Signed lower left: *E. Vuillard*.
GR 1.128

History:
Studio; Paris, Georges
Maratier; Zurich,
Mrs. Marianne Feilchenfeldt.

Exhibitions:
London, Malborough Fine
Art, *Roussel, Bonnard,
Vuillard*, May 5 – June
12, 1954, no. 64; Zurich,
Kunsthaus, *Vuillard:
Gemälde, Pastelle, Aquarelle,
Zeichnungen, Druckgraphik*,
September 17 – October 25,
1964, no. 148.

Bibliography:
A. Salomon, *Edouard
Vuillard. Catalogue raisonné
de l'œuvre peint*, being
prepared.

In March 1899, Vuillard and his mother moved into 28 Rue Truffaut in the seventeenth arrondissement in Paris, where they would live until 1904. The painter extended his subject range by exploring his immediate surroundings. He used an atmospheric pictorial style, drawing some of his inspiration from urban landscapes, especially for his views of public gardens, a theme he would develop in a series of decorative panels commissioned in 1894 by the Natansons. The view from his Rue Truffaut studio does not have the same monumental character, but is a sketch of an everyday landscape.

The Rau collection painting is categorized among the series of Paris views, but its small size appears more like an originally designed landscape. The site is seen slightly from above, and the trees stand out against the building's facade. Relief is abolished. The foreground's void is the only thing that introduces a bit of depth into the composition. This method of handling space brings to mind some of the Nabis' works, where the influence of Japanese prints was essential. Vuillard sought deep, unexpected effects to recreate the site's atmosphere. The light on the facade in the background contrasts with the subdued tones of the green masses. The use of a multitude of greens of varying densities and shapes creates a harmony into which the cardboard's neutral background is perfectly integrated. The artist's preference for this material takes on special interest here. The oil paint he used on the unprepared surface makes infinite variations in the values' nuances and modulations possible. He obtained a dull, flat look that is close to glue painting and closely bonds with the cardboard. It gives the works tones a "surprising subdued resonance" (Chastel, 1946).

This work was painted around 1900, a turning point when Vuillard was moving towards new pictorial experiments. Its simplicity and decorative character make it clearly similar to great compositions such as the *First Fruits* (Pasadena, The Norton Simon Foundation), which was painted for Thadée Natanson in 1899. Furthermore, the flowering chestnut tree motif can be found several times in his major decorative works, such as the public gardens series and the 1895 stained glass project, but with a clear desire to stylize forms.

However, the freedom of execution shown here by Vuillard recalls how comfortable he felt in his everyday world. As in his indoor scenes, he penetrates the intimacy of a silent place.

Ch. D.

Edouard Vuillard (1868–1940)
Self-portrait, 1906

Oil on panel.
H: 41 cm; W: 32.5 cm.
Signed in red, lower right:
E. Vuillard.
GR 1.1021

History:
Artist's collection; New York,
Sam Salz; New York, Donald
S. and Jean Stralem.

Exhibitions:
Richmond, Virginia Museum
of Fine Arts, *Paintings by the
Impressionists and Post-
Impressionists*, 1950; New
York, MoMA – Cleveland
Museum of Art, *Edouard
Vuillard*, 1954, p. 103;
Minneapolis Institute of Arts,
The Nabis and Their Circle,
1962; New York, Wildenstein
& Co, Inc, *Vuillard*, 1964,
no. 32; Houston, Sakowitz,
Festival of the Arts, 1965,
no. 57; New York, Parke-
Bernet Galleries, *Art Treasures
Exhibition*, 1967; Philadelphia,
The Pennsylvania State
University, College of Arts
and Architecture, *Edouard
Vuillard 1868–1940.
Centennial Exhibition*, 1968,
no. 21; Toronto, Art Gallery
of Ontario – San Francisco,
Palace of the Legion of Honor
– Chicago, Art Institute of
Chicago, *Edouard Vuillard
1868–1940*, 1971–1972,
no. 57, repr. p. 231; New
York, Metropolitan Museum
of Art, 1990; Lyon, Musée
des Beaux-Arts – Barcelona,
Fundació Caixa de Pensions –
Nantes, Musée des Beaux-
Arts, *Edouard Vuillard*,
1990–1991, p. 14, no. 101.

Bibliography:
Life Magazine, vol. XXXVII,
no. 18, November 1, 1954,
p. 74, repr.; S. Preston,
Edouard Vuillard, New York,
1971, p. 120, repr. p. 121;
A. Dumas and G. Cogeval,
Vuillard, Paris, 1990,
no. 101, p. 221, repr. p. 14.

During the last twenty years of his life, Vuil-
lard was beset by dissatisfaction, doubt and
disappointment. In the portraits, which ac-
counted for a major share of his work dur-
ing this period, he set new challenges for
himself. He became the most highly
sought-after portrait painter of the upper
bourgeoisie, keeping pace with a relentless
flow of commissions. Vuillard depicted the
model as well as his or her environment,
giving as much importance to the back-
ground as to the figure. The search for a
certain kind of truth was crucial to him, and
he believed that the surrounding space re-
vealed as much about the sitter as anything
else. "I don't do portraits; I paint people
in their homes," he was fond of saying.
This *Self-portrait* depicts Vuillard at home
in his studio, where he lived surrounded by
many memories. Seated in a red velvet arm-
chair, the liveliness of his penetrating, in-
tense gaze is underscored by the warm,
voluptuous chromatic palette of ochre, red
and saffron tones. Here, the purpose of the
self-portrait is not to show off the individ-
ual or his ego. On the contrary, the figure
is discreet and self-effacing. It is therefore
obvious that the topic is painting and its ef-
fects. Vuillard painted another self-portrait
in 1912 (Zurich, Bührle Foundation). The
composition is similar but the cold green
chromatic scheme is completely different.
The precisely-drawn face reveals a smooth
pate – the painter was practically bald by
the time he was thirty-five – and a bright
red beard that earned him the nickname
"Zouave". The window behind him lets in
sunlight that illuminates his forehead, while

on the right-hand side the juxtaposed
brushstrokes do not reveal the exact out-
lines of the room's features. This part of
the painting, which is almost non-figura-
tive, may be an allusion to the artist's as-
sociation with the Nabis, who sometimes
pushed painting to the limits of abstraction.
Despite the subject's nearness, there is a
strong sense of depth and volume.
Vuillard developed a new conception of
space, light and colour, and the work ra-
diates a sense of calm and mystery. He did
not paint portraits across from the model,
but worked from memory. This *Self-portrait*
is probably no exception. The most im-
portant thing was to reconstitute a mem-
ory, a timeless perception where past and
present merge.
A patient, observant artist, Vuillard thought
long and hard about his works in the silence
of his studio before actually painting
them. They depict "the ordinary and mo-
tionless existence of inner life" that
Maeterlinck spoke about. Vuillard was part
of a long European portrait tradition dat-
ing back to the seventeenth and eighteenth
centuries, and his admiration for self-por-
traits by Rembrandt and seventeenth-cen-
tury Dutch painters is well-known. Those
masters were continuously reflecting upon
their art, and Vuillard was probably con-
sciously following their example. Driven by
the desire to express all of his visual sen-
sations, Vuillard perfectly illustrated a com-
ment by his friend Mallarmé, who said, "I
have never proceeded by anything but al-
lusions."
F. K.

Edouard Vuillard (1868–1940)
Portrait of Monsieur André Bénac, 1936

Tempera on canvas.
H: 129.5 cm; W: 152.2 cm.
Signed and dated lower left:
E. Vuillard 1936.
GR 1.601

History:
Paris, Andre Bénac; Paris,
Mrs. Candrelier-Bénac; Paris,
Jacques Candrelier-Bénac;
London, Christie's, July 3,
1979, no. 61.

Exhibitions:
Paris, Musée des Arts
Décoratifs, *E. Vuillard,*
May–July 1938, no. 212;
Geneva, Palexpo, *La
Fondation pour l'écrit. Salon
international du livre et de la
presse. Le livre et la presse
dans la peinture,* 1996;
Florence, Palazzo Corsini,
*Bonnard, Vuillard, Denis,
Vallotton... I Nabis alle
origini dell'arte moderna,*
1998; Montreal, Musee des
Beaux-Arts, *Le temps des
Nabis,* 1998.

Bibliography:
W. George, "Vuillard et l'âge
heureux", in *L'Art vivant,*
no. 221, May 1938, p. 27,
repr.; B. Dorival, *Les étapes
de la peinture française
contemporaine,* Paris, 1943,
vol. II, p. 167; J. Salomon,
Vuillard, témoignage, Paris,
1945, p. 122; C. Roger-Marx,
Vuillard et son temps, Paris,
1945, pp. 107–108; C. Roger-
Marx, "Vuillard, peintre de la
vieillesse", in *L'Amour de
l'art,* no. 6, November 1945,
p. 152; C. Roger-Marx,
Vuillard, Paris, 1948, p. 20;
J. Salomon, *Vuillard admiré,*
Paris, 1961, p. 182, repr.; A.
Salomon, *Edouard Vuillard.
Catalogue raisonné de
l'œuvre peint,* being
prepared.

In 1915, Vuillard started painting large portraits as commissions for the Paris high bourgeoisie. All of these late works, which are characterized by a painstaking realism, were often harshly judged in relation to his earlier paintings. The 1936 *Portrait of Monsieur André Bénac* illustrates what C. Roger-Marx called the "social nightmare", offering a reassuring view of an unadventurous society.

Mr. Bénac, a former member of the Council of State, an officer in the Legion of Honor, had himself immortalized in the familiar world of his office. Pointing out the seventy-eight year-old figure's friendly good-naturedness, C. Roger-Marx wrote, "There is goodness, clear-sightedness and something rather touching in those blinking little eyes, in those jowls, in the fat hand gently laid on the edge of the desk" (1945, pp. 107–108).

Vuillard was fond of portraying his models in their everyday setting. "I don't do portraits, I paint people in their homes," he told Maurice Denis in 1876, in keeping with the theories Duranty espoused in his manifesto, *La Nouvelle Peinture* in 1876. The over-abundant details and realistic depiction of the crowd of objects cluttering the desk in the foreground are striking. Eyeglasses, pens, an inkwell, magnifying glass, calender, telephone are randomly juxtaposed and, in a humorous touch, a popular comic book appears in this punctilious inventory of objects. The figure is set back in the middleground, integrated into his setting. In a different version of the portrait, the artist has tightened the frame around the model, eliminating all the picturesque details that distract the eye. He likewise dispensed with the window in order to obtain a closed space and focus attention on the elderly gentleman (London, sale at Sotheby's, April 7, 1976).

As usual, in the Rau collection painting Vuillard demonstrates great skill in structuring space by using a traditional perspective featuring several planes. An inventive opening to the outside allows a gentle winter light to bathe the entire room. "Here light illuminates the smallest details of the clothes, the slightest elements of a still life where purple abounds," adds C. Roger-Marx (1945, p. 107). The painter uses subtle reflections on the table, magnifying glass and richly carved Renaissance cabinet, juxtaposed with a myriad of colour touches. The glue paint technique, which was one of the artist's favourites, catches the light and confers the maturity of a fresco on his work.

Vuillard was attached to traditional concerns such as an interest in detail. He painted a completely classical work which has sometimes been labelled academic. This return to classicism illustrates the cultural context between the wars, which was characterized by a revival of order and the desire for formal stability. In 1938, the painting was among a splendid group of commissioned portraits presented at the Musée des Arts Décoratifs retrospective, which revealed Vuillard's late style.

C. Roger-Marx wondered about the value of this last period. He made a remarkable judgement that today has taken on its full meaning: "Instead of condemning such a body of work as a whole, it must be realized that with time the fuss will die down and the unity be redone" (1945, p. 108).
Ch. D.

Maurice Denis (1870–1943)
July, 1892

Oil on canvas.
H: 38 cm; W: 61 cm.
Signed and dated lower right:
MAVD 92.
GR 1.599

History:
Sold by the artist to
Ambroise Vollard, 1892;
Dr Ducroquet's collection;
London, Christie's,
November 28, 1972, no. 116.

Exhibitions:
Paris, Indépendants, 1892;
Paris, Orangerie, *Maurice
Denis*, 1970, no. 45; Lyon,
Musée des Beaux-Arts –
Cologne, Wallraf-Richartz-
Museum – Liverpool, Walker
Art Gallery – Amsterdam,
Rijksmuseum Vincent van
Gogh, *Maurice Denis*,
1994–1995, no. 33;
Lausanne, Musée Cantonal
des Beaux-Arts, *De Vallotton
à Dubuffet: une collection en
mouvement*, 1996–1997;
Florence, Palazzo Corsini,
*Bonnard, Vuillard, Denis,
Vallotton... I Nabis alle
origini dell'arte moderna*,
1998; Montreal, Musée des
Beaux-Arts, *Le temps des
Nabis*, 1998.

Bibliography:
G. Cogeval, "Le sacre du
quotidien", in *Connaissance
des arts*, October 1994, p. 95.

*In 1888, Maurice Denis (Granville, 1870 –
Paris, 1943) entered the Académie Julian,
where he met Bonnard, Vuillard and Sérusi-
er. The following year they formed the Nabi
group. The "Nabi aux belles icônes" soon be-
came the movement's theoretician. In 1890,
he published the group's first manifesto. In
1893, he married Marthe Meunier, who was
to become omnipresent in his work. Denis
travelled several times to Italy, where he dis-
covered the Italian primitives. He was a
mystical artist who attempted to revive re-
ligious painting. In 1919, he founded the
Ateliers d'Art Sacré with Georges Desval-
lières. He devoted a large share of his work
to decoration, but was also a highly talent-
ed illustrator and a prolific author.*

July was exhibited at the 1892 Salon des
Indépendants with *April*, *September* and *Oc-
tober* under the title *Four Panels for the
Decoration of a Young Girl's Bedroom*. The
four paintings were designed as a cycle of
the seasons in which *July* represents sum-
mer but winter is absent. In 1893, Gustave
Geffroy described the group as "delicate
gaiety, slow dances, obsessional gestures,
frail hands picking flowers, pale dresses,
a dark park, the pink countryside" (*La Vie
Artistique*, 2nd series, 1893, p. 372).
Maurice Denis gradually turned towards a
new aesthetic. Abandoning Pointillism, the
painter depicted female silhouettes in a
purely imaginary ornamental landscape,
where the vegetation forms wide bands of
colour. As in *April*, to which the Rau col-
lection painting seems to correspond,
picking flowers is a pretext for a repetition
of supple arabesques, such as the silhou-
ette bending over near the tree that, like
an emblematic figure, illustrated a poem
by Verlaine ("Ecoutez la chanson bien
douce") in *Sagesse* and reappears in an
1894 cartoon for a stained-glass window,
Women at the Creek (Saint-Germain-en-
Laye, Musée Départemental du Prieuré).
The work contains a few Japanese-inspired
details, such as the sinuous elements de-
rived from engravings by Harunobu and
Utamaro and the centering on the tree,
which is used as a repoussoir in a compo-
sition with an approximate perspective.
Denis abandoned traditional iconography
for more personal symbols and principals.
In 1892, he began making use of themes
based on Symbolist and Medieval epic po-
etry. In *July*, he introduced the image of a
woman in a paradisiacal garden where pale,
nuanced tones underscore a dreamlike at-
mosphere. Although *July* was clearly an at-
tack on the Nabis' principles, Denis had al-
ready developed a very personal style. The
decorative cycle is part of a long pictorial
tradition, but for Jean-Paul Bouillon the
modernity of a work like *July* heralded,
"with a similar sensibility", *Composition II*
and the *Joy of Living* by Matisse.
Ch. D.

Maurice de Vlaminck (1876–1958)
Fauve Landscape near Chatou, 1907

Oil on canvas.
H: 50 cm; W: 65 cm.
Signed in black paint, lower
left: *Vlaminck*.
CR 1.35

History:
Basel, Ernst Beyeler, 1968.

Exhibitions:
Basel, Galerie Beyeler,
Présence des maîtres, June-
September 1967, no. 53,
repr. fig. 53; Ingelheim
am Rhein, Altes Rathaus,
*Die Explosion der Farbe,
Fauvismus und Expressionismus
1905–1911*, 1998.

Since 1900, Maurice de Vlaminck (Paris, 1876 – Paris, 1958) and André Derain had been sharing a studio in Chatou. In his own way, each of them contributed to Fauvism's full blossoming in Paris. "Each one plants his easel," Vlaminck said, "Derain facing Chatou, the bridge, the bell tower, the motif; me further away, attracted by the poplars. Of course, I finished first. I look at Derain's work. Solid, intelligent, powerful, already Derain. 'What about you?,' he says to me. My canvas pivots at the end of my arm, Derain looks, remains silent for a moment, nods his head and finally utters: 'It's beautiful." "That was the beginning of the entire Fauvist movement", asserted de Vlaminck, who continued, "What is fauvism? It's me [...] my way of rebelling and freeing myself at the same time, of refusing the school and indoctrination. My blues, my reds, my yellows, my pure colours without mixing tones. I undoubtedly contaminated Derain a little" (quoted by J. Leymarie, Le Fauvisme, Geneva, 1987, p. 29). De Vlaminck had discovered van Gogh's work when he saw a retrospective exhibition of the artist's work at the Galerie Bernheim-Jeune in Paris during the spring of 1901. He was impressed by the unusual technique, and started furiously spreading his paints on the canvas, casting aside the line of the drawing. Painting became his "release": I was a tender, violent barbarian. I instinctively conveyed, without method, a truth that was not artistic, but human" (ibid., p. 36).

This *Fauve Landscape near Chatou* fits in with a series of landscapes painted in the Ile-de-France, such as the *Gardens at Chatou* of 1904 (Chicago, Art Institute of Chicago), *Banks of the Seine at Chatou* of 1904–1905 (Musée d'Art Moderne de la Ville de Paris) and *View of Chatou* of 1906 (Tel Aviv Museum). It was done on the banks of the Seine near Chatou about 1907. The artist mainly used the three primary colours, red, yellow and blue. The paste is thick, and the wide, fat strokes heighten the contrasts. De Vlaminck squashed the tube directly onto the canvas, spreading the pigments on with a knife.

A dual treatment emerges from this painting. On the one hand, the colour could be independent of the motif, as the trees in the foreground on the right demonstrate. With this arrangement the artist asserted a personal pictorial language, Fauvism, where colour governs space and light. On the other hand, the painter takes the opposite approach by letting the bare canvas show, for example in the line of the two houses, and appropriates it as a value. About one of his Ile-de-France landscapes, de Vlaminck wrote, "I set myself up in bright sunlight. The sky was blue, the wheat seemed to tremble and shake in the torrid heat, yellow with the full range of colours, quivering as they were about to suddenly catch on fire. Vermilion was the only colour that could render the dazzling red of the tiles on the hillside facing me. The orange of the earth, the harsh, bitter colours of the greenery and walls and the ultramarine and cobalt of the sky were excessively harmonious in a sensual, musical order. The series of colours on the canvas, with all their power and resonance, were the only things that could, in being orchestrated with each other, convey the colourful emotion of this landscape" (Leymarie, 1987, p. 68). From 1908 on, de Vlaminck increasingly let the web supporting the work show through, which enabled him to structure his compositions and emphasize volumes.
F. K.

Raoul Dufy (1877–1953)
The Beach at Sainte-Adresse

Oil on canvas.
H: 76 cm; W: 97 cm.
Signed lower right: *Raoul Dufy*.
GR 1 912

History:
Geneva, Galerie Max Moos;
Paris, sale at Drouot's,
November 24–25, 1924,
no. 50, repr.; London,
Sotheby's, June 30, 1981,
no. 32, repr.

Exhibitions:
Los Angeles-New York-
London, *The Fauve
Landscape*, 1990, fig. 24
p. 227, repr.; Sydney, Art
Gallery of the New South
Wales – Melbourne, National
Gallery of Victoria, *The
Fauves*, 1995–1996, p. 130,
no. 43; Martigny, Fondation
Pierre Gianadda, *Raoul Dufy,
séries et séries noires*, p. 25,
no. 5; Ingelheim am Rheim,
Altes Rathaus, *Die Explosion
der Farbe, Fauvismus und
Expressionismus 1905–1911*,
1998; Lyon, Musée des
Beaux-Arts – Barcelona,
Museu Picasso, *Rétrospective
Raoul Dufy*, 1999.

Bibliography:
M. Laffaille and F. Guillon-
Laffaille, *Raoul Dufy,
catalogue raisonné de l'œuvre
peint*, supplement, Paris,
1985, fig. 1828 p. 23.

Raoul Dufy (Le Havre, 1877 – Forcalquier, 1953) was the eldest son in a large, music-loving family. At the age of fourteen he started working at a coffee import firm in the port of Le Havre. In 1892 he registered at the Municipal School of Fine Arts and took classes with Charles Lhuillier, who had been Cabanel's student and a great admirer of Ingres. One of his classmates was Othon Friesz (1879–1949). After performing his military service in 1898–1899, he obtained an annual grant of 1,200 francs from his native city, enabling him to register at the Ecole Nationale des Beaux-Arts in Paris. In 1900 he met his friend Friesz at the studio of Léon Bonnat (1833–1922), and the two former classmates moved into an apartment together in Montmartre.

From 1901 Dufy took part in the Salon des Artistes Français, but he preferred exhibiting at the more innovative Salon des Indépendants (from 1903 to 1936) and Salon d'Automne (beginning in 1906). At the time, his painting was influenced by Claude Monet and Camille Pissarro, as his views of Paris and Normandy beaches demonstrate.

In 1905 the artist experienced a major revelation. At the Salon d'Automne he discovered the Cage aux Fauves *and Matisse's famous painting* Luxury, Calm and Voluptuousness. *This event marked the beginning of his Fauve period, characterized by bright colours. In 1908 it resulted in a technique similar to Cézanne's before leading, after a brief Cubist period, to a definitive style after the first world war. The artist's lively curiosity spurred him on to probe the various forms of art, which explains his abundant output of ceramics, fabrics, tapestries, lithographs, watercolours, book illustrations and ballet sets. The range of these works demonstrates the scope of his creativity.*

In 1906 Raoul Dufy returned to the Normandy coast, which he had already visited in 1902, 1903 and 1905, to spend the summer with Albert Marquet in Sainte-Adresse, whose beach he painted. Raoul Dufy and Albert Marquet were such close friends that they planted their easels side-by-side to paint the same subjects. Some of the views

of Le Havre and Trouville are so similar that it is sometimes difficult to tell whether they were painted by one or the other.

Sainte-Adresse is a little seaside resort on the English Channel that had already been immortalized by Boudin, Monet, Jongkind and Friesz. Dufy was sensitive to the atmosphere there, which could be found only in Normandy, the cradle of Impressionism. He was impressed by the wet skies and shimmering light. The artist conveyed the ephemerality of a moment with a spontaneous drawing style and bright colours. He described his evolution himself: "Around 1905–1906, I was painting on the beach at Sainte-Adresse. Until then, I painted the beaches the way the Impressionists had done, and had reached the saturation point. I understood that using nature as my model would lead me to infinity, all the way to its twists and turns and smallest, most fleeting details. I remained outside the painting [...]. I set up my easel and started looking at my tubes of paint and my brushes. How, with that, could I manage to render not what I saw, but what is, what exists for me, my reality ? [...] From that day on, it was impossible for me to go back to my sterile battle with the elements that offered themselves to my sight."

The moment Raoul Dufy distanced himself from reality, his work was no longer an imitation of nature but the sensitive expression of the emotions he felt. The colours in the *Beach at Saint-Adresse* are no longer limited to the ones he actually saw. They have become autonomous in relation to the line, as the foreground demonstrates. Raymond Cogniat recalled, "one day he noticed that the sensation of shape is independent of the sensation of colour. A little girl wearing a red dress and playing on a green lawn leaves behind a trace, a sensation in red, when she moves." Dufy did not base his choice of colour range on a reality, but rather on the value of the tones that surrounded him. Therefore it was not the lifelikeness of the details that interested him, but the intensity of the whole. He based his painting's organization on reds, greens, blues, oranges and violets backed up by deep blacks. However, the colours in

these "moving images" are enhanced on-
ly by their relationship to light. In the *Beach
at Sainte-Adresse*, shadows no longer exist.
Black, which is used as a real colour, does
not darken the painting but, on the con-
trary, brightens it. The light's intensity is
rendered not by whites but by blacks, which
accentuate the burst of pure tones from the
artist's palette.

This work sums up Dufy's temperament and
basic trademarks. He was obsessed by light
and used harsh colours to render it. More-
over, the line describes an expressive,
arabesque drawing style. The brushstrokes
capture movement and provide the com-
position with rhythm. An apparent lightness
and spontaneity emanate from this paint-
ing. This is partly due to the bright, fresh
palette, but in fact it is also the end result

of many preparatory studies. Dufy tireless-
ly filled his sketchbooks with various sil-
houettes until he captured the expressive
line, then filled in his canvas with a speed
that has an air of controlled improvisation
about it.

However, this painting's grace and cheer-
fulness are based on a sound organization
of space, which is stabilized by the line of
the landing stage. An airy, dynamic tech-
nique breathes live into the beach. Raoul
Dufy was nothing less than an enchanter.
In the Rau collection painting his lively, joy-
ful style, featuring incisive strokes, bright
tones and a supple drawing technique, con-
veys the transparency of air, the vibration
of light, the movement of colour and the
calm instability of the sea.

F. K.

Kees van Dongen (Cornelis Theodurus Marie van Dongen, known as Kees van Dongen, 1877–1968)
Little Girl with Sailor Collar or *Dolly van Dongen*, 1912

Oil on canvas.
H: 55 cm; W: 55 cm.
Barely visible signature,
upper right: *van Dongen*.
GR 1.801

History:
Marly-le-Roi, private
collection; Paris, Madame van
Dongen's collection; London,
Sotheby's, July 3, 1979,
no. 96.

Exhibitions:
Liège, Salon triennal, *Van
Dongen*, 1921; Saint-
Germain-en-Laye, salons
de l'Hôtel de Ville, *Chefs-
d'œuvre de collections privées
de Gauguin à Kupka*,
February 14 – March 8,
1967, no. 93; Paris, Musée
National d'Art Moderne, *Van
Dongen*, October-November
1967, no. 83; Rotterdam,
Museum Boymans-van
Beuningen, *Van Dongen*,
December 1967 – January
1968, no. 83; Tucson,
University of Arizona
Museum, *Van Dongen*, 1971,
no. 75, repr.; Warsaw-
Katowice, *Les salons d'automne
à Paris*, April-May 1973;
Geneva, Musée de l'Athénée,
Van Dongen, July-October
1976, no. 33; Paris, Musée
Jacquemart-André, *La Ruche,
l'Ecole de Paris à Montparnasse,
1910–1930*, 1978, no. 52;
Ingelheim am Rhein, Altes
Rathaus, *Die Explosion
der Farbe. Fauvismus und
Expressionismus 1905–1911*,
Internationale Tage
Ingelheim, Boehringer
Ingelheim GmbH, 1998.

*Kees van Dongen (Delfshaven, 1877 – Mona-
co, 1968) was twenty years old when he ar-
rived in Paris in July 1897. At first, he led
a poverty-stricken, bohemian life. In 1905,
he took part in the Salon d'Automne in Paris.
Since his painting was hung next to one by
Matisse in the* Cage aux Fauves *(room VII),
he was considered a member of the Fauve
movement from the outset. He was very
close to André Derain and Maurice de Vlam-
inck, extolling pure colours and rejecting the
academic values of perspective, space and
light in an Impressionistic naturalism.
In 1908, van Dongen's friendship with Max
Pechstein led him to take part in the exhi-
bitions of the Die Brücke Berlin group. His
painting revealed definite affinities with the
German Expressionists. He was increasing-
ly successful, obtaining a contract with the
Galerie Bernheim-Jeune in Paris in 1909. His
growing fame would make him a privileged
witness to Parisian life.*

When van Dongen painted this portrait of
his daughter in Paris in 1912, he had just
left his apartment at 6 Rue Saulnier in the
Nouvelle Athènes neighbourhood for 33
Rue Denfert-Rochereau in the Montpar-
nasse quarter. This move marked the be-
ginning of a lifestyle change that can be
seen in his work. He organized big parties
in the new studio and increasingly moved
in fashionable circles. The next year,
1913, he exhibited *Le Tableau* at the Sa-
lon d'Automne in Paris. This painting was
a nude for which his wife, Guss, had posed.
There was an immediate scandal and the
painting was taken down by the police,
which consequently made it famous.
The abundant, harsh colours van Dongen
had been using a few years earlier (*Acro-
bat with Bare Breast*, 1907–1908; Paris,
Musée National d'Art Moderne; *At the Bois
de Boulogne*, 1907–1908; Le Havre, Musée
des Beaux-Arts) are softened in this portrait
of a child. Stylization and schematization
give way to refined, elegant lines. This new
technique is clearly evident in this picture
of his only daughter, Augusta, affectionately
nicknamed Dolly. She was eight years old
when she posed for this portrait, which, as
usual, shows her wearing a bow in her hair

(*My Daughter with the Teddy-bear*, 1911;
My Daughter, 1912; *Dolly en costume
marin*, 1914). Dolly was the object of no less
than a cult on the part of her father. She
sat for him many times until 1914. Edmond
des Courrières, a critic and van Dongen's
friend, expressed the artist's affection for
children: "Because he loved them, van Don-
gen painted children the way they really
are, little animals barely tainted by civi-
lization. With a few subtleties, he has ren-
dered their clumsy or graceful poses, their
wise airs of big dolls."
Here, a knowing, mischievous sensuality ra-
diates from the child's face. As a confirmed
colourist, the painter was already evoking
what would become posterity's vision of
twentieth-century femininity. The eyes are
made bigger by khol, the lips are full and
the face is fringed with green shadows. The
turquoise touch of the bow in the hair, red
of the lips and virginal white of the shirt
front are so many chromatic foils that light-
en the painting's dark blue, almost black
background and highlight the model's flam-
boyant hair. The crimson line on the sleeve
stresses the navy blue collar's intensity.
This bold colour harmony is one of French
Fauvism's and German Expressionism's
contributions to van Dongen's style.
F. K.

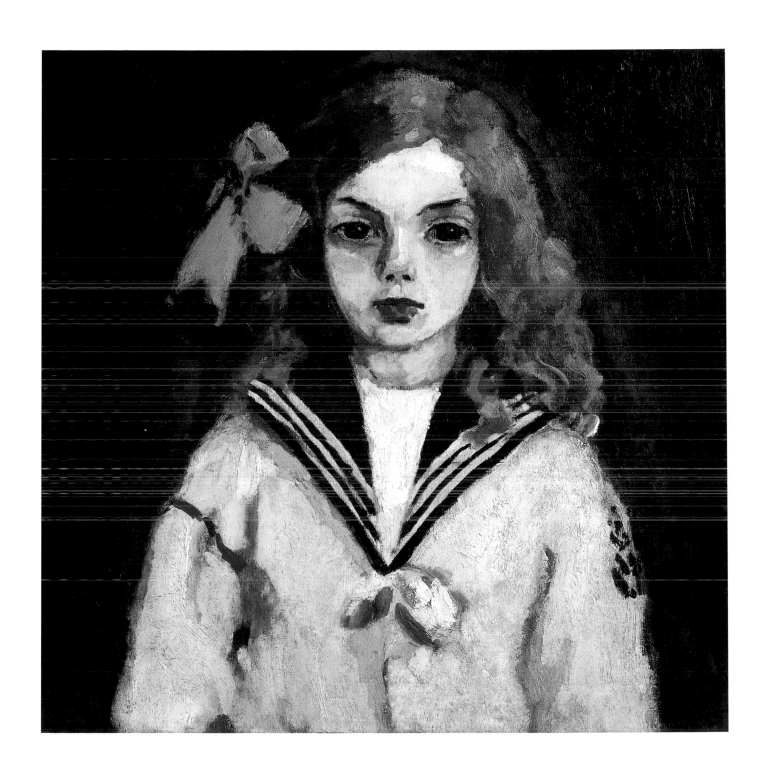

Edvard Munch (1863–1944)
Portrait of Madame von Hoffmann, 1927

Oil on canvas.
H: 92 cm; W: 73 cm.
Signed and dated upper left:
Edv Munch 1929. On the
back: *Munchmuscct Oslo*.
GR 1.101

History:
Hamburg, Senator
Hudtwalcker's collection;
Geneva, sale at Galerie Motte,
December 8, 1970, no. 81,
repr.

Edvard Munch (Loetgen, Norway, 1863 – Ekely, Norway, 1944) lived in Christiania from 1864 and began technical college in 1879. He worked with Julius Middelthun at the National Arts and Crafts School in 1881, and the following year with Christian Krogh. After a first trip to Paris in 1885, he returned in 1889 to work with Léon Bonnat and exhibited at the Salon des Indépendants and Salon de l'Art Nouveau in 1895. His work was increasingly acclaimed throughout Europe and he travelled to Germany in 1893, Italy in 1899 and Prague in 1905. In 1908–1909 he was treated for psychological disorders. The same year he was made a Knight of the Royal Order of Saint Olaf. Pursuing his career, he exhibited in Cologne in 1912 and Berlin in 1927, and began working on the decoration of the Oslo Town Hall in 1928. In 1936 he exhibited in London and the following year eighty-two of his works were confiscated in Hitler's Germany. He died in 1944 near Oslo in the house he had bought in 1916.

This painting, entitled *Woman in Green* in the Galerie Motte catalogue of 1879, is a real portrait. As has sometimes been thought, it is not that of Maria Agatha Hudtwalcker, wife of the Hamburg collector who owned this work, but of Ludwig von Hoffmann's wife. Munch painted this portrait in September 1927, not in 1929 as he himself indicated on the canvas, when the couple came to visit him at Ekely. It has been proven that Munch sometimes signed and dated his works several years after he painted them, without adding anything else to the picture. The date of 1927 is all the more plausible because a photograph was published in the Norwegian newspaper *Aftenposten* on September 3, 1927, showing Munch and Mr. and Mrs. Hoffmann standing round the sketch, presently in the Munch Museum collection in Oslo, for the portrait.
A work from his mature period, this richly coloured painting demonstrates Renoir's influence on Munch. The extremely simple composition shows the frontal, half-length figure sitting behind a table. Halfway between Impressionism and Expressionism,

the painting's intense luminosity is the first thing that strikes the eye. The forms, for example the hands, are but colours, barely delineated by a contour line. Munch goes further into modernity, demonstrating a certain boldness by leaving some parts of the hat white, uncovered by paint.
Munch's work is also surprising in the face's colours, which are a sort of tonal inversion. The forehead and eyes are in light tones, the cheeks in darker hues, evoking the radiance of a beautiful summer day. This impression is reinforced by the violet of the clothing, which expresses the reflection of light in the blue jacket. The green background is of an intensely powerful expressiveness which suggests a full garden. A few vertical brown lines represent tree trunks and visible brushstrokes depict the foliage. The technique creates a green ambience that entirely permeates the sitter by colouring the shadows of her white blouse and her face a pale green.
Ph. L.

Alexej von Jawlensky (1864–1941)
Maria II, 1901

Oil on canvas.
H: 74.8 cm; W: 62.8 cm.
Signed upper left: *A. Jawlensky*;
inscription on the back:
A. Jawlensky / "Maria" II.1901.
GR 1.39

History:
Munich, Galerie Gunzenhauser, December 1971, no. 1.

Exhibition:
Dortmund, Museum am Ostwall, *Alexej von Jawlensky, Reisen-Freunde-Wandlungen 1893–1937*, 1998.

Bibliography:
C. Weiler, *Alexei Jawlensky: Köpfe, Gesichte, Meditationen*, Hanau, 1970, p. 149; "Jawlensky bei Gunzenhauser", in *Artis*, December 12, 1971, p. 40, repr.; "Jawlensky zum Gedächtnis", in *Die Kunst*, December 12, 1971, p. 722, repr.; J.-J. Lévêque, *Les années de la Belle Epoque, 1890–1914*, Paris, 1991, p. 417, repr.; *Catalogue raisonné de l'œuvre peint de Jawlensky*, London, 1991, p. 48, no. 23, repr.

Alexej von Jawlensky (Tver, Russia, 1864 – Wiesbaden, 1941) went to secondary school in Moscow from 1874 to 1882. Refusing a military career, he trained at the Academy of Fine Arts in Saint Petersburg in 1889, then in Munich in 1896, where he was the student of Anton Azbé until 1899 and met Kandinsky. In 1903 he travelled to Paris and Normandy, and in 1905 met Henri Matisse. In 1909 he founded the New Association of Munich Artists with Kandinsky and the Blaue Reiter in 1911. From 1912 on he frequented Emil Nolde and Paul Klee, creating the Blauen Vier with Klee, Feininger and Kandinsky in 1924. In 1934 he began to paint his Meditations.

Jawlensky's training in Saint Petersburg and with Anton Azbé in Munich had provided him with a sound technique. His early works were heavily marked by realism before being influenced by van Gogh and Neo-Impressionism.

Jawlensky painted this portrait in 1901, as the inscription made on the back of the painting by the artist's son indicates. The painter showed his model half-length and turned to the left, with a flower-bedecked hat on her head. Maria was the sister of Jawlensky's wife, Helen. The artist painted her a first time in *Maria I* (private collection; *Catalogue raisonné*, 1991, no. 22, repr.). The young woman, seen frontally in a less expressive pose, is wearing a similar hat with flowers. More importantly, the technique suggests that the two versions were painted at a brief interval.

The surprise aroused by the Rau collection work, whose style is rather unusual for Jawlensky, stems from its sketchy technique, which is achieved with broad brushstrokes that catch the light. The face is more detailed, delicately rendering the figure's personality traits but without really seeking to depict an expression, which gives the painting its Impressionistic character. Throughout his life Jawlensky painted the female figure, which constitutes the major part of his oeuvre. From 1908 to 1913 he painted the *Expressive Heads*, a series of wide, abstract, brightly coloured and almost square-shaped faces. In 1917 he began the *Abstract Mystic Heads* series, where the outline is pronounced and the colours still very lively. Finally, from 1934 to 1937 the *Meditations* series presented small figures. In 1906 Jawlensky painted other half-length female figures, seated in a chair. Examples are the *Young Woman in a Yellow Apron* and *Young Woman in a Pink Dress*, both in private collections (*Alexei Jawlensky vom Abbild zum Urbild*, 1979, nos. 13, 14). These works serve as pretexts for spatial constructions. They are studies in composition in which the figurative subject as such is no longer very important. The artist's expressiveness was already leaning towards the abstract, his style being linked more to the structure of forms than to their perception. The strong outline in these paintings underscores the structure of the face.
Ph. L.

August Macke (1887–1914)
Clown in a Green Costume

Oil on canvas.
H: 121.5 cm; W: 72 cm.
GR 1.658

History·
Hamburg, sale by Dr Ernst
Hauswedel, June 8–10, 1972,
no. 1426, repr.; Cologne,
Lempertz's.

Bibliography:
Vriesen, p. 326, no. 327,
repr.

August Macke (Meschede, 1887 – Perthes, 1914) spent his childhood in Cologne and Bonn. He took classes at the Art Academy and School of Decorative Arts in Dusseldorf from 1904 to 1906. He travelled to Paris in 1907 and became a student of Lovis Corinth in Berlin from 1907 to 1908. The collector Bernard Koehler encouraged him to go back to Paris in 1908. He joined the Blaue Reiter after meeting Franz Marc and Kandinsky in Munich in January 1910, but settled in Bonn in the month of October. In April 1914 he left for Tunisia with Paul Klee, returning to die on the front of Champagne at the beginning of the First World War.

In his catalogue, Vriesen dates the *Clown in a Green Costume* from 1912, when Macke lived in Bonn and was a member of the Blaue Reiter, the first pictorial movement in Germany to head towards abstraction. However, this date does not correspond to the painting's style. At the time, Macke's innovations were taking the course mapped out by Picasso's and Braque's Cubism as well as Italian Futurism. In the work of this period, Macke translated space into a rigid construction of oblique lines, and coloured his pictures with vivid hues. From then on the subjects' movements became the true basis of his experimentation. Vriesen dated the *Clown in a Green Costume* to 1912 by comparing it with other works which were painted the same year and have a similar theme.

Macke loved the theatre, circus and shows of any kind. Walter Gerhardt, one of his friends, relates that he often went to the Appollotheater in Bonn, and that he drew while the performance was in progress. In October 1912 Macke saw Diaghilev's Russian Ballets in Cologne. He was particularly impressed by the *Carnival* ballet, in which Waclaw Nijinsky and Tamara Karsawina danced to the music of Robert Schumann. He made some sketches of it on the spot, which today are in the Bremen Kunsthalle, and executed several pictures on this theme. The first, the *Russian Ballet I*, depicts the most important scene of the performance, when Harlequin and Colombine dance while Pierrot finds himself

alone, in a melancholy mood. The second, *Ballet Russe II: Nijinsky and Karsawina*, was destroyed. In 1913 Macke reworked this theme in *Pierrot* (Bielefeld, Kunsthalle) by organizing the space whose linear structure, bright colours and geometric forms place the accent on the figure's solitude. A black chalk drawing done the same year depicts *A Clown and a Woman Riding a Horse*. The composition of the scene, which takes place in a circus ring, is more reminiscent of Seurat's *Le Cirque* than of *Clown in a Green Costume*. Despite the thematic similarity, Macke's stylistic development points to an earlier date for this last piece, that is to say around 1909–1910. In the *Clown in a Green Costume* the apple green suit contrasts with the blue-green background. Macke did not yet experiment much with turning forms and space into geometric shapes. In reality, this painting is stylistically more similar to works such as the *Self-portrait in Litewka* of 1909.

The artist is shown full-length and the same simplification of forms can once more be seen, particularly in the hands whose fingers are not defined. Also characteristic of Macke's work around 1910 is the emphasis upon contour lines, which lend his figures a very particular, almost melancholic expression.

Ph. L.

Emmanuel Mané-Katz (1894–1962)
The Rabbi, 1925

Oil on canvas.
H: 60 cm; W: 67 cm.
Signed and dated upper
right: *Mané-Katz 25*.
CR 1.515

History:
Geneva, sale at Galerie Motte,
November 2, 1971; Paris,
Drouant collection.

Bibliography:
R. S. Aries, *Mané-Katz, The
Complete Works*, London,
1970, vol. I, p. 40, no. 125
repr. (no signature, no date).

Emmanuel Mané-Katz (Krementchuk, Ukraine, 1894 – Haifa, 1962) was completely immersed in the Jewish tradition during his childhood. His father, director of conscience (schamesch) at the Krementchuk synagogue, brought him up in accordance with the precepts of orthodox Judaism, planning for him to become a rabbi. The young Emmanuel broke the Mosaic law forbidding the representation of images, and learned to draw in secret. He left his hometown's ghetto for the first time to study at the School of Fine Arts in Vilna, but knew nothing of lay life and quickly returned home. Soon afterwards, an artist from Odessa encouraged him to enroll in the School of Fine Arts in Kiev, where he was introduced to European culture.

He arrived in Paris in 1913 at the age of nineteen and tried joining the Foreign Legion at the outbreak of war, but was turned down because of his small size. He then travelled to London, Marseille, Athens, Sofia, Bucharest and Krementchuk, visiting museums where he became familiar with the works of the old masters, especially Rembrandt. He also discovered works by his contemporaries, including André Derain, who had a decisive influence on him.

After nine years since his first trip to France, Mané-Kats returned to Paris in 1921. In the meantime, he had forged a style in which traditional Judeo-Slav themes were his main source of inspiration. He gradually became known as one of the painters of the Jewish soul alongside his elders, Amedeo Modigliani and Chaim Soutine. Mané-Katz painted this *Rabbi* in 1925. The very assertive technique and intimist character suggest that this may be one of his earliest paintings of a live model. This spiritual father inspires intellectual and moral respect.

The painting, which is outstanding for its powerful composition, demonstrates André Derain's influence, especially in the use of pure colours. The crimson of the long beard focuses the viewer's attention, while the background nuanced with small, light, luminous strokes ranging from red on the right to blue on the left makes it stand out against a field dominated by scarlet tones. The artist did not pick these tones by accident. The choice powerfully and brilliantly asserts his religious identity. Mané-Katz sought to keep the Torah's culture alive in his art.

His itinerary in the Paris School and the Montparnasse group was much more "orthodox" than Chagall's, for example. Mané-Katz came to the foreground as one of the diaspora's greatest painters. He was a witness to the scattering of the people of Israel, Judeo-Slav folklore and Yiddish literature. In his exile, he demonstrated loyalty to the tradition in which he was born.
F. K.

After 1940

Marie Laurencin (1883–1956)
Three Young Girls and Two Dogs, 1940

Oil on cardboard-lined
canvas.
H: 38 cm; W: 46 cm.
Signed in ink, upper right:
Marie Laurencin.
GR 1.179

History:
Silvano Lodi's collection.

Bibliography:
D. Marchesseau, *Catalogue
raisonné de l'œuvre peint par
Marie Laurencin*, supplement
being prepared.

The young Marie Laurencin (Paris, 1883 – Paris, 1956) was surrounded by poets, including Guillaume Apollinaire and Max Jacob, and artists, such as Picasso and Braque. By 1905, she was already moving in a circle of innovative artists, gradually finding her identity, the feminine mystique. Her stormy affair with Guillaume Apollinaire and the twists and turns of her love life were in the news. Each of her works can be viewed as one of the pages of a diary where the self-portrait and alter ego appear side by side. The legendary grace in each of Marie Laurencin's paintings reveals her personal vision of woman.

These *Three Young Girls and Two Dogs* seem to have been painted during the 1940s, as other versions demonstrate (*Three Young Girls and Two Dogs*; *Catalogue raisonné*, 1986, no. 834).

Marie Laurencin painted many variations on the same composition, especially during the last fifteen years of her life. As usual, she used a palette of lemon yellow, fuchsia pink, delicate blues and greens that are thinned down with turpentine. She explained, "I didn't like all colours. So why should I use the ones I didn't like? Stubbornly, I put them aside. I used only blue, pink, green, white and black. As I grew older, I accepted yellow and red" (*Conferencia*, August 15, 1934).

These colours, which are painted in light strokes, and the creamy, smooth paste, loaded with ceruse white, express the figures' sensuality. The discreet, nearly flat modelling gives importance to the texture. Some structural particularities – the ribbons in the hair, the arabesque yellow scarf and the fabrics' diaphanous aspect – demonstrate the painter's concern with finding a balance. This construction in space places the figures in a playlet. Big black eyes and small, full mouths accentuate the mischievous character of these impish, roguish little girls. The looks on their faces are almost the same, yet reflect different moods. Their slender, sinuously bending bodies evoke both a farandole and part of a blind man's bluff, with two rapidly sketched dogs. The artist's inner world is conveyed between the dream and reality, the freshness and fragility of these actresses. Marie Laurencin's work contributed the grace and ambiguous softness of her feminine world to twentieth-century art.
F. K.

Giorgio Morandi (1890–1964)
Still Life with Bottle and Glasses, 1945–1955

Oil on canvas.
H: 30.3 cm; W: 45 cm.
Signed lower left: *Morandi*.
GR 1.678

History:
Geneva, Galerie Motte, circa
1973.

Giorgio Morandi (Bologna, 1890 – Bologna, 1964) was the son of a cultivated Bologna family. In 1907 he began taking classes at his native city's Academy of Fine Arts. He remained there for the rest of his life, as a teacher of drawing from 1914 to 1930 and printmaking from 1930 to 1956. The only time he left Italy, it was to see a major Cézanne exhibition in Zurich in 1956. However, at a very young age he had already travelled the length and breadth of his native country. He discovered works by Cézanne in 1909, Renoir, Giotto, Masaccio and Monet in 1910 and Matisse in 1914. Seurat and Corot also strongly influenced his oeuvre.

Morandi deliberately chose to spend most of his time in Bologna, but he was not isolated from the artistic world. He took part in the Futurist movement in 1914, the metaphysical Valori Plastici in 1918 and the Novecento Italiano in 1926. His paintings would always be shown at the greatest international exhibitions.

Morandi stands out radically from his contemporaries because of his work's unclassifiable nature. His oeuvre, which is essentially composed of landscapes and still lives, is based on a powerful, modernist yet timeless discipline and thematic obsession.

Giorgio Morandi created a highly personal, thought-provoking iconography by taking up the traditional genre of the still life. The artist intelligently laid the humblest objects, such as bottles, vases, pitchers, cruets and ewers, out on his studio table and recreated their colour in the painting's imaginary space. All of these simple, lifeless, traditional and familiar vessels have a soul. Morandi's resolutely mature simplicity enabled him to compose an organization similar to a landscape's, with its special, meaningful reliefs in the organization of the composition.

Each of his paintings is ordered according to an intensely rigourous architecture that is always imbued with singularity. The artist paid particular attention to his choice of objects, painting some of them beforehand. This demonstrates the acuity of his eye as well as the extreme sensibility of his temperament. Each painting constitutes the perpetual renewal of an eternal scene. Whatever the number, shape, colour, position or lighting of each of the items the painter shows, the subject's obsessional nature responds to his endless quest.

The composition of the Rau collection's *Still Life with Bottle and Glasses* suggests that it must have been painted between 1945 and 1955. Four perfectly simple, cylindrical objects are lined up on a grey-ochre table. There is a white jar with beige edges, a straw-yellow bottle containing a pink-ochre liquid, a white cup with grey edges and a dark green jar. The vessels stand out against a light beige background painted with broad strokes that let the canvas show through in spots. The delicate, limited colour range attests to an extreme economy of means. Perhaps in this way Giorgio Morandi's work evokes that of Chardin and Corot.

At the centre of the artist's intense, meditative approach to painting is his contemplation of nature and the silent world of objects. Colour and texture are not important in his work. Here, as in each of his many other paintings in the still life genre, which he endlessly renewed, he probed the subtle, inexpressible relationships between shapes and volumes. These objects are imposing because of the simple power of their intimate presence. They alone justify the painting's urgent necessity.

Morandi's quest to capture the sense of the eternity of things transforms the simplest still life into meditative, sensitive painting. Jean Leymarie summed it up well when he wrote, "Morandi renews a genre that marks his work with pure moments of grace [...] his work is a reflection of modern anxiety, the split between being and appearing. His miracle is having managed to strike [...] the difficult balance between bursting reality and controlling reason, between objectivity which is hidden and subjectivity which is hurrying" (*Giorgio Morandi*, 1971).
F. K.

261

List of Illustrations

	1400	1500	1600	1700	1800	1900	2000
Kees van Dongen (1877–1968)						▬▬▬▬▬	
André Derain (1880–1954)						▬▬▬▬	
Expressionism							
Edvard Munch (1863–1944)						▬▬▬▬	
Alexej von Jawlensky (1864 1941)						▬▬▬▬	
August Macke (1887–1914)						▬▬	
Emmanuel Mané-Katz (1894–1962)						▬▬▬▬	
After 1940							
Marie Laurencin (1883–1956)						▬▬▬▬	
Giorgio Morandi (1890–1964)						▬▬▬▬	